RODIN

The B. Gerald Cantor Collection

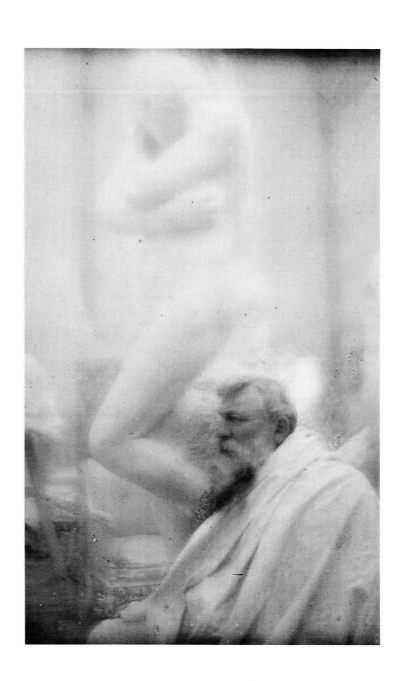

RODIN

The B. Gerald Cantor Collection

by Joan Vita Miller and Gary Marotta

The Metropolitan Museum of Art
New York

This publication was issued in connection with the exhibition *Rodin: The B. Gerald Cantor Collection* held at The Metropolitan Museum of Art, April 19, 1986, to June 15, 1986.

Published by The Metropolitan Museum of Art, New York
Bradford D. Kelleher, Publisher
John P. O'Neill, Editor in Chief
Barbara Burn, Project Supervisor
Cynthia Clark, Editor
Karen Embertson, Designer
Heidi Haeuser, Production Coordinator

Library of Congress Cataloging-in-Publication Data
Miller, Joan Vita.
 Rodin: the B. Gerald Cantor collection.
 Bibliography, p. 161
 1. Rodin, Auguste, 1840–1917—Exhibitions.
2. Cantor, B. Gerald, 1916– —Art collections—
Exhibitions. 3. Sculpture—Private collections—
United States—Exhibitions. I. Marotta, Gary.
II. Metropolitan Museum of Art (New York, N.Y.)
III. Title.
NB553.R7A4 1986 730'.92'4 85–25853
ISBN 0-87099-442-5 (MMA)
ISBN 0-87099-443-3 (MMA, pbk.)
ISBN 0-8050-0029-1 (Holt)

The objects in the exhibition were photographed by Lynton Gardiner, with the exception of the following: no. 10, Michael McElvy; no. 11, Los Angeles County Museum of Art; nos. 12 and 14, Mary Rezny; no. 20, Joe Sandberg; no. 21, The Fine Arts Museums of San Francisco; no. 25, B. Gerald Cantor Collections; no. 29, Joe Sandberg.

Composition by Trufont Typographers
Printed by Rembrandt Press, Inc.
Bound by Publishers Book Bindery, Inc.
Printed in the United States of America

On the jacket/cover: *The Burghers of Calais*, 1884–95, cast 1985 (detail).

Frontispiece:
Edward Steichen, *Rodin—The Eve*, 1907. Autochrome, 6¼ x 3⅞ in. The Metropolitan Museum of Art, The Alfred Stieglitz Collection, 1949, 55.635.9

Contents

Acknowledgments

The authors have had access to the resources of two great institutions. We are grateful to B. Gerald Cantor, Chairman of the Board of the Cantor, Fitzgerald Group, Ltd., and to Philippe de Montebello, Director of The Metropolitan Museum of Art, for providing us with the support necessary to complete this work.

The staff of The Metropolitan Museum of Art was extraordinarily responsive. Emily Rafferty, Vice-President for Development, John Ross, Manager of the Department of Public Information, and Olga Raggio, Chairman, Department of European Sculpture and Decorative Arts, bestowed crucial help and encouragement. Clare Vincent, Associate Curator, Department of European Sculpture and Decorative Arts, read our manuscript and guided us through innumerable factual quandaries. Barbara Burn, Executive Editor, Museum Publications, provided us with editorial counsel and supervised the book's production, ably coordinated by Heidi Haeuser. Designer Karen Embertson elegantly solved the problem of fitting text and illustrations together. Cynthia Clark's close reading of the text and keen editorial work not only improved the narrative but also inspired us to rethink several issues; we are particularly indebted to her. Patrick Coman and the staff of the Museum's Thomas J. Watson Library were always considerate and helpful.

The Cantor, Fitzgerald Group has shared in this effort. We are grateful to B. Gerald Cantor and to Iris Cantor for supplying essential information as well as unstinting support. Vera Green, Curator for Cantor, Fitzgerald in California, provided valuable criticism. Susan A. Zeitlin, assistant in the Art Department at Cantor, Fitzgerald in New York, organized logistical support and tracked down important documentation. Thanks are also due to Simone Saade, who served as translator and typed the text, as well as to Deirdre Chapman, who facilitated communication with the Musée Rodin.

We are indebted to the Brooklyn Museum, the California Palace of the Legion of Honor, the Los Angeles County Museum of Art, the National Gallery of Art, and the Stanford University Art Museum for their cooperation in parting with their Rodins for this exhibition. Mme Hélène Pinet, archivist, and Mme Renée Voisin, assistant to the curator, at the Musée Rodin, were particularly successful in securing photographs. Jean Bernard, Director of the Coubertin Foundry, worked valiantly against tremendous odds to assure delivery of the only lost-wax cast of *The Burghers of Calais*. We also thank Monique Laurent of the Musée Rodin, Professor Albert Elsen of Stanford University, and John Tancock of Sotheby's for their support and assistance.

Our chronology is based on the earlier works of Albert Elsen and John Tancock and was compiled for us by editorial assistant Zachary Leonard and reviewed by Ruth Butler, professor of art at the University of Massachusetts. Alain Beausire, *documentaliste* at the Musée Rodin, made extensive revisions in that compilation. We are beholden to these scholars for separating fact from speculation and ideology in the life of Rodin.

This book is built upon the specialized studies of other scholars. Our footnotes indicate, we hope, where our primary obligations rest, but they doubtless fall short of acknowledging the full weight of our debt to contemporary American scholarship in asserting Rodin's place in the history of art.

Joan Vita Miller
Gary Marotta

Director's Foreword

It is most appropriate that the first exhibition to be held in The Metropolitan Museum of Art's new Iris and B. Gerald Cantor Exhibition Hall should be a selection of sculptures by Auguste Rodin from the B. Gerald Cantor Collection, because forty-one years ago Mr. Cantor, then a young entrepreneur, visited the Metropolitan Museum and fell in love with a marble sculpture. That sculpture was Rodin's *Hand of God*. As Mr. Cantor recalls, it was about two years later that he bought a small bronze version of the *Hand of God* and thus began what would ultimately become the most comprehensive private collection of Rodin's sculptures in the world.

To speak of a single B. Gerald Cantor Collection is somewhat misleading, however, as there have, in fact, been several, owing to Mr. and Mrs. Cantor's generous gifts to a long list of American museums, ranging geographically from the Museum of Modern Art and the Brooklyn Museum in his native New York to the Los Angeles County Museum of Art and the B. G. Cantor Rodin Gallery at Stanford University in California. In the past year, the Metropolitan Museum has joined this group as the recipient of twenty-one of a promised gift of thirty-one works. Among them are some very significant additions to the Museum's well-known collection, a collection that includes the first considerable body of works by Rodin—bronzes, marbles, terra-cottas, and plaster studies, as well as drawings and prints—to be acquired by a public museum in America.

The majority of Mr. and Mrs. Cantor's gifts to the Metropolitan Museum are included in this exhibition as part of a selection from the Cantor Collection and the former B. G. Cantor Sculpture Center. Some are drawn from three of Rodin's great public commissions: the model for the prodigious *Gates of Hell*, undelivered and unfinished at the sculptor's death; *The Burghers of Calais*, Rodin's best-known and perhaps most successful monument; and the brooding, expressionistic *Monument to Balzac*, which suffered the wrath of its original commissioners. The variety of works exhibited here encompasses preparatory studies and models as well as individual figures and groups detached from their larger compositions and presented as separate works of art; one monument in its final state, *The Burghers of Calais*, newly cast in bronze for the occasion by the Coubertin Foundry in Saint-Rémy-les-Chevreuse, France, is also included. A fourth commission, the *Monument to Claude Lorrain* in Nancy, France, is represented by a model for the figure of the great seventeenth-century French painter. Other works are drawn from Rodin's private creations: portraits of family members or friends, intimate studies of the human body in motion, under stress, or as victim of varying psychological states.

These works have been chosen neither in an attempt to survey the entire B. Gerald Cantor Collection nor the entire range of the sculptor's oeuvre but rather to illustrate the depth and seriousness of Mr. and Mrs. Cantor's interests, as well as to complement the Rodin sculptures that may be seen in a nearby gallery devoted to the Museum's collection of late nineteenth- and early twentieth-century French sculpture. Thanks to the Cantors' recent substantial gift of endowment funds, this gallery is now known as the B. Gerald Cantor Sculpture Gallery.

We are very grateful to Joan Vita Miller, Curator of the Cantor Collections, and to her coauthor and husband, Gary Marotta, University Dean and Associate Professor of History, Long Island University, for their participation as informative and gracious guides through Rodin's life and work as reflected in the B. Gerald Cantor Collection. The present exhibition and catalogue may properly be viewed as a celebration of Mr. and Mrs. Cantor's long-standing commitment to share their delight in the work of the preeminent French sculptor with a wide American public, and it is in that spirit that this book is dedicated to them.

Philippe de Montebello, *Director*

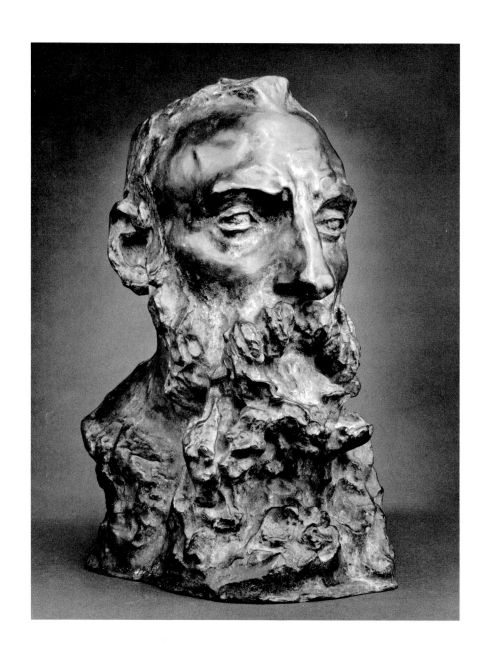

Camille Claudel
Bust of Auguste Rodin
1888–92
Bronze, 15¾ x 9¼ x 11 in.

Introduction

Rodin: A Sketch

Descended on his father's side from Norman lower-middle-class stock and on his mother's side from the peasantry of Lorraine, Auguste Rodin was born in 1840 in a working-class section of Paris near the Panthéon.[1] He was a mediocre student at best, but he showed a talent for art early in life. His father sent him to the Ecole Impériale Spéciale de Dessin et de Mathématiques, known as the Petite Ecole, where the young Rodin learned how to model and to draw from memory under the instruction of Horace Lecoq de Boisbaudran. He frequented the Louvre and the Bibliothèque Impériale, took additional classes at the Manufacture des Gobelins and the Collège de France, and studied animal anatomy with Antoine-Louis Barye at the Musée d' Histoire Naturelle. Rodin was determined to enter the Ecole des Beaux-Arts, but he was rejected three times. This rejection would have a profound impact on his life: always, he would rebel against the French academic establishment; always, he would yearn for official recognition.

After his third rejection, humiliated yet still determined, Rodin began working for commercial decorators and sculptors. His uncertain career nearly ended with the death of his sister, Maria. Shaken, he entered the Order of the Fathers of the Holy Sacrament in 1862. Rodin's compulsion to sculpt resumed; he left the order and rented a stable to serve as his first studio. Earlier, Rodin had made portraits of his father, Jean-Baptiste, and of the superior of the monastery, Father Eymard. In his freezing studio, Rodin now created *The Man with the Broken Nose*, modeled after a neighborhood man called Bibi; he submitted it to the Salon of 1864—his first official competition—and identified himself as a student of Barye and of the commercial sculptor Albert-Ernest Carrier-Belleuse. The entry was rejected.

During this period Rodin met Rose Beuret, a poor neighborhood seamstress. She became his lover and companion for life, and in January 1866 they had a son, Auguste-Eugène Beuret. Rose Beuret also modeled for Rodin and was the subject of several outstanding works, such as *Mignon* and *The Mask of Rose Beuret*. Despite Rodin's legendary sexual promiscuity, she remained always loyal and faithful.

The Franco-Prussian War of 1870 left Rodin without work. During the winter, just before the rise of the Commune, Rodin departed Paris for Belgium to join Carrier-Belleuse in executing a commission to decorate the Brussels Stock Exchange. Work was plentiful, and Rodin stayed in Belgium for six years. During these years he expanded and refined his craftsmanship.

Rodin made enough money in Belgium to travel to Italy in 1875, the year of the fourth Michelangelo centennial. He visited Turin and Genoa and stayed longer in Florence and Rome. He was profoundly moved by Michelangelo, and he wrote to Rose Beuret that the great Renaissance artist "is letting me into some of his secrets." In later years he wrote, "I owe my liberation from academics to Michelangelo."[2]

The two-month trip to Italy proved decisive. When Rodin returned to Brussels he executed *The Bronze Age*, and in 1877 he exhibited it at the Paris Salon. The thirty-seven-year-old sculptor at last attracted some attention; ironically, he was accused of molding the sculpture from life. Nevertheless, Rodin believed he could gain acceptance at the Salon. Over the next few years he produced the monumental figures *Saint John the Baptist Preaching*, *Eve*, and *Adam* and continued to enter public competitions.

During the 1880s he secured commissions for *The Gates of Hell* and *The Burghers of Calais*. In 1889 his reputation grew as a result of the Galerie Georges Petit joint Monet/Rodin exhibition. Rodin had enemies, but by now outstanding critics, including Camille Mauclair, Gustave Geffroy, Octave Mirbeau, and Roger Marx, would come to his defense. Also in 1889 he received commissions for the

Monument to Claude Lorrain and the *Monument to Victor Hugo*. Finally, in 1891, he received the very attractive and highly prized commission for the *Monument to Balzac* from the Société des Gens de Lettres.

In 1883 Rodin met the high-spirited nineteen-year-old Camille Claudel, who became his mistress for fifteen turbulent years. Theirs was a passionate and productive love, during which Rodin reached the height of his creativity. Claudel assisted him on *The Burghers of Calais, The Gates of Hell,* and the marble replicas of his bronzes and modeled for several studies, among them *Thought* and the portrait busts *Camille Claudel* and *Camille Claudel in a Bonnet.* Her own sculpture was brilliant—she was the foremost female sculptor in France at the turn of the century—and Rodin's favorite portrait of himself was her *Bust of Auguste Rodin.* It has a naturalistic expression, powerfully profiled, revealing Rodin's intensity and rugged handsomeness. Claudel failed to persuade Rodin to leave Rose Beuret. In 1898 she left Rodin, became despondent, and suffered a nervous breakdown. In 1913 her family committed her to an insane asylum, where she was kept for thirty years until her death.[3]

Rodin emerged from these years as the most controversial and famous sculptor in the Western world. In 1900, at the age of sixty, he offered his first major retrospective exhibition, known as the Exposition Rodin, in a special pavilion at the Place de l'Alma, near the entrance gate of the Universal Exposition. At the dawn of the new century Rodin was celebrated as the greatest sculptor since Michelangelo and Donatello, and he was lionized as the prophet of bold modernity. Men and women of wealth, power, and influence sought him out. He was friendly with the great intellectuals, writers, journalists, performers, and critics of his time, and a new generation of artists came to Paris to pay him homage.

Rodin reveled in his popularity, and he worked to promote his reputation and to supply the market for his sculpture. He gave many interviews, the critics Paul Gsell and Judith Cladel became his Boswells, and the poet Rainer Maria Rilke interpreted his genius.[4] He used photography not only to perfect his works in progress but also to build his own image as a prolific creative giant.[5] And he fed the insatiable demand for his art by employing a small army of artisans. The Collas machine, a kind of pantograph invented by the French engineer Achille Collas in 1836, was worked by Rodin's "perfect collaborator," Henri Lebossé; it made numerous enlargements and reductions of his sculpture. Rodin was the sculptor of the avant-garde and bourgeoisie alike; between 1898 and 1918 the Barbedienne foundry alone produced 231 bronze casts of *The Eternal Spring* and 319 of *The Kiss,* in a selection of four sizes. Indeed, during his lifetime Rodin employed at least twenty-eight foundries.[6] As his clientele expanded with his reputation, and the commissions for busts increased, Rodin nonetheless preserved time to continue his work on fragments and studies for his private use and personal experimentation.

Judith Cladel and the critic Gustave Coquiot convinced Rodin that he should give all of his work to the state on the condition that the Hôtel Biron—in which Rodin worked and which was owned by the French government—be converted into a museum. It was a long, typically controversial campaign, strongly opposed by the Right and, later, even by the extreme Left in the Chamber of Deputies. Arrangements were finally worked out in July 1916, and the Musée Rodin was established.[7]

In his old age Rodin's productivity diminished, he became erratic, his business affairs suffered, and he quarreled or withdrew from many of his friends. Alleged friends, admirers, and imposters exploited his fame and looted his collection, but Judith Cladel and the minister of commerce, Etienne Clémentel, intervened to

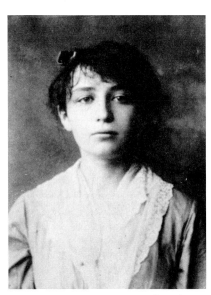

Portrait of Camille Claudel. (Photo by César, Musée Rodin)

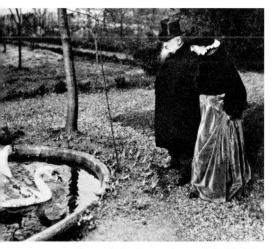

Rodin with his biographer Judith Cladel at Meudon. (Photo, Roger-Viollet)

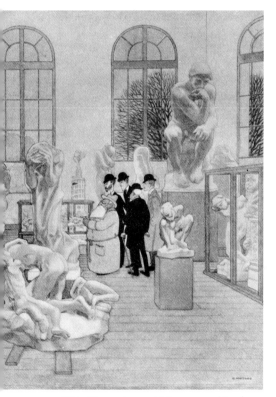

This illustration, which appeared in the German review *Jugend*, portrays Rodin in a dressing gown similar to that worn by Balzac, guiding English members of Parliament through his studio at Meudon. The year is 1907, when Rodin received an honorary degree from Oxford. (Photo, Musée Rodin)

protect his estate. Rodin, seventy-six, married Rose Beuret, seventy-two; she died two weeks later. "How beautiful she is—a piece of sculpture," he said as he watched her on her deathbed.[8] Rodin died within a year of Rose, on November 17, 1917. He was buried at Meudon, and a cast of the monumental *Thinker* was set over the grave site.

Rodin and His Collectors: The Rise and Fall of a Reputation

Rarely does an artist rise from poverty and obscurity to enjoy unprecedented international fame and to witness the assembly of major collections of his work. The Musée Rodin in Paris contains the world's largest, most comprehensive, and most distinguished collection of his works. But the Musée does not have a monopoly on Rodin, and even before its establishment serious collections were developed outside of France by, among others, Karl Jacobson in Denmark, Max Linde and August Thyssen in Germany, Kate Seney Simpson and Thomas Fortune Ryan in the United States, and numerous individuals in England.[9] As early as 1903 the dancer Loïe Fuller brought enough of Rodin's works to the National Arts Club in New York to form the first significant exhibition in the United States. Fuller also interested Alma de Bretteville Spreckels and Samuel Hill in collecting Rodin's sculpture. The Spreckels collection now forms the basis of the Rodin collection at the California Palace of the Legion of Honor in San Francisco, and the Hill collection now constitutes the main body of the smaller Rodin collection at the Maryhill Museum of Fine Arts in Maryhill, Washington. In 1908 fifty-eight drawings by Rodin were exhibited at "291," the Photo-Secession gallery established in New York by Alfred Stieglitz and Edward Steichen. But the first great American museum to open a gallery devoted exclusively to Rodin was New York's Metropolitan Museum of Art, which in 1912 announced the opening of its exhibition of thirty-two works.[10]

Shortly after his death, Rodin's reputation began to slip into critical disfavor, although he remained popular among the public and the great international collectors. M. Kojiro Matsukata, the Japanese industrialist, assembled a Rodin collection that was donated to the National Museum of Western Art in Tokyo. The Philadelphia film magnate Jules Mastbaum donated his huge collection to the Rodin Museum, located near the Philadelphia Museum of Art. Both Mastbaum and Matsukata collected Rodin sculpture during the 1920s and were generous philanthropists, each commissioning casts of *The Gates of Hell* for his countrymen and each contributing to the Musée Rodin collections.[11]

As the canons of neoclassical art collapsed and modern art advanced at an extraordinary pace, Rodin no longer seemed audacious. From the 1920s to the early 1950s, the avant-garde passed him by and collectors showed little interest in him. The formalist Roger Fry, who once helped to select Rodin works for The Metropolitan Museum of Art, criticized him for his sentimentality and lack of refined taste. Fry dismissed Rodin: "His conception is not essentially a sculptural one. Rodin's concern is with the expression of character and situation; it is essentially dramatic and illustrational." Expressive, symbolic, and literary content were replaced as goals by the simple and abstract in form, and modeling was no longer fashionable. The English critic Kenneth Clark consigned Rodin to the dark past as one "with whom an epoch and an episode have come to an end." Rodin failed at irony, was too serious, too public, and too accessible. The critic Leo Steinberg felt that he had outgrown Rodin.[12]

So too, perhaps, had the public. The Rodin Museum in Philadelphia reported a sharp decline in attendance. No scholarly articles or exhibitions on Rodin appeared during the 1930s. The Musée Rodin in Paris was ignored; its collections

Portrait of Rodin with *The Thinker* and the *Monument to Victor Hugo,* 1902. (Photo by Edward Steichen, B. Gerald Cantor Art Foundation)

were not well maintained. The Metropolitan Museum of Art put its Rodin bronzes in storage, leaving only the marble sculptures on public display. The Spreckels collection of early casts and original plasters was also kept in storage at the California Palace of the Legion of Honor. The Boston Museum of Fine Arts labeled its bronze *Iris* "unexhibitable." New York's Museum of Modern Art did not even possess any of Rodin's sculpture until 1955. Everybody, conceded the critics, knew *The Kiss, The Thinker,* and Rodin; the sculptures had become clichés and the artist passé.[13]

Rodin Rescued: Scholars and Criticism

Rodin's latter-day critics were not entirely wrong. In fundamental ways, Rodin *was* conservative. His sculpture was representational. He drew inspiration from the ancients, from the Gothic, from the Renaissance. He was dramatic and concerned with literary and classical motifs. But in their enthusiasm for purity in modern art, the critics riveted their attention on the traditional in Rodin. They failed to see him in historical context; they either forgot, ignored, or were ignorant of his battles with nineteenth-century orthodoxy, his liberation of form and material, his experimentation with fragments and motion, and his insistence on personal artistic expression. Rodin in fact was of his time, yet he looked both to the past and to the future.

Rodin's revival began with scholarship. In 1949 Albert Elsen, under the supervision of Meyer Schapiro at Columbia University, started his serious research into the historical meaning of Rodin. In 1952 Elsen published a preliminary appraisal in the *Magazine of Art* and in 1960 published his *Rodin's Gates of Hell.* During the years between these two publications, the revision of Rodin's reputation proceeded. In 1953 the Museum of Modern Art organized a major exhibition of twentieth-century sculpture; the curator featured Rodin as the precursor of modern sculpture. Leo Steinberg, in his review of the exhibition catalogue in *Art Digest,* accepted the proposition of Rodin's essential link to the "contemporary vision." In 1954 Curt Valentin exhibited forty-four Rodin sculptures, all but one of them bronze casts or original plasters. "This show," wrote Steinberg, "marked a turning point in Rodin's posthumous fortune. For me it meant a loyalty renewed, and being restored to my childhood enthusiasms."[14] And in 1957 The Metropolitan Museum of Art exhibited nearly its entire Rodin collection on the balcony above the Museum's main entrance—where it remained prominently on view for more than a decade.

By this time Rodin scholarship and exhibitions were advancing apace. In addition to Elsen in America, Joseph Gantner in Austria and J. A. Schmoll gen. Eisenwerth in Germany were reconsidering Rodin's historical import, particularly through an examination of his partial figures. In 1962 the Louvre opened its *Rodin inconnu* exhibition, and in 1963 the Charles E. Slatkin Galleries in New York mounted a penetrating Rodin exhibition that toured twelve museums in the United States and Canada—the brilliant, provocative introduction to the catalogue was written by Leo Steinberg. In that same year, 1963, the Museum of Modern Art launched a major Rodin retrospective, accompanied by a comprehensive study and appraisal, Albert Elsen's *Rodin.*[15]

The rescue of Rodin succeeded. "Within the Western anatomic-figure tradition," wrote Steinberg, "Rodin is indeed the last sculptor. Yet he is also the first of a new wave, for his tragic sense of man victimized is expressed through a formal intuition of energies other than anatomical. . . . For while modern art was in the making Rodin seemed irrelevant. And now . . . it is his relevance that astonishes us as we look again."[16]

4

The initial rescue effort was indeed a success, but Rodin's lifeline to permanency remains tenuous. Steinberg celebrates Rodin because of his affinities with the modern temper; Rodin is resuscitated by Steinberg solely because of his relevance to twentieth-century art. At the start of his essay, Steinberg asks the reader to put most of Rodin aside, to forget the marbles, the monuments, the rhetorical and expressive pieces. "Rodin is accepted in his twentieth-century guise," observes Rodin scholar John Tancock, "but rejected totally as an artist of the nineteenth century."[17] For the rescue to be complete, Rodin must be appreciated in his nineteenth-century context as well as in his relationship to the history of art. Rodin must be seen in his diversity as a great watershed figure, and his rediscovery must be grounded in close, serious study if Rodin is to endure and to elude a return to oblivion.

B. Gerald Cantor and the Rediscovery of Rodin

In 1945, when Rodin was in disfavor, the young B. Gerald Cantor, just returned to civilian life from the U.S. Army to resume his career in the securities business, saw Rodin's marble *Hand of God* in The Metropolitan Museum of Art. Eighteen months later Cantor acquired his first Rodin, another version of the same sculpture. This marked the beginning of a long and earnest commitment to the artist and his work: Cantor has devoted four decades to the study of Rodin literature and the amassing of the world's largest and most distinguished private Rodin collection.[18]

The search for knowledge led Cantor to Mme Cécile Goldscheider, then curator of the Musée Rodin. Mme Goldscheider introduced Cantor to the full range of Rodin's oeuvre: not only the pretty marbles that first caught his interest, but the monuments, bronzes, busts, studies, partial figures, and fragments as well. The curator and the financier became good friends, and, with the support of the French government, the Musée Rodin authorized new casts of original plaster models and studies, the majority of which had never been executed during Rodin's lifetime.

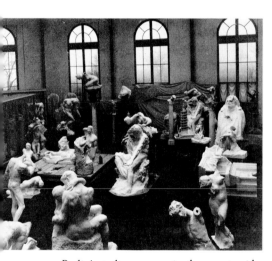

Rodin's studio-museum in the countryside, at Meudon, ca. 1912(?). (Photo by Jacques-Ernest Bulloz, Musée Rodin)

Cantor's passion for Rodin was intense, his acquisitions prodigious. He did far more than revive a sagging market, although prices for Rodin sculpture began to rise in the 1960s and have been rising ever since. He engaged in a comprehensive, long-term exhibition program, touring selections from his vast and growing collection throughout the world. In 1967 the Los Angeles County Museum of Art first exhibited Cantor's collection. In the introduction to the catalogue *Homage to Rodin,* Mme Goldscheider wrote: "The B. Gerald Cantor collection not only typifies the recurrent interest in Rodin's work, but surveys little-known areas within the master's prolific working life. The Cantor collection is certainly the most important private collection in the United States."[19] It would become the most important private collection in the world.

Cantor is heir to an American tradition of distinguished Rodin collectors, including Loïe Fuller, Thomas Fortune Ryan, Kate Seney Simpson, Samuel Hill, Alma de Bretteville Spreckels, and Jules Mastbaum. B. Gerald Cantor has far surpassed all of them in the size and diversity of his collection and in the scale of his benefactions.[20] His philosophy of "art must be seen" has led him to startle the art world with his gifts: he donated 33 Rodins to the Los Angeles County Museum; nearly 150 to the Stanford University Museum of Art; 21 to The Metropolitan Museum of Art; 55 to the Brooklyn Museum; 10 to the Museum of Modern Art; and 10 to the College of the Holy Cross, Worcester, Massachusetts. During the past twenty years he has also given hundreds of Rodin sculptures to other museums as well as to other colleges and universities across America. He

has donated millions of dollars for the development of exhibitions, galleries, and sculpture gardens. B. Gerald Cantor has generously bestowed his gifts during his lifetime and disseminated them widely to reach the largest serious audience.

Perhaps Cantor's most enduring investment in Rodin appreciation has been his support of Rodin studies. The scholarships, research grants, travel fellowships, and publication subventions, particularly to scholars at Stanford University, may enable Rodin to remain forever "rediscovered." Cantor was introduced to Stanford by his friend Peter S. Bing, former President of the Board of Trustees at the university. When Cantor learned of Albert Elsen's work at Stanford, he determined to join forces with the scholar to make the United States the world center for Rodin studies. The Stanford University Rodin collection, which includes manuscripts, reminiscences, and other bibliographical materials, is the world's largest outside of the Musée Rodin in Paris. The Musée, once insulated from American scholars, has been made accessible by the current curator, Mme Monique Laurent, due in part to the diplomacy of B. Gerald Cantor.

As a result of Cantor's commitment, a school of Rodin studies has flourished at Stanford around the premier Rodin scholar, Albert Elsen. The work of these scholars has been outstanding: *Rodin and Balzac,* with an exhibition at Stanford; *The Partial Figure in Modern Sculpture: From Rodin to 1969,* with an exhibition at the Baltimore Museum of Art; *Rodin Drawing, True and False,* with exhibitions at the National Gallery of Art, Washington, D.C., and the Solomon R. Guggenheim Museum, New York; and *Rodin's Burghers of Calais,* with an exhibition at Stanford.[21] Former Cantor Fellows, such as Kirk Varnedoe and Daniel Rosenfeld, among others, are teaching, researching, and publishing, taking their places alongside such already established scholars as Albert Elsen, John Tancock, Jacques de Caso, Patricia B. Sanders, Athena Tacha Spear, and Ruth Butler.

The exploration of new fields of Rodin scholarship culminated in the 1981 Rodin retrospective at the National Gallery of Art in Washington, D.C., which was organized by Elsen. The massive exhibition publication, *Rodin Rediscovered,* is a critical anthology of the latest research, and it goes far toward documenting Rodin's diversity and securing the survival of his reputation.[22] For the exhibition Cantor commissioned a unique cast of *The Gates of Hell.* Iris Cantor, who shares her husband's passion for Rodin, produced the film *Rodin: The Gates of Hell* for the occasion. Her award-winning documentary, itself a work of insight and art, is a valuable addition to the study of Rodin.

Cantor's belief that "art must be seen" has led not only to an extensive dissemination of his own collection but also to the development of collections of excellence at the Los Angeles County Museum of Art and Stanford University in California and at the Brooklyn Museum and The Metropolitan Museum of Art in New York. His insistence on public accessibility prompted the opening of the B. G. Cantor Sculpture Center at the corporate offices of Cantor, Fitzgerald in New York City and the B. Gerald Cantor Rodin Sculpture Garden on the campus of Stanford University.

Cantor works to advance public appreciation of art through his personal and corporate philanthropy as well as through his policy roles as a trustee of The Metropolitan Museum of Art and as a member of the Business Committee for the Arts. He continues to build his collection, which includes sculpture by other artists, such as Bourdelle, Kolbe, and Manzù, in addition to paintings from the Impressionist, Post-Impressionist, and Expressionist periods. This extraordinary public and private labor is guided and assisted by Iris Cantor, who succeeds her husband as a trustee of the Los Angeles County Museum of Art.

In recognition of these many ventures, Cantor has received numerous commen-

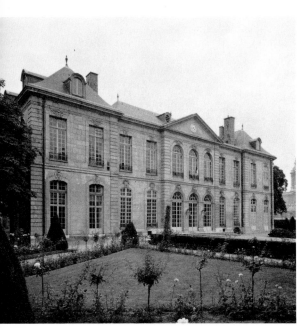

In 1908 Rodin rented the ground floor of this eighteenth-century Parisian town house, known as the Hôtel Biron. The mansion was a residence for many writers and artists, including Jean Cocteau, Isadora Duncan, and Henri Matisse. Years later the Hôtel Biron became the Musée Rodin. (Photo, Musée Rodin)

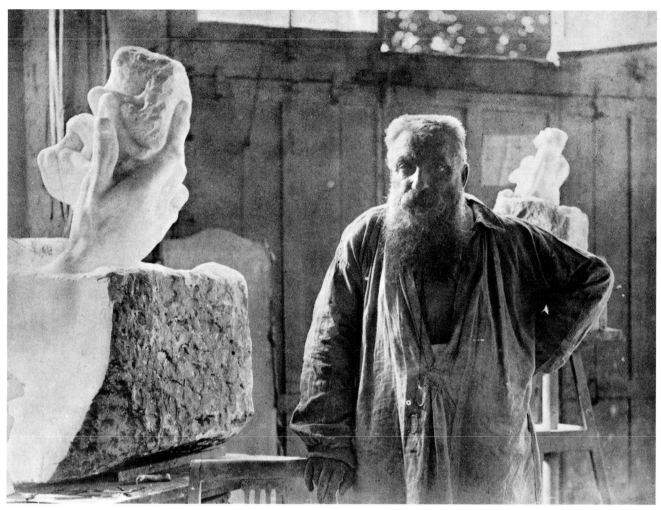

Rodin with the *Hand of God*, 1902(?).
(Photo, Musée Rodin)

dations and honorary degrees, including membership as an Officer of the Order of Arts and Letters conferred by the French Ministry of Culture. A particularly meaningful gift, from the directors of the Musée Rodin, is a plaster of the *Hand of God*—the sculpture that first fired Cantor's passion for Rodin. The directors expressed their gratitude "for the magnificent effort that you made and continue to make to assemble the most important collection, ever achieved, of the works of the great French sculptor. You are," the citation continues, "always ready to exhibit or even to donate these works, which you selected with so much competence and love."

Rodin has been rescued and is being rediscovered. B. Gerald Cantor has played a vital role in this process. This exhibition pays tribute to Rodin and to his greatest collector. *Rodin: The B. Gerald Cantor Collection* is a selection of sixty-eight representative sculptures from the corpus of Rodin's work—from his earliest bust through his monuments to his late personal studies. Especially for this exhibition, Cantor has commissioned a cast of the monumental *Burghers of Calais*. Included as well are a bust of Auguste Rodin by Camille Claudel and a model of the "lost-wax" bronze casting process. The catalogue text, like the exhibition, breaks no new ground; its intent is to introduce and to appreciate genius, and its appraisal of Rodin is openly partisan.

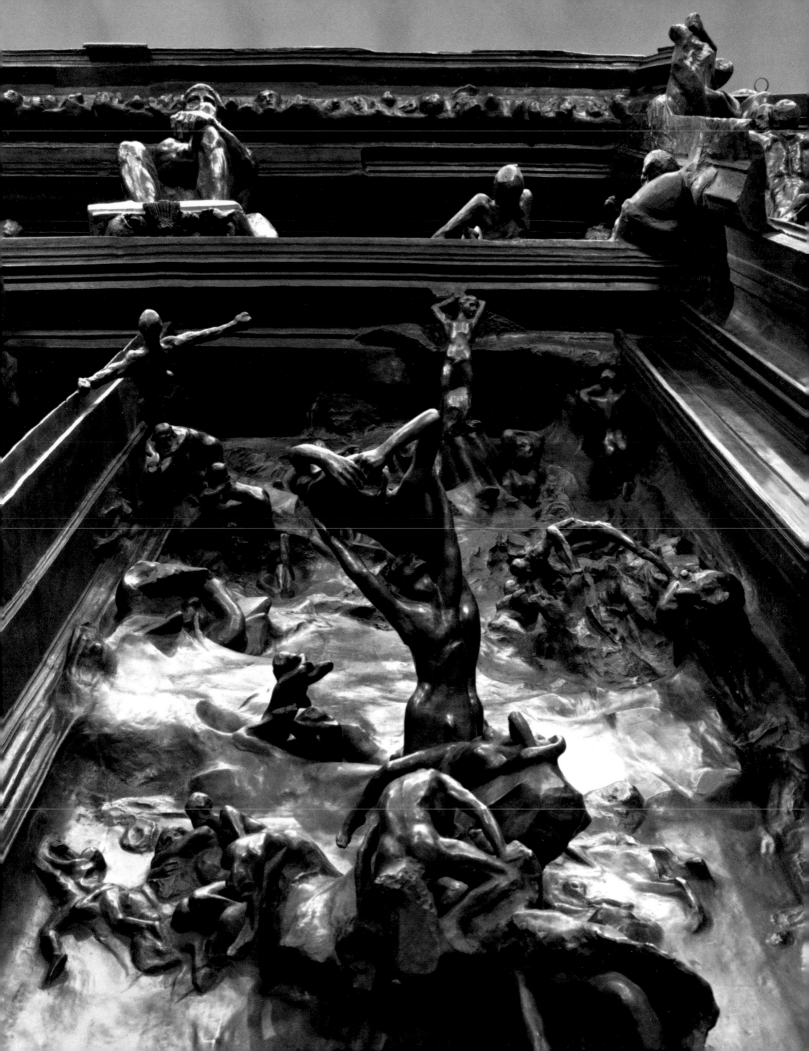

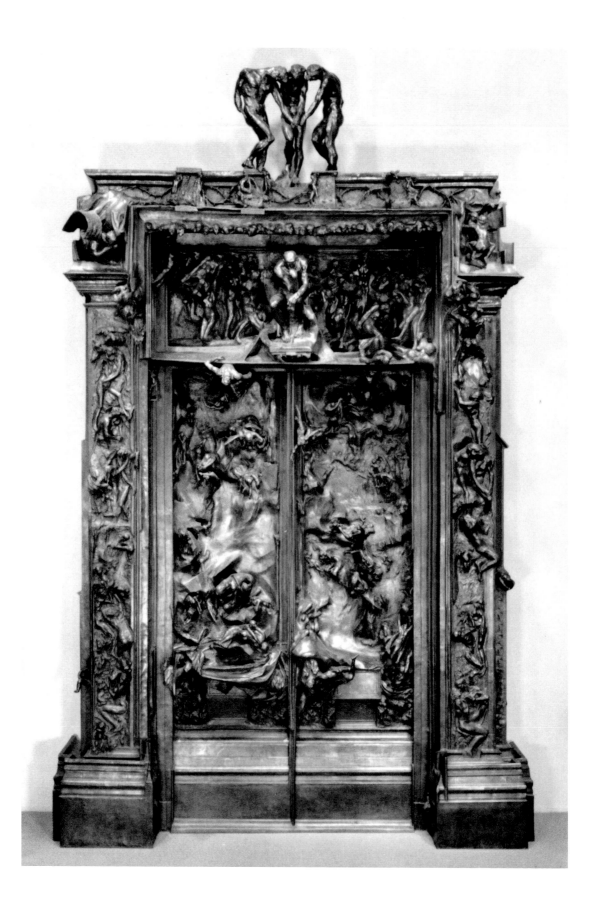

The Gates of Hell

The Gates of Hell is a public monument to a private vision. It is also the most important and most prodigious work by one of the most important and most prodigious sculptors in the history of Western civilization.

The history of *The Gates of Hell* began officially on August 16, 1880, when the French minister of public instruction and fine arts authorized Rodin to proceed, in the words of the commission, with "a decorative door destined for the Museum of Decorative Arts: 'Bas reliefs representing the *Divine Comedy* of Dante.'"[1] But the *Gates* was not "destined" for the new Parisian museum, for that museum—to have been constructed on the site of the former Cour de Compts, destroyed by fire during the Paris Commune of 1871—was never built. Instead, the Gare d'Orsay railroad station was erected on that site in 1900, the same year Rodin first exhibited the plaster *Gates* to the public. As a result, the French government never called for its delivery or bronze casting. Since Rodin's death, however, five privately funded bronze casts have been made. They can be seen in Tokyo, Zurich, Paris, Philadelphia, and Stanford, California; this last, commissioned by B. Gerald Cantor and the only one produced by the "lost-wax" method as Rodin wished, has toured the United States and now permanently resides at Stanford University. Nevertheless, the *Gates* does at last seem "destined" to be located at a museum on the original site: the Gare d'Orsay station is being renovated and transformed into the Musée d'Orsay, which will replace the Musée du Jeu de Paume as the Louvre's showcase for late nineteenth-century French art. Among its treasures will be the 1917 plaster model of *The Gates of Hell*.[2]

When Rodin received the commission in 1880, he was an impoverished artist, without academic training or awards. Worse still, he had acquired a reputation for fraud: critics had charged that his *Bronze Age* and *Saint John the Baptist Preaching* were not sculpted but cast from the bodies of models. Rodin insisted on an official inquiry. He was vindicated, and the government purchased his statues, but the attacks had hurt and enraged him. Yet despite these attacks, Rodin was acquiring a following, and Edmond Turquet, undersecretary of fine arts, arranged the commission for him. Rodin suggested the theme of the *Divine Comedy* and decided to mold many small figures in bas-relief to prove that he did not cast from life.[3] While Rodin recognized his opportunity for a masterpiece, with such a theme and a point to prove, he did not begin the *Gates* with a master plan. The *Gates* evolved, conceptually and sculpturally, over a period of twenty years.

Rodin went to work. He read and reread Dante, and he sketched, filling copybook after copybook with his drawings. Sculptural plans were only part of the work, however, for he would also have to be an architect. Just as he had turned to the medieval epic poem for his theme, Rodin turned to the Renaissance for the prototype of the doors themselves. His first sketches for the architecture of the doors derived from Lorenzo Ghiberti's *Gates of Paradise*, the east portals of the Baptistery of San Giovanni Battista in Florence.

Dante and Ghiberti served as starting points. The ten panels on Ghiberti's doors were reduced to eight, perhaps corresponding to the number of circles in the *Inferno*. But as Rodin began to mold his sculptures other influences absorbed him, until only a few figures, such as *Ugolino and His Sons* and *Paolo and Francesca*, were inspired by Dante. These other influences included characters from the Bible and from mythology. He called on his own earlier works, too, such as *The Man with the Broken Nose* and the head of *Saint John the Baptist*, as well as the people around him. Rodin even incorporated a likeness of himself. Additional figures were invented, unidentified sufferers. Possibly even more potent a source of inspiration than Dante's *Divine Comedy* was Baudelaire's *Les Fleurs du mal*, an edition of which Rodin illustrated while working on the *Gates*. Like the *Divine*

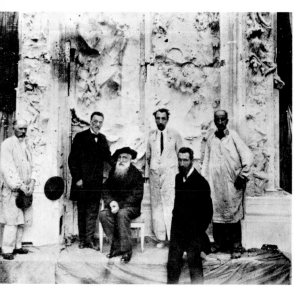

Rodin with friends in front of the denuded full-scale plaster model of *The Gates of Hell.* Standing at the artist's right is Léonce Bénédite, first curator of the Musée Rodin; to his left is Henri Lebossé, who was responsible for reductions and enlargements of Rodin's sculpture; in the foreground is Eugène Rudier of the Alexis Rudier Foundry, where the *Gates* was originally cast. (Photo, Collection Robert Descharnes)

Comedy, Les Fleurs du mal expressed a tragic view of the human condition, and Rodin responded to Baudelaire's evocation of sexual decadence and images of seduction, fatal women and rejected, remorseful men.

The early architecture of the *Gates* could not contain Rodin's expanding conception. (He would eventually populate the *Gates* with some 186 figures.) Rodin soon abandoned the eight-framed door panels and, using designs from French Gothic churches and Baroque art, replaced them with two huge, cavernous, undulating panels. These would capture light and shadow and carry a multitude of figures in high and low relief, swirling, jumping off the structure, defying the rigid framework of conventional decorative architecture.

There is a certain composition to the *Gates,* notably in the placement of the larger figures. The monumental *Adam* and *Eve,* freestanding before the *Gates,* form the base of a pyramid, at the zenith of which stand *The Three Shades* and, directly below them, *The Thinker.* This arrangement rivets our attention on the plenitude of reliefs adorning the *Gates.* There is no sequential story neatly illustrated on clearly defined panels, however. As Rodin stated, "There is no intention of classification or method of subject, no scheme of illustration or intended moral purpose. I followed my imagination, my own sense of arrangement, movement, and composition."[4] Rodin was driven by a large, consuming idea, producing a large, extraordinarily detailed dramatic effect. It touches our sense of the nether side of life.

Rodin's commission set the date of 1885 for the delivery of the doors. In January 1883 Roger Ballu of the Ministry of Fine Arts visited Rodin at his studio. Ballu reported that he saw only isolated groups, but that the work was "extremely interesting. . . . This young sculptor reveals a really astonishing originality and power of expression. . . . Beneath the energy of the attitudes, beneath the vehemence of the poses expressive of movement, he conceals his disdain for . . . a coldly sculptural style." Ten months later, Ballu visited Rodin again, and his second report, now touching on the composition of the portals, was even more favorable. "The design of the work will, I think, be a startling one . . . when it is completed, this portal may seem a little strange in parts, but it will be a work of daring, it will command attention as an original creation. It may be criticized in the name of consecrated principles and prevailing rules; it will be accepted by virtue of the undeniable power of the style in which it is executed. It will be truly, and in the full sense of the word, a work of art."[5]

By 1885 Rodin had informed the government that a plaster model would be finished shortly, had secured an estimate for a bronze cast for the *Gates,* and had taken on several major commissions. Nonetheless, he continued to work on the *Gates,* experimenting, redesigning, refining. He publicly exhibited several of its statues.

Rodin once called the *Gates* his "Noah's Ark"[6] of inventions, and the progeny issuing from that monument are remarkable. Indeed, many of the figures created for the *Gates* have become independent works of art and are frequently better known than the portals themselves. *The Kiss, The Thinker, The Three Shades, The Prodigal Son, Fugitive Love, Adam,* and *Eve* are some of the most popular pieces that have been reproduced, enlarged, or reduced in several media to meet the demand for Rodin's art. Although Rodin decided not to incorporate *The Kiss* in the *Gates,* it remains a self-sufficient artistic achievement and perhaps the best known of his works. *The Gates of Hell* made Rodin both famous and wealthy.

During these years Rodin was also working on many other commissions, including the controversial *Burghers of Calais* and *Balzac.* His studio was constantly visited by intellectuals, artists, journalists, disciples. The *Gates* generally received high praise and established Rodin's reputation as the greatest sculptor

Caricature of Rodin carrying *The Gates of Hell* on his back, 1884. Watercolor by Charles Paillet. (Photo by Gabe Weisberg, Manufacture de Sèvres, Bibliothèque)

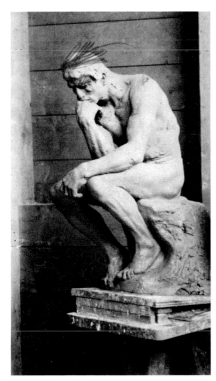

Clay model of *The Thinker*, 1880–81, in front of the wooden box frame for the *Gates*. Pencil notations on the head suggest Rodin's dissatisfaction with the modeling. (Photo, Musée Rodin)

since Michelangelo, but it did not escape criticism entirely. The *Gates*, said the critics, was derivative—a literary, not an original, creation. Its sculpture was described as obscene, vulgar, illogical. Rodin was described as crazy and accused of betraying the public trust by not completing the *Gates*. Rodin's friends, such as the American sculptor Truman H. Bartlett, and Rodin himself issued strong, convincing defenses in the public press. Still, criticism persisted, particularly the notion that the *Gates* was not ready for delivery.

The Universal Exposition was scheduled for Paris in 1900. It gave Rodin an opportunity to exhibit the *Gates* publicly, to demonstrate it was complete. With financial aid from several friends, he planned a major retrospective of his works. He built a pavilion in the Louis XVI style at the Place de l'Alma, adjacent to the exposition, where he displayed 170 of his works, including a plaster model of the monumental *Gates of Hell*, which was largely denuded of the high reliefs. Rodin sold over 200,000 francs' worth of sculpture and received orders from museums and collectors around the world. Everything, including the sculptures derived from the *Gates*, was for sale; everything, that is, except the *Gates* themselves.

Still, the critics insisted that a scandal was involved in the nondelivery of the *Gates*. That the Museum of Decorative Arts was never erected and that the government never called for the delivery of the *Gates* appear to have been ignored. Although it is true that Rodin himself never felt that the *Gates* was "finished" in his meaning of the term—for he believed that art was continually unfolding and developing, yielding to new experiments and formations—it was certainly completed. Albert Elsen, the definitive scholar of the *Gates*, writes: "If the government in 1900 had called for the bronze casting of *The Gates of Hell*, Rodin would have complied, with or without modifications. The same could be said, in my view, if the government had called for the casting in 1889 or 1885."[7]

The plaster *Gates* was removed after the 1900 exhibition and remained in Rodin's studio until it was assembled in 1917 under the supervision of Léonce Bénédite, first director of the Musée Rodin. The 1917 plaster *Gates* contained more sculptural pieces than the 1900 plaster, but the additional high-relief pieces had been in the studio at least since 1900. "M. Bénédite and Mademoiselle Cladel," according to an article published a month after Rodin's death, "work without rest to arrange the Musée Rodin. . . . They will set up a plaster cast of the *Porte de l'Enfer*. . . . During Rodin's last days," the article continues, "M. Bénédite gathered in the studio of the rue de l'Université all the *morceaux* of the *Porte de l'Enfer*, and he was greatly surprised to notice that the monument was complete. It was not lacking one piece."[8]

The Gates of Hell drew initial inspiration from a Christian cosmography, but Rodin's final *Gates* reveals a secular hell. *Adam* and *Eve*, as independent statues of the first man and woman, stand before the *Gates*, inviting us to look at their progeny. Yet no Christ sits in the tympanum, just as no angels or saints stand on the lintel above. Nor is there reference to a Savior or Devil, Heaven, Hell, or Redemption. *The Three Shades* stand at the summit; it is *The Thinker*, originally conceived as Dante, then transformed into the universal poet-artist, then transformed again into mankind—beholding, musing—who now occupies the tympanum.

There is no didactic narrative. Instead, the *Gates* is everywhere peopled by living men and women, agonizing in their passions, perversions, and tragedies. Their "evil demons," as the novelist Anatole France wrote, "are their own passions, their loves and hatreds; they are their own flesh, their own thought."[9] The *Gates* dramatically draws us to the depths of the human condition. It is Rodin's unprecedented modern vision, born of experience, sympathy, and pity, not of vengeance. Hell, Rodin insists, is here on earth, to be faced alive and, finally, alone.

The Three Shades

Dante, in the *Inferno*, describes three shades who danced in a circle as they told of their woe in Hades.[10] Rodin's *Three Shades* stand at the center of the top lintel of *The Gates of Hell*, crowning the tympanum just above *The Thinker*. The downward gesture of their left arms and their heads conveys despair as it summons the viewer to gaze upon the *Gates*. Each shade in *The Three Shades* is the same figure, not a different sculpture; each is repeated and juxtaposed to form a new composition. Art historian John Tancock observed that their abbreviated right hands—the modeling, creative hand—may symbolize the powerlessness of the shades to change the fate of human suffering.[11]

Their formal history derives from Rodin's *Adam*, but the *Shades* show less tension and greater coordination of movement.[12] This 38¼-inch version of *The Three Shades* is the original size and was intended for the *Gates;* the enlarged version of about 1898 adds the hands and reveals the Michelangelesque muscularity Rodin so admired in Italian Renaissance sculpture. The positioning of *The Three Shades* at the summit of the *Gates*, reminiscent of Gothic tympana, may also have been influenced by Andrea Sansovino's three stone figures on the lintel above Ghiberti's *Gates of Paradise* at the Baptistery of San Giovanni Battista in Florence.[13]

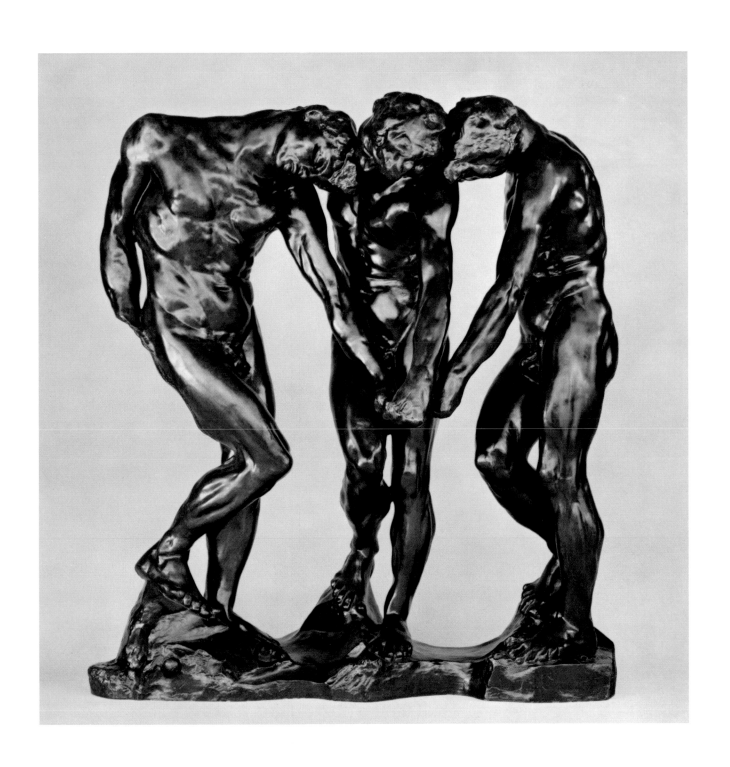

1. *The Three Shades*
1881–86, cast 1969
Bronze, 38¼ x 37 x 20½ in.

15

Fallen Caryatids

The ancient Greeks considered caryatids to be priestesses, and draped versions of them were used as architectural props, supporting columns in the form of upright women. Unlike their Greek counterparts, Rodin's caryatids are compressed forms ridden with burden, existing as autonomous works of art.

In the *Purgatorio* Dante describes frightened souls trying to expiate their sins by carrying huge stones on their backs.[14] The stone in Rodin's *Fallen Caryatid with Stone* has been characterized by the critic Gustave Geffroy as "heavy like unhappiness," and the poet Rainer Maria Rilke observed that the caryatid "bears its burden as we bear the impossible in dreams from which we can find no escape."[15] Thus, the stone symbolizes not only physical suffering but mental anguish as well, both inescapable. The fatalism of these figures is reinforced by the *Fallen Caryatid with Urn*, since the urn is associated with tomb ornamentation and is a symbol of mourning and bereavement.[16]

Rodin conceals the caryatid figure in the *Gates* under voluminous drapery and a swirling scroll. Contorted like the figures on medieval doorways, she rests in the upper-left corner. Both the *Fallen Caryatid with Urn* and the *Fallen Caryatid with Stone* were considered by Rodin and his friends to be among his very best compositions,[17] and the latter was the first figure from the *Gates* to be reworked into marble and exhibited as a freestanding work of art.[18] There are numerous versions of each, in various media, including bronze, marble, and limestone.

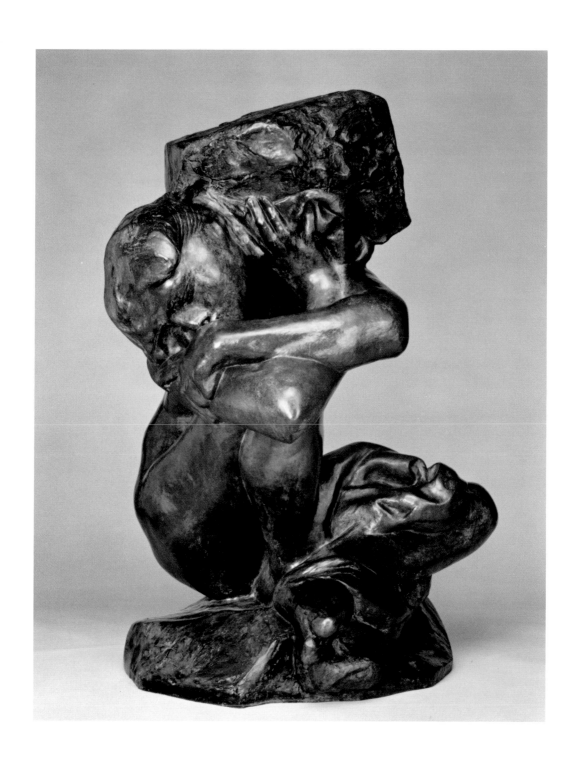

2. *Fallen Caryatid with Stone*
Ca. 1881, cast 1981
Bronze, 52½ x 33 x 39 in.

17

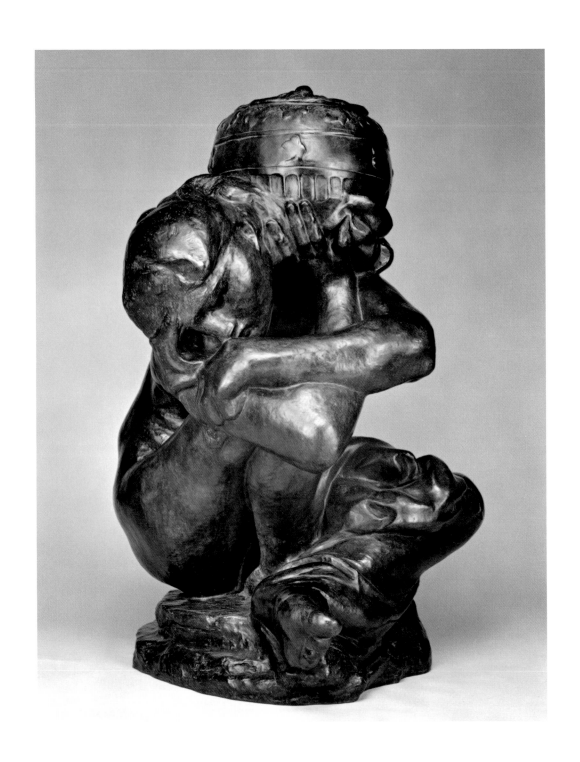

3. *Fallen Caryatid with Urn*
1883, cast 1981
Bronze, 45¼ x 36¾ x 31⅛ in.

18

4. *Drawing of Ugolino and His Son*
Ca. 1875–80
Ink, 5⅜ x 3⅝ in.

Ugolino and His Sons

The story of Ugolino, chronicled by the medieval historian Villani, is dramatized in Dante's *Inferno*. Ugolino della Gherardesca, count of Donoratico and admiral of the Pisan fleet, was involved in the complicated and treacherous politics of the Italian city-states of the thirteenth century. The archbishop of Pisa had him accused of treason and imprisoned, together with his sons. "The Pisans," wrote Villani, "caused the tower to be locked, the key thrown into the Arno, and all food to be withheld from them."[19] Dante, in relating the story, has Ugolino cry from Hell: "Through agony I bit; and they, who thought/ I did it through desire of feeding, rose/ O' the sudden, and cried, 'Father, we should grieve/ Far less, if thou wouldst eat of us. . . .' / . . . Whence I betook me, now, grown blind, to grope/ Over them all, and for three days aloud/ Call'd on them who were dead. The fasting got/ The mastery of grief."[20]

Rodin was obsessed by the Ugolino story long before he obtained the commission for the *Gates*, and his sketchbooks contain more than thirty drawings on the theme.[21] In Dante's version it appears that Ugolino, now blind, starves to death as did the children. It is uncertain whether he cannibalizes them. The nineteenth-century interpretation, however, has Ugolino devouring his sons. Rodin's studies of this grim theme begin with a tender Ugolino cradling his sons, as in the *Drawing of Ugolino and His Son*. Ugolino sits upright, with the boy, probably the first son, Gaddo, draped across his lap, recalling the iconography of the dead Christ and the Virgin Mary.[22] It is the portrait of a horrified but compassionate Ugolino. The sketches go on to portray a continuing degradation, until the famished father, bestialized, pounces on the flesh of his children.

Early sculptures and an 1880 clay model of the *Gates* show Ugolino seated in a vertical position, his dead son across his lap.[23] On the completed *Gates*, *Ugolino and His Sons* appears on the middle of the left door, at eye level, with Ugolino no longer up-

19

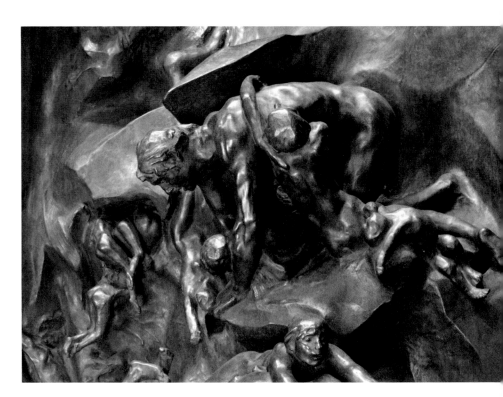

The Gates of Hell, detail of the left door panel with *Ugolino and His Sons*. (Photo, Bill Schaefer)

right. Here a blind Ugolino, starved and near death himself, crawls on the ground. The horizontal figure, hunched over his children, resembles the beast he is becoming. One child, his head turned upward, may still be alive, as Ugolino appears to caress him with his arm. Another son pulls himself up from the side, reaching his arm across his father's back. The two younger children are dead. Ugolino, still retaining his humanity, is horrified by the cadavers and his own crazed thoughts.

The *Torso of Ugolino's Son* is a fragment derived from the complete sculpture of *Ugolino and His Sons*. It is the son, probably Uguiccione, reaching up with his arm across his father's back, but now separated from his environment. In this remarkable fragment, arms and legs as well as muscular and facial details have been discarded. Only the clarity of the conceptual gesture, the horror, the pity, and the pleading, remain. Rodin, drawing on a medieval theme, anticipated the essence of modern sculpture.

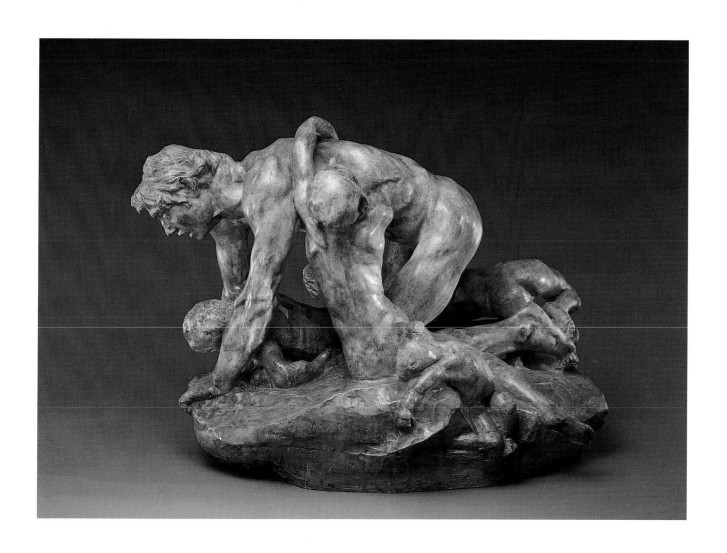

5. *Ugolino and His Sons*
1882
Plaster, 16½ x 25⅛ x 15 in.

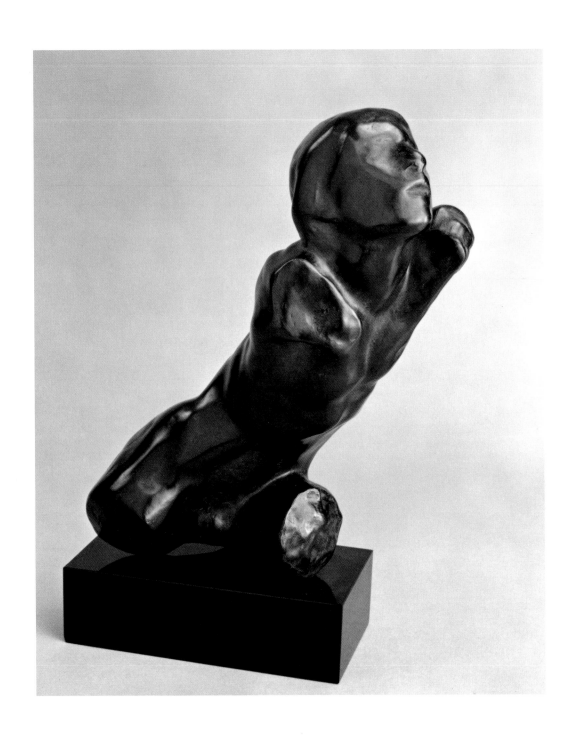

6. *Torso of Ugolino's Son*
1882, cast 1980
Bronze, 9½ x 7⅜ x 4½ in.

22

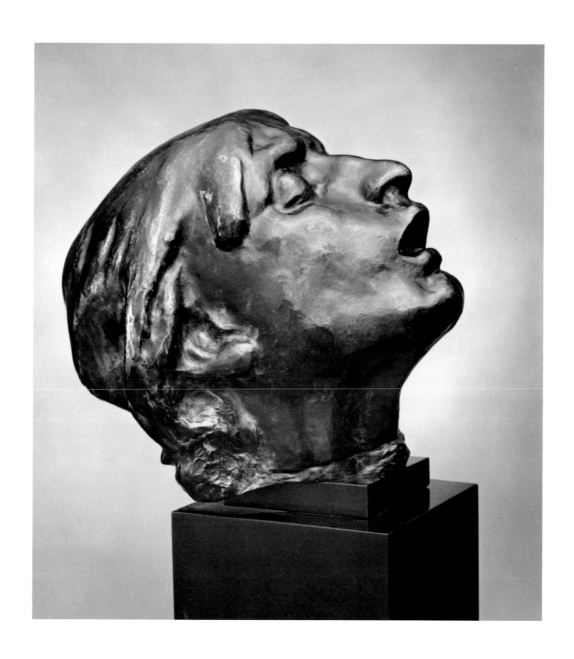

7. *Head of Sorrow*
1882, cast 1963
Bronze, 9 x 9 x 10½ in.

23

Rodin's assistant, Henri Lebossé, attaches the *Head of Sorrow* to the enlargement of *Ugolino and His Sons* at Meudon, 1906. (Photo, Philadelphia Museum of Art)

Head of Sorrow
Fugitive Love
The Prodigal Son
Paolo and Francesca

Rodin demonstrated a genius for combining, recombining, juxtaposing, enlarging, and reducing figures and parts of figures to form new, vital compositions.[24] In some part this method derives from the industrial concept of interchangeability, but for the most part it stems from Rodin's conviction that art is transformable, always alive and never finished.

The *Head of Sorrow* is the same head that appears on the son who pulls himself onto his father's back in *Ugolino and His Sons*. This head appears three more times on *The Gates of Hell*: on the male figure in *Fugitive Love*, which appears twice; and on Paolo in *Paolo and Francesca*. Detached from the *Gates*, the head also appears on the figure of *The Prodigal Son*, itself a repositioning of the isolated male figure in *Fugitive Love*. The *Head of Sorrow*, with its open mouth and closed eyes expressing grief, held great fascination for Rodin. As an independent work it was known by many titles, including *Head of Orpheus, The Last Sigh, Anxiety,* and *Joan of Arc*.[25]

The head is sexually neutral, and Rodin used it for both male and female figures.

On *Fugitive Love*, the female below eludes the grasp of the male, whose back moves along the back of her legs as he grasps for his lover. She flies away from him, holding her head, her lips curled in a disdainful smile. He writhes in torture. Physically, since they are back to back, their carnal union is impossible. Not only fusing Dante's damned adulterers and Baudelaire's tormented souls, Rodin also here symbolizes man's psychological inability to comprehend woman—a prevalent theme in nineteenth-century European art and literature.[26] *Fugitive Love* appears twice on the right portal of *The Gates of Hell*: above the lower-right corner, with the female figure underneath; and in the middle, reversed and extending outward in high relief, the female figure changed both in posture and in relation to the male body.

The male body in *Fugitive Love*, a forceful portrayal of suffering and long-

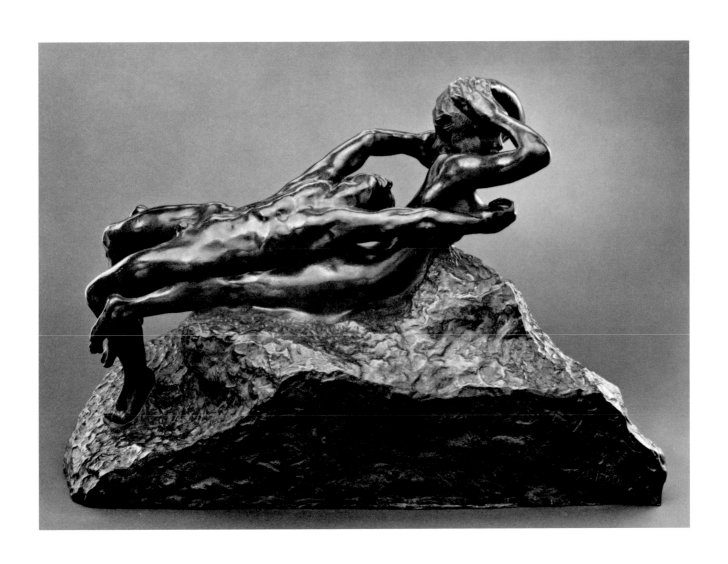

8. *Fugitive Love*
1881
Bronze, 20¾ x 33 x 15 in.

ing, was separated and exhibited in 1894 as a single work entitled *The Prodigal Son*.[27] In *The Prodigal Son* this versatile figure is upright and in a suppliant position, body arched, face and arms raised to heaven. "I have accented the swelling muscles which express distress," said Rodin. "I have exaggerated the straining of the tendons which indicate prayer." His cries, in Rodin's words, are "lost to the heavens."[28]

Dante, in the *Inferno*, meets the lovers Paolo Malatesta and Francesca de Rimini. Francesca explains that their love began innocently while "reading about Lancelot and how love seized upon him. . . . But there was one passage that was our ruin. When we read how this tender lover kissed a smile on the adored mouth, he who shall never leave me tremblingly kissed me on the mouth."[29] The lovers were discovered by Francesca's husband, who murdered them both. Paolo and Francesca were consigned to the circle of carnal sinners for their adultery. The pathos of this story moved Rodin, and

he was determined to incorporate it in the *Gates*, giving it as prominent a position as Ugolino.

The story of Paolo and Francesca inspired *The Kiss*, but Rodin did not incorporate that work in the *Gates*, perhaps because, as Rainer Maria Rilke said, he wanted to eliminate "everything that was too solitary to subject itself to the great totality."[30] Yet *Paolo and Francesca* survive in the *Gates*—in a very different form, however—on the lower-left door, below *Ugolino and His Sons*. They appear in a tender but exhausted embrace, Paolo's arms draped across Francesca's back and shoulder. The tragic lovers are fated to an eternity of unrealized desire. In this sense, *Paolo and Francesca* symbolize all the frustrated lovers on the *Gates*.

26

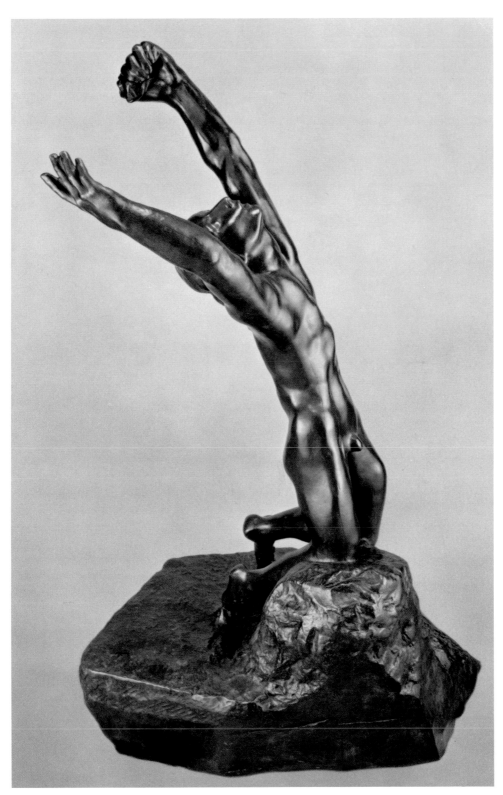

9. *The Prodigal Son*
Ca. 1885–87, cast 1969
Bronze, 54⅜ x 34⅜ x 28⅝ in.

27

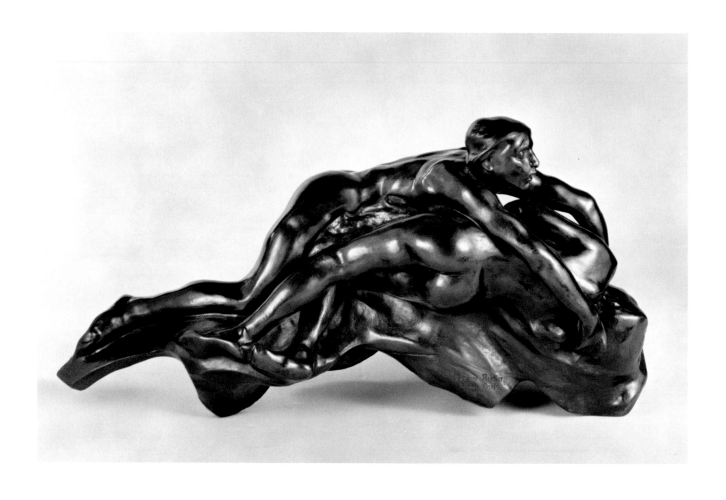

10. *Paolo and Francesca*
1889, cast 1981
Bronze, 12⅛ x 22¼ x 14¾ in.

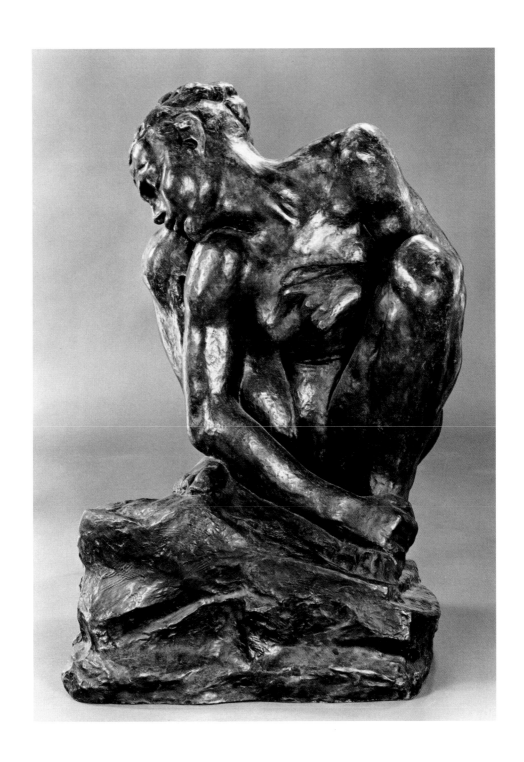

11. *Crouching Woman*
1880–82, cast 1963
Bronze, 37½ x 25 x 22 in.

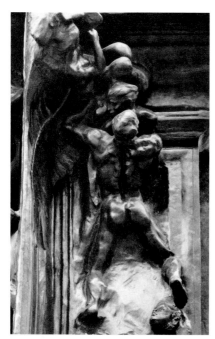

The Gates of Hell, detail of the upper-right pilaster with the *I Am Beautiful* couple. (Photo, Bill Schaefer)

Crouching Woman
I Am Beautiful

The *Crouching Woman* appears twice in *The Gates of Hell:* to the left of *The Thinker* in the tympanum and cradled in the arms of the figure known as the *Falling Man* in a composition called *I Am Beautiful.* The compact *Crouching Woman,* executed at the same time as *Adam, Eve,* and *The Shade,* reflects the influence of Michelangelo. The locked limbs suggest immobility, and her left hand, which squeezes her breast, possibly represents a lament for a lost child[31] (children without parents appear elsewhere on the portal). The solitary figure arouses intense pathos. The *Crouching Woman,* however, when joined to the male figure in *I Am Beautiful,* evokes entirely different meanings; suddenly she is transformed from a forlorn, bereft woman into a yielding, voluptuous lover.

Created by joining two independently conceived figures, *Crouching Woman* and *Falling Man, I Am Beautiful* appears on the upper-right pilaster of *The Gates of Hell.* To achieve this coupling, Rodin had to modify the figures slightly to accommodate each

other's embrace. As an individual work, the *Falling Man*[32] has his right leg bent back at the knee with his foot in the air and his arms pointed downward. In *I Am Beautiful* both feet touch the ground, bracing him for the weight of his lover, and his arms extend upward, enveloping the female. The *Crouching Woman* has also undergone alterations. She no longer grasps her foot. Instead, her arm hangs motionless, accentuating her submissive attitude. The individual figures thus transformed, a powerful, muscular male now gathers a trembling, submissive woman in his arms, lifting her to his mouth. At the Exposition Rodin of 1900, one critic described it as "magnificent" but "evidently not intended to be used in the education of young girls."[33]

The title *I Am Beautiful* comes from Baudelaire's poem, which is inscribed on the base of the sculpture: "I am beautiful as a dream of stone, but not maternal;/ And my breast, where men are slain, none for his learning,/ Is made to inspire in the Poet passions

that, burning,/ Are mute and carnal as matter and as eternal."[34] The poet, apparently, holds the beauty for a tantalizing moment only, then is denied eternal pleasure.

12. *I Am Beautiful*
Ca. 1881–82, cast 1968
Bronze, 27¾ x 12 x 12½ in.

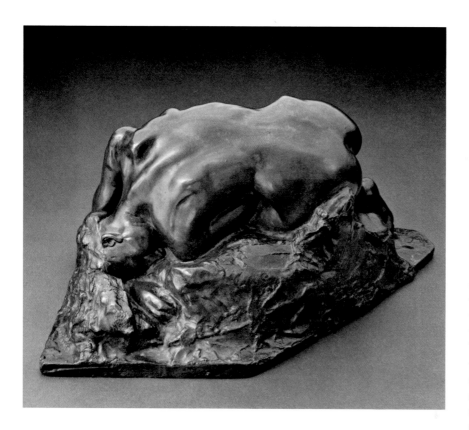

Danaïd

In Greek mythology the fifty daughters of King Danaüs, known as the Danaïds, murdered their bridegrooms at their father's command on the first conjugal night and were condemned forever to pour water into a bottomless vessel in Hades.[35] The lithe figure of the *Danaïd* was prepared for the *Gates*, but Rodin never incorporated it into the monument.[36] The figure is shown curled on a rock, exhausted, her hair spilling over like water, the vessel under her arm. She is sensuous, but fated to eternal sorrow and frustration. Rodin highlights the smooth shape of the *Danaïd* by contrasting it against the rough, jagged surface of the rock. "It is wonderful to walk slowly about," said the poet Rilke, "to follow the long line that curves about the richly un-folded roundness of the back to the face that loses itself in the stone as though in a great weeping."[37]

13. *Danaïd*
Ca. 1884–85
Bronze, 8½ x 15⅜ x 10¼ in.

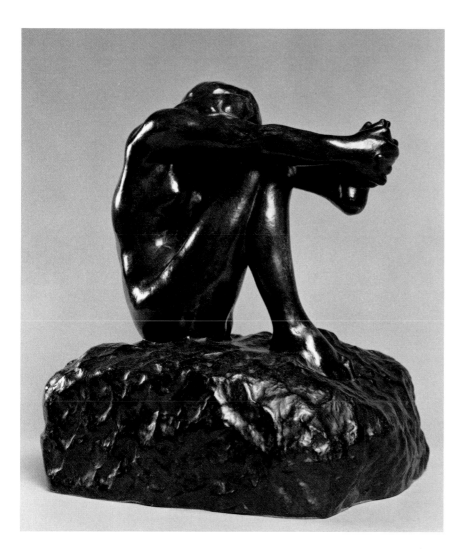

Despair

Victor Frisch, Rodin's studio assistant, noted that "Rodin preserved over twelve figures embodying the various human expressions of despair."[38] This *Despair* holds her raised left foot with both hands, her body straining and pushing, recalling Rodin's dance movements. *Despair* is located in the upper-left door of *The Gates of Hell*. Like the *Fallen Caryatid with Stone,* she is partly hidden by drapery.[39] The French expression that "equates putting one's foot in one's hand with sexual orgasm may have occurred to Rodin and made this unusual and expressive pose all the more appropriate for *The Gates of Hell,*" observed Albert Elsen.[40]

14. *Despair*
Ca. 1890, cast 1967
Bronze, 12½ x 12 x 9 in.

Fragment of the Right Pilaster

By February 1885, both the right and the left decorative pilasters of *The Gates of Hell* were complete. This fragment is a reduction of the middle section of the right pilaster, located between the two lovers entitled *I Am Beautiful,* above, and the two sets of lovers below. The figures on the pilaster are closely related to the nymphs, satyrs, and cupids depicted by Rodin on works done for the Manufacture de Sèvres from the middle of 1879 to 1882.[41]

This fragment illustrates two fundamental ways in which Rodin broke with accepted historical and contemporary methods of modeling sculpture in relief. Students of the Ecole des Beaux-Arts were taught to model from a single viewpoint perspective, but Rodin modeled his figures as if they would be seen from numerous angles— front, back, and side. One of the methods Rodin used to accomplish this was to sculpt a figure or group of figures away from the portal and then experiment with its placement on the *Gates.* This facilitated variety in the degree to which the figures would be hidden, resulting in both high and low relief. The undulating surface of the *Gates* encouraged this type of experimentation.[42] In contrast to the ancient friezes of Roman sarcophagi, Rodin's figures are neither static nor uniform, but dynamic.

Beaux-Arts students were also taught to compartmentalize figures in their own defined space, whereas Rodin's figures commingle discreetly. The leg of the middle female figure reaches down to touch the lifted arm of the figure below, for example, while the leg and foot of the top female in profile curve along the shoulder and arm of the frontal figure below. The figures are free, yet they touch, with chubby infants acting as connecting motifs. The figures even break out of the architectural frame itself, as seen where the knee of the middle figure and the foot of the top figure graze the pilaster's edge, and the knee of the figure below intrudes into and beyond the frame of the pilaster.[43]

The date of this right-pilaster frag-

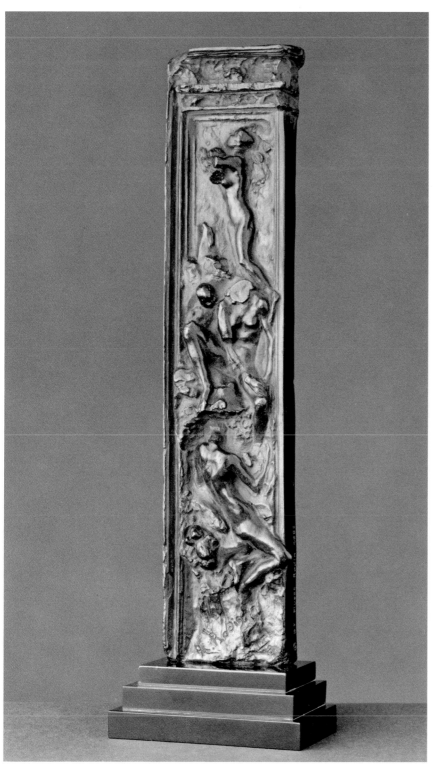

ment is uncertain. Historians cite 1900 or thereabouts for reductions of the left-pilaster fragments. Their premise is based on the Rodin retrospective of 1900 that exhibited a stripped-down version of the plaster *Gates of Hell*. The absence of high-relief sections in the Cantor bronze would also date this reduction to about 1900.[44]

15. *Fragment of the Right Pilaster of the Gates of Hell*
Ca. 1900, cast 1982
Bronze, 10¾ x 2¼ x 1¼ in.

35

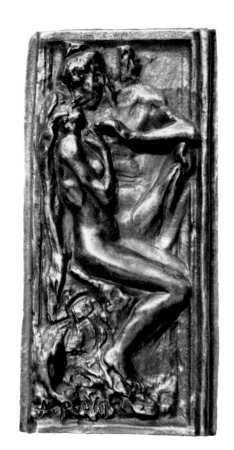

16. *Embracing Couple*
1898, cast 1979
Bronze, 4¼ x 2⅛ x ½ in.

Embracing Couple

The *Embracing Couple* appears in the lower-right pilaster of *The Gates of Hell*. Its subject could have been influenced by designs Rodin created for decorative porcelain vases earlier in his career. Unlike those frolicking nymphs and satyrs, however, this bas-relief depicts lovers in emotional turmoil and was probably inspired by Baudelaire's *Les Fleurs du mal*. Absent here is the tenderness displayed by the couple in *The Kiss;* these lovers are frenetic. The tendons in the neck and leg of the male are tense as he grips his partner's face from around her neck, throwing it back and toward him. Her body is smooth, and she appears physically to yield to his clutch. His legs are open, but hers are closed. Their embrace may be artificial and given in despair, since the couple appears to be incompatible.[45]

There are two plaster reliefs of this subject, one in the Cleveland Museum and one in the National Gallery, Washington, D.C., but neither has the left arm of the male intact. That the Cantor bronze has the full arm suggests that it was taken from an earlier plaster, since, as art historian Athena Tacha Spear documents, the *Gazette des Beaux-Arts* of May 1898 reproduced the lower-right pilaster, showing the *Embracing Couple* with the male's left arm complete.[46]

36

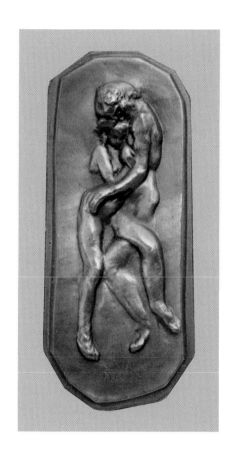

Protection

Protection is a reduction of the composition with two lovers entitled *Vain Tenderness*, which appears in the upper-left pilaster of *The Gates of Hell*. The young couple embraces softly, her hand on his arm, her left leg draped across his thigh; his left arm touches her hip, his right hand moves to caress her shoulder. It is a tender embrace, but it is in vain. Conceived in the 1880s, *Vain Tenderness* was probably one of the earliest works Rodin modeled for the *Gates*. In 1905 a group called Les Amis de la Médaille planned to cast this relief under the title of *Art Embracing Matter*. By 1916 *Vain Tenderness* was reduced in size, and a medal was cast for the French Actors Guild as *Protection*.[47]

Rodin's choice of title may have been ironic, for vain also connotes vanity. Rodin could have been suggesting that vanity, normally considered a vice, may be essential to the protection of actors, or, possibly, that the medal might protect them from vanity.

The following words are impressed on the reverse side of the medallion:

PROTECTION / COMPOSE PAR / AUGUSTE RODIN / POUR / THE FRENCH ACTORS FUND / AU PROFIT DE L' / AIDE AUX ARTISTES / ET EMPLOYES DE THEATRE / EN COLLABORATION / AVEC / L'ASSOCIATION / DES / DIRECTEURS DE THEATRE / DE PARIS / PARIS. NEW-YORK / MCMXVI

17. *Protection*
1916
Bronze, 3¾ x 1⅝ x ¼ in.

Rodin, in his later years, with *The Thinker*. (Photo, B. Gerald Cantor Collections)

The Creator

At the base of the inward right side of *The Gates of Hell* is a small crouching figure in low relief called *The Creator*. The figure rests on his knees, his legs tucked, body leaning forward, his left arm lifted to his brow, as if in thought. The right arm holds a small female figure near his shoulder, close to his head. Albert Elsen, in his early study of the *Gates*, interpreted the male figure as a "reference to God as maker of the world and its laws." Albert Alhadeff later argued that the figure was a self-portrait of Rodin and represented the artist's signature. It is indeed Rodin's face, with its large profile, high forehead, and long, wavy beard. The secondary female figure can be interpreted as an inspiring muse, but is more likely a personification of the "idea born from the creative effort," arising out of Rodin's "will, as Athena once sprang from the forehead of Zeus." Elsen indicated that this may have been Rodin's last work for the *Gates*, and his later study agrees that *The Creator* is a self-portrait of Rodin, albeit as "a godlike artist."[48] Rodin's description of *The Thinker* as it evolved bears an uncanny resemblance to his self-image in *The Creator*: "I conceived another thinker, a naked man . . . his feet drawn under him . . . he dreams. The fertile thought slowly elaborates itself within his brain. He is no longer dreamer, he is creator."[49]

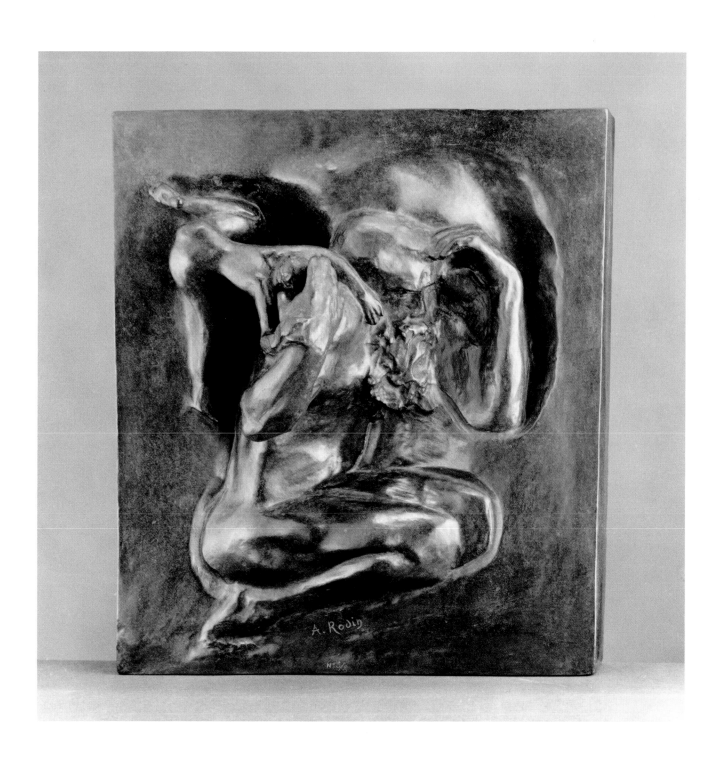

18. *The Creator*
Ca. 1900, cast 1983
Bronze, 16 x 14¼ x 2½ in.

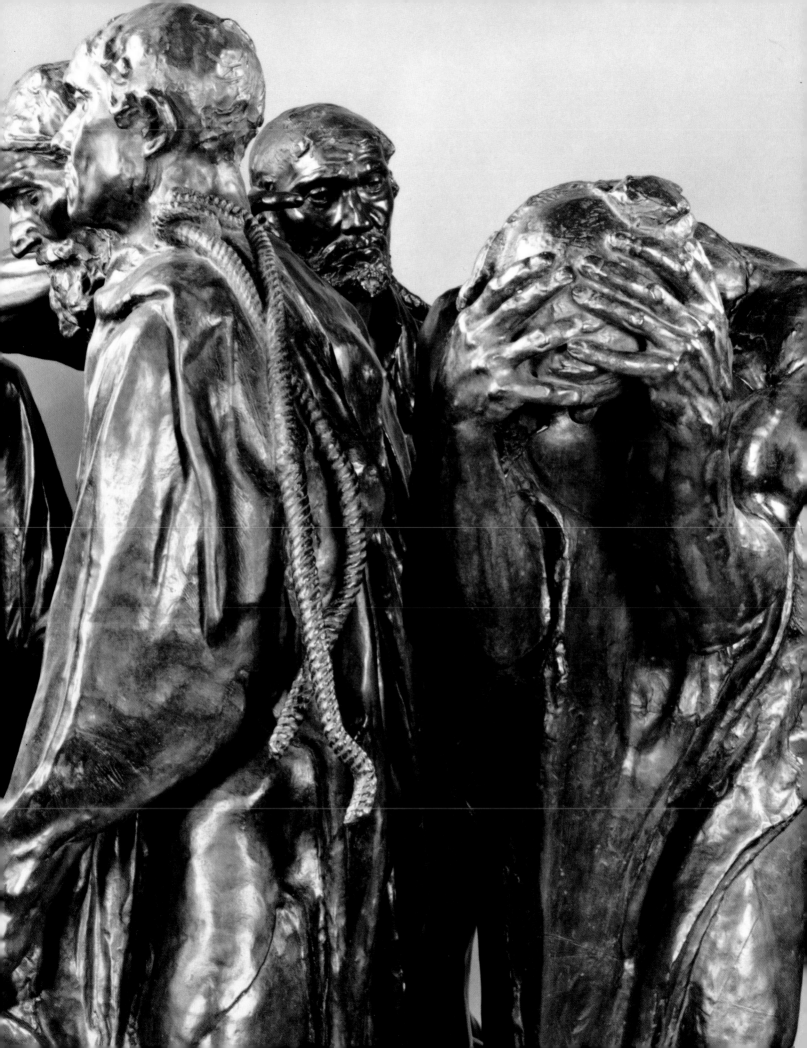

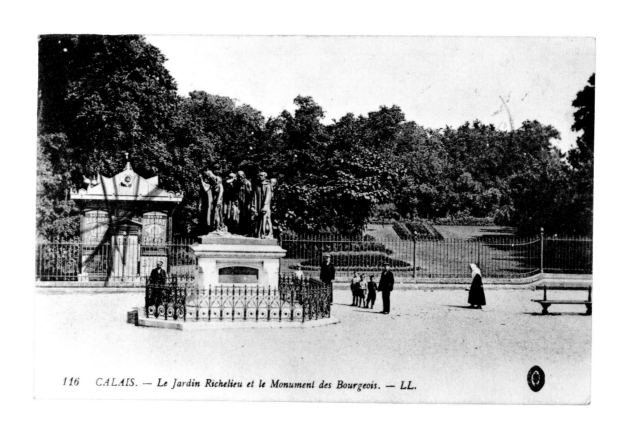

116 CALAIS. — Le Jardin Richelieu et le Monument des Bourgeois. — LL.

The Burghers of Calais

The Burghers of Calais was Rodin's first completed major public monument. It commemorates a dramatic historical event narrated in the medieval *Chronicles* of Jean Froissart: in 1347, during the Hundred Years' War, six leading citizens of the French town of Calais volunteered to hostage themselves to King Edward III of England in return for his lifting the eleven-month siege of the city and thus saving it from annihilation. The English king demanded that the six hostages wear sackcloth and halters, carry the keys to the city, and present themselves at his camp, ready for execution. Their lives were spared at the last moment, owing to the pleading of Queen Philippa, the pregnant wife of Edward III.[1] In *The Burghers of Calais* Rodin portrays these secular martyrs at a unique psychological moment, as they are about to leave the city to march to the king's camp. Each man expresses his own personal anguish even as the six stand united in a common fate and cause. *The Burghers of Calais* is a triumph in sculpture, composition, and feeling. It captures, in Rodin's words, "the truth of history."[2]

In September 1884 the municipal council of Calais voted unanimously to commission a statue of Eustache de Saint-Pierre, the first burgher to offer his life for the city. This decision by the council was embroiled in historical and political controversy.

The facts narrated in Froissart's *Chronicles* had been challenged as early as the eighteenth century by, among others, the skeptic English philosopher David Hume and by the iconoclastic French philosopher Voltaire, who in his *Essai sur les moeurs* accused Eustache de Saint-Pierre of treason, of complicity with King Edward III. The debate raged but was later quelled by the force of French nationalism. For, in the years following France's defeat in the Franco-Prussian War of 1870, the French government of the Third Republic encouraged the erection of public monuments to inspire patriotism, and the government was particularly interested in sustaining the spirit of the famous burghers: like Calais in 1347, Paris in 1870 had been besieged by a foreign army that had exacted total surrender.

This controversy over historical accuracy was exacerbated by local politics. Calais, an old and traditional city, was about to be merged with the neighboring and more prosperous industrial city of Saint-Pierre. Despite their differences, the two cities moved toward unification to foster economic development; this movement accelerated in 1882 when the English Parliament announced its decision to build a tunnel under the Channel to connect Dover with Calais. The municipal councils of Saint-Pierre and Calais recognized that their consolidation would create a major "maritime, industrial and commercial center: a large city whose prosperity will be even greater after the union." In order to join the two cities, however, the medieval walls of Calais would have to be demolished. The outraged citizens denounced the plan. The mayor of Calais, Omer Dewavrin, then proposed to erect a monument to Eustache de Saint-Pierre and successfully lobbied with Paris to unite the two cities under the name Calais—the name of the city that "immortalized the devotion of Eustache de St. Pierre and his companions."[3]

Auguste Rodin, who had served in the Paris National Guard during the Franco-Prussian War, perceived the proposed monument as a timely opportunity to create a masterpiece. He had learned of the commission from his young artist friend Alphonse Isaac, who also lent Rodin Froissart's *Chronicles*. Rodin saw the burghers as Froissart described them: not Eustache de Saint-Pierre alone, but six martyrs "with their heads and their feet bare, halters round their necks and the keys of the town and castle in their hands."[4] Eustache de Saint-Pierre would be joined by Jean d'Aire, Jacques and Pierre de Wiessant, Jean de Fiennes, and Andrieu d'Andres. Rodin summoned his friends—Isaac, Jean-Charles Cazin, Alphonse Legros, Jean-Paul Laurens—and campaigned for the commission.[5]

Overleaf:
The Burghers of Calais, detail. Cat. no. 32

Opposite:
Postcard of *The Burghers of Calais* in front of the Richelieu Garden, where they stood from 1895 to 1914. (Photo, Musée Rodin)

43

Mayor Dewavrin personally sought candidates from among the great sculptors of the nation. Isaac, a native of Calais who had worked to elect Dewavrin to the municipal council in 1878, advised the mayor to visit Rodin at his studio in Paris. Dewavrin was immediately impressed, but the council took eighteen months to officially invest Rodin with the commission.

Rodin modeled two maquettes for the council. In the first maquette, submitted in the autumn of 1884, Rodin arranged the six figures in a compact cube, linked by a rope and elevated triumphantly on a pedestal. By January 1885 the council decided in favor of Rodin yet insisted that a second maquette, one-third the final size, be submitted prior to the completion of the monument. On January 28, 1885, the contract was signed. Rodin worked on the figures for the second maquette, designing small nudes, then enlarging and clothing them. The burghers, now modeled separately and without pedestal, remained in level, cubic form, with the figure of Eustache de Saint-Pierre at the center. Rodin significantly altered their movements and gestures and left space between the figures. The burghers were not portrayed as brave, high-headed patriots but rather as men who were mortal, forlorn, resigned, afraid. Only their purpose reconciled them to their fate.[6]

He submitted the second maquette in August 1885. The council was critical, objecting to Rodin's failure to glorify the burghers and to his presentation of them in cubic form rather than in the pyramidal arrangement prescribed for heroic monuments. The committee cautioned:

> This is not the way we envisaged our glorious citizens going to the camp of the King of England. Their defeated postures offend our religion. . . . The silhouette of the group leaves much to be desired from the point of view of elegance. The artist could give more movement to the ground which supports his figures and could even break the monotony and dryness of the silhouette by varying the heights of the six subjects. . . . We feel it our duty to insist that M. Rodin modify the attitudes of his figures and the silhouette of his group.[7]

Rodin defended himself, placing his design in the tradition of French Gothic art and denouncing academic convention. In a letter to Dewavrin, he wrote:

> I read again the criticisms I had heard before, but which would emasculate my work; the heads to form a pyramid (Louis David method) instead of a cube (straight lines) means submitting to the law of the Academic School. I am dead against that principle, which has prevailed since the beginning of this century but is in direct contradiction with previous great ages in art and produces works that are cold, static and conventional. . . . I am the antagonist in Paris of that affected academic style. . . . You are asking me to follow the people whose conventional art I despise.[8]

Dewavrin and Jean-Paul Laurens overcame the objections, and Rodin was authorized to proceed with the project. Rodin worked feverishly on the details of the figures. He separately modeled hands, feet, trunks, and heads. He spent most of his time on hands. Several hundred studies of the group, isolated figures and parts of figures, were produced; over 250 of them were later cast in bronze.[9] Rodin combined and recombined the parts until his burghers came to life. The individual figures of the burghers were finished by the end of 1888.

The plaster model of *The Burghers of Calais* was exhibited to the public for the first time in 1889 at the Monet/Rodin exhibition held at the fashionable Galerie Georges Petit in Paris. It received critical acclaim, with Octave Mirbeau in the *Echo de Paris* proclaiming it "more than the work of a sculptor of genius."[10] But Dewavrin was not reelected mayor of Calais, and the new mayor showed no inclination to support the project. Not until 1893, with Dewavrin in office again, did public support for the monument enable the council at Calais to complete the national subscription for its financing.[11]

The 5,000-pound monument, now cast in bronze, was finally unveiled in Calais

The enlarged *Nude Study* of Pierre de Wiessant in Rodin's studio, 1886. In the background is *The Second Maquette*. (Photo by Charles Bodmer, Musée Rodin)

on June 3, 1895. The thirty thousand people at the celebration were treated to a lecture, a torchlit parade, a gymnastics competition, a music festival, a ball, and a fireworks display. "It was probably the greatest official triumph of his career," writes Mary Jo McNamara, scholar of Rodin's *Burghers of Calais*.[12]

Despite his public triumph, privately Rodin was displeased, for the monument was erected neither in the setting nor in the manner he desired. Rodin no longer wanted it on a tall pedestal, as originally conceived, but on a low base in front of the town hall, "like a living chaplet of suffering and of sacrifice. . . . My figures," Rodin wrote, "would so have appeared to direct their steps from the municipal building toward the camp of Edward III, and the people of Calais of to-day, almost elbowing them, would have felt more deeply the tradition of solidarity which unites them to these heroes."[13] Instead, *The Burghers of Calais* was installed on a high pedestal, enclosed by an iron fence, in front of the Richelieu Garden.

In 1925, eight years after Rodin's death, *The Burghers of Calais* was relocated to the front of the Calais Town Hall, on a pedestal close to the ground, where one could see six anguished men united in a moment of truth to a fate each had freely chosen. They are heroic and they are human: "Their soul pushes them onward, but their feet refuse to walk," Rodin explained.[14]

Assemblage of plaster heads and hands from *The Burghers of Calais*, ca. 1900. (Photo, Musée Rodin)

The First Maquette

In 1884 the municipal council of Calais decided to commission a monument in honor of the city's medieval hero Eustache de Saint-Pierre. The patriotic appeal of the council declared: "Since 1347, the name of Calais has been intimately connected with that of Eustache de St. Pierre, and it is not possible for anyone, from the scholar to the child who stammers the history of France, to pronounce the one without evoking the memory of the other." Omer Dewavrin, the mayor of Calais, took charge of finding "an eminent sculptor" for the commission.[15]

The competition was keen, with Rodin matched against two academic sculptors of superior reputation, Emile Chatrousse and Laurent-Honoré Marqueste. Rodin had influential friends in Calais, but it was the originality of his conception for *The First Maquette* that won the commission for him.

Rodin had studied Jean Froissart's medieval chronicle of the historic drama as well as paintings and sculptures of its episodes. Painters often portrayed all six burghers, usually kneeling before the English king; sculptors had limited themselves to the heroic Eustache de Saint-Pierre, usually representing him at the moment he volunteered to be the first hostage.[16] Rodin made three crucial decisions in *The First Maquette:* first, to portray all six burghers; second, to organize them on a single plane in cube formation; third, to portray the complex psychological moment of their departure from the city gate. "The idea," Rodin wrote to Mayor Dewavrin, in what might be described as a hard sell,

> seems to me to be completely original from the point of view of architecture and sculpture. Moreover, the subject itself is original and imposes an heroic conception; this group of six self-sacrificing figures has a communicative expression and emotion. The pedestal is triumphal and has the rudiments of a triumphal arch, in order to carry, not a quadriga, but human patriotism, abnegation, and virtue. . . . Rarely have I succeeded in giving a sketch such élan and sobriety. Eustache de Saint-Pierre, alone, his arm slightly raised, leads his

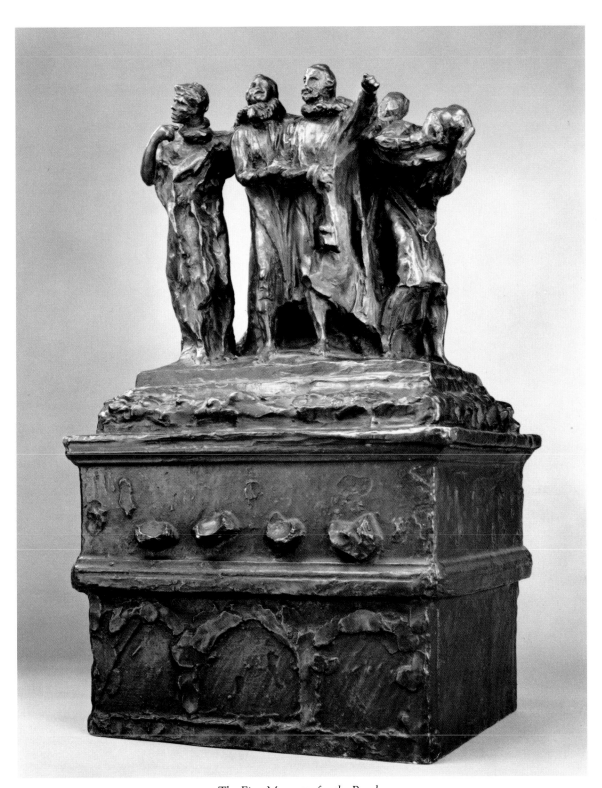

19. *The First Maquette for the Burghers
 of Calais*
1884
Bronze, 24 x 14⅞ x 13½ in.

relatives and his friends by the dignity of his determined movement.[17]

The composition of *The First Maquette* is that of four figures densely packed at the center and one figure at each of the sides. In the front, with heads raised, stand Jean d'Aire and Eustache de Saint-Pierre, who, with arm held high, takes the first step, urging the others to follow. Behind them are Jacques de Wiessant and Jean de Fiennes, facing each other. To these figures are joined, at front left, Pierre de Wiessant, and, at right, Andrieu d'Andres. They stand in contrast to the central four, with Pierre de Wiessant pointing to himself and Andrieu d'Andres holding his head in his hands. The figures are connected physically, demonstrating collective solidarity, and symbolically by a heavy rope, announcing their common fate. Rodin dramatized the heroic nature of the six burghers by raising them on a high pedestal, which is divided into four horizontal levels and embellished with three triumphal arches in low relief.

The maquette derives from French Gothic calvaries; the pedestal recalls the victory monuments of ancient Rome and Napoleonic France. Rodin's first idea is a patriotic statement of courage in defeat. It is also a contradiction of the prescribed canons of nineteenth-century academic sculpture that dictated a single heroic figure atop a pyramidal form.

The Second Maquette

The First Maquette won the commission for Rodin. The contract between the mayor of Calais and Rodin, executed on January 28, 1885, called for Rodin to deliver a second maquette "one-third the final size of the monument, thoroughly worked out, finished, and completed, needing only to be enlarged and perfected. He will, however, ultimately incorporate in the final group any changes an examination of said model by the Committee would suggest."[18] On February 12, Rodin wrote that the study would be finished early in 1886. He actually submitted it to the council in early August 1885.

For *The Second Maquette* Rodin worked on shaping the individual figures. He chose as models men of character rather than physical perfection: Auguste Beuret, Rodin's son; a painter of Calaisian background, Jean-Charles Cazin; and the Abruzzi peasant Pignatelli. It was Rodin's method to sculpt nude figures before clothing them. In a letter to Dewavrin on July 14, 1885, Rodin wrote that the ma-

quette was near completion. "It is made to be executed on a large scale, so there are negligences of details that should not be the cause of astonishment. . . . The nudes, that is to say the part underneath, are complete, and I am going to have them executed definitively so as not to waste any time. You see it is the part one does not see, which is nonetheless the most important, that is finished."[19] Rodin did not tell the full story.

Rodin had remained faithful to the three crucial decisions he made for *The First Maquette*. But the bearing of the individual burghers in *The Second Maquette* differs sharply: gone are the heads held high, the strong frontal mass, the sense of solidarity, the forward gait. The individual burghers have taken on more human dimensions; they are resigned, afraid of their impending deaths. There is space between them, they do not touch, the rope no longer joins them. Sculpted separately, they stand alone—physically and psychologically. Rodin plumbed their souls, and the figures in

The Second Maquette are close to their appearance in the final version of *The Burghers of Calais*.

Unlike the figures of *The First Maquette*, the enlarged forms for *The Second Maquette* were produced on individual bases not joined together on a single pedestal. This procedure enabled Rodin to experiment with various combinations of the figures. It is therefore difficult to determine their final configuration at the time Rodin assembled them in the Calais Town Hall. Cécile Goldscheider, former curator of the Musée Rodin, has reconstructed the maquette by matching lines dug into the bases. That reconstruction, wrote Mary Jo McNamara, is "quite convincing visually, but it does not match the description" of *The Second Maquette* reviewed in *Le Patriote* just one day after its exhibition. Albert Elsen discovered photographs of an arrangement of the *Second Maquette* figures in the archives of the Musée Rodin, but these photographs correspond neither to Goldscheider's reconstruction nor the *Le Patriote* review.

"One cannot be absolutely certain that what one sees in the photograph was the arrangement Rodin showed the Calais commissioners," wrote Elsen of his own discovery, "as the photographs do not show if the bases of the figures were connected."[20]

There is no question, however, on the reception given *The Second Maquette* by the Calais commissioners. They were highly disapproving. Both the commission and *Le Patriote* criticized *The Second Maquette* for utterly failing to follow the rules established by the Ecole des Beaux-Arts for heroic monumental sculpture. They wanted a pyramid, not a cube; glory, not dejection. Rodin was "staggered by this volley of criticism," wrote his friend and biographer Judith Cladel.[21] He defended himself with passion, describing academic conventions as sterile—the "cube gives expression; the cone is the hobbyhorse of pupils competing for the *Prix de Rome*."[22] In a letter to the newspapers, he argued that his sculpture was true to its history—an "expression of the era of Froissart" that

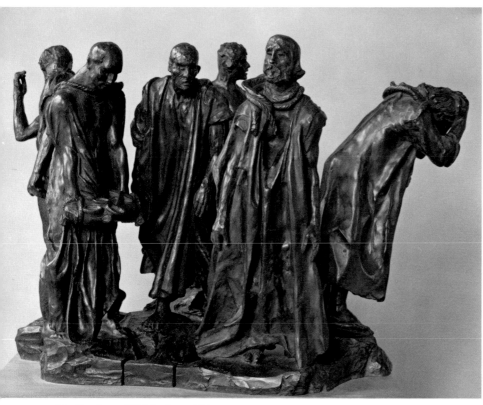

The Burghers of Calais, Second Maquette,
1885. (Photo, Musée Rodin)

embodies the artistic, medieval purity of the "Gallic soul."[23] Nor, Rodin insisted, were the burghers expressing humiliation; rather they were genuine heroes, for, as he told the critic and journalist Paul Gsell, "The more frightful my representation of them, the more people should praise me for knowing how to show the truth of history."[24]

Rodin had been uncertain and anxious during the creation of *The Second Maquette,* but "now that he had finally made up his mind about his work, he was immovable," Cladel wrote. If the committee had forced him to make drastic changes, as the contract allowed, then, speculated Cladel, "he would have withdrawn it, as he was to do later with the *Balzac,* despite the serious question for him of expenses."[25]

Rodin dared to break with entrenched academic dogma and to reveal heroes as frail human beings. His fight for the monument was "crucial in the fight against 'the outmoded sculptural style' and false 'theatrical art' of the Ecole des Beaux-Arts."[26] Rodin prevailed.

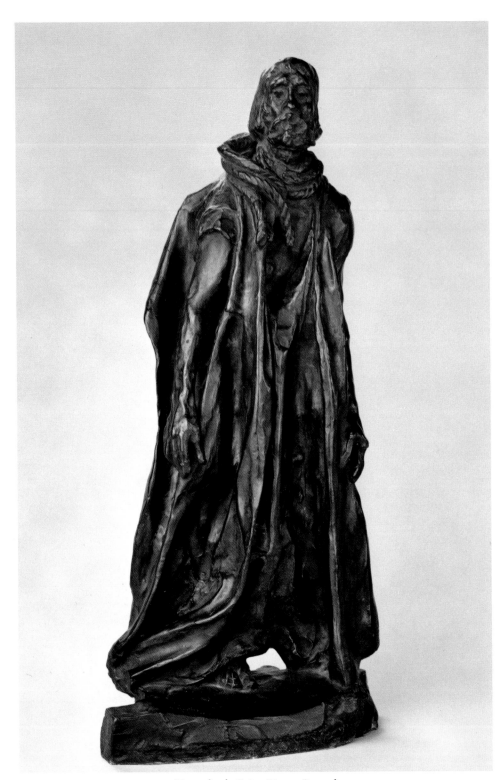

20. *Eustache de Saint-Pierre, Second Maquette*
1885, cast 1971
Bronze, 27½ x 12 x 11½ in.

Eustache de Saint-Pierre, 1885. Nude study based on the model Jean-Charles Cazin, which served as the figure of Eustache in *The Second Maquette.* (Photo, B. Gerald Cantor Art Foundation)

Eustache de Saint-Pierre

Eustache de Saint-Pierre, described by Froissart as the richest citizen in the town and the first to rise to save it, was the hero of Calais and a legend in French national history. He is the crucial figure in the evolution of *The Burghers of Calais,* and much of controversy in the stormy history of the monument involves the portrayal of this figure.

In *The First Maquette* Rodin endows Eustache de Saint-Pierre with heroic prominence. Head erect, his right arm raised and his left hand holding the key to the city, Eustache takes the first forward step. He is the courageous leader of men to a tragic fate.

As he prepared *The Second Maquette,* Rodin worked first on the individual figures, sculpting nude versions of them. For the model of Eustache, Rodin selected his friend and fellow artist Jean-Charles Cazin, a native of Calais who claimed to be a descendant of Eustache de Saint-Pierre. In the *Nude Study* of Eustache, the head looks down to the right, dejected; his arms are at his sides. "Rodin," wrote McNamara, "had already decided to depict Eustache dragging himself forward with the weight of his body pulling down against his will."[27] The "dignity of his determined movement," as Rodin described Eustache's deportment in *The First Maquette* to Mayor Dewavrin, has been radically changed.[28]

It was the *Nude Study* of Eustache, modeled after Cazin, then clothed in heavy, voluminous Gothic drapery, that served as the figure of Eustache in *The Second Maquette.* His forlorn facial expression is emphasized by the heavy rope around his neck; his arms are at his sides—and the key to the city is gone. "Public opinion," wrote Dewavrin to Rodin, "is vigorously pronounced against the attitude of Eustache."[29] Indeed, the council at Calais, in their critical letter to Rodin, found the defeated figure of Eustache de Saint-Pierre to be the most offensive aspect of *The Second Maquette.*

Rodin refused to bow to the council, but his own judgment led him to modify the figure and head of Eustache

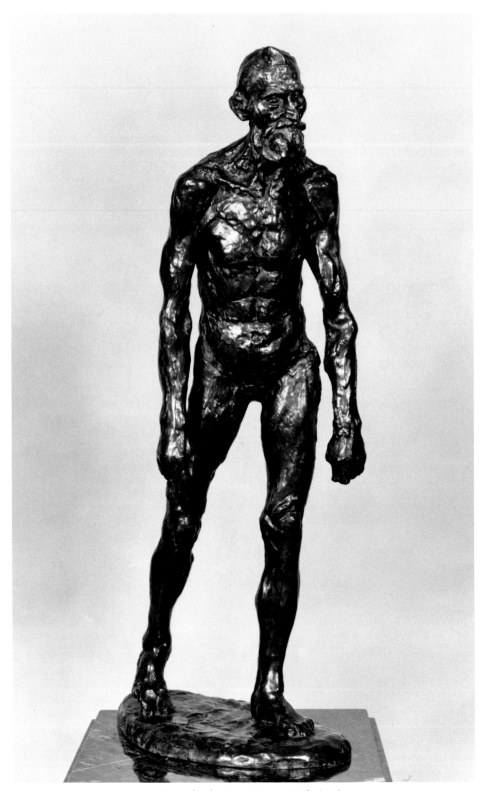

21. *Eustache de Saint-Pierre, Nude Study*
1885–86, cast 1965
Bronze, 38½ x 13 x 17 in.

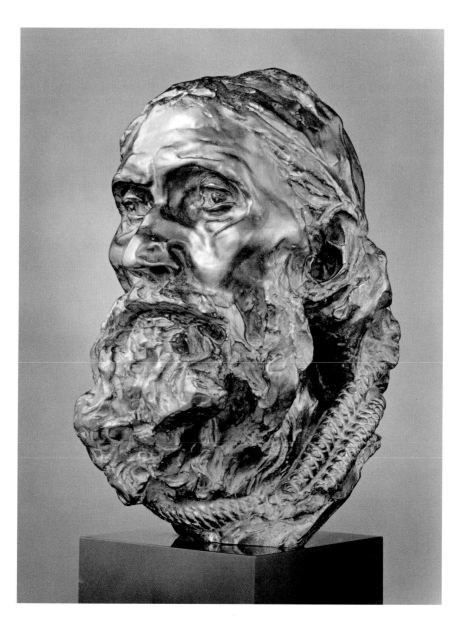

22. *Eustache de Saint-Pierre,*
 Final Head
By 1889, cast 1983
Bronze, 16 x 9½ x 11½ in.

during 1885–86. These modifications were not along the lines recommended by his critics, however. Rodin abandoned the nude study based on Cazin; he was too youthful to portray the aging, emaciated Eustache. Rodin began a second *Nude Study* after Pignatelli, the Italian peasant who had earlier modeled for his *Saint John the Baptist Preaching* and *Ugolino*. This is the version exhibited here.

In describing Eustache, Jacques de Caso noted a number of anatomical inaccuracies: the legs and arms are of different lengths; the abdominal muscles do not correspond to the movement of the figure; and the neck is not properly positioned, favoring the left.[30] These exaggerations seem contrary to Rodin's philosophy of realism in art, of his practice of following nature. In a conversation with Paul Gsell on the altering of the nude form, Rodin replied, "I accentuate the lines which best express the spiritual state that I interpret . . . a mediocre man copying nature will never produce a work of art; because he really looks without

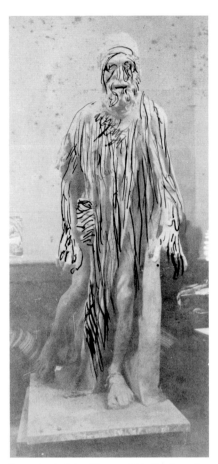

Eustache de Saint-Pierre, 1886. Study with ink notations indicating refinements of the clay surface to be made by Rodin. (Photo by Victor Pannelier, Musée Rodin)

seeing, and though he may have noted each detail minutely, the result will be flat and without character."[31]

Rodin also modeled Eustache's head separately, probably using a combination of the model Pignatelli and a portrait of Eustache de Saint-Pierre done after a bust by the sculptor Eugène Cortot.[32] The *Final Head* is the one used in the final monument of *The Burghers of Calais.* Rodin succeeded in showing age and character by building up flesh rather than drawing lines into the surface of the face. The bags under the recessed eyes, the prominent cheekbones, the smooth forehead, and the contrasting sharp nose and pinched nostrils—all produce contours for the play of shadow. It is the head of an old man, tired and desolate.

The *Nude Study,* modeled after Pignatelli, became the basis for the *Grand Model* of Eustache de Saint-Pierre in the final *Burghers.* In the *Grand Model,* Eustache de Saint-Pierre, still dressed in heavy Gothic drapery and the rope still around his neck, is haggard; rough skin and weak muscles cling to frail

bones. Arms, slightly bent, hang from stooped shoulders. The body, consistent with the mental state revealed in the head, barely drags itself forward.

Throughout the preliminary studies of Eustache de Saint-Pierre, both nude and clothed, one can follow the evolution of the figure as Rodin experimented with physical problems of body structure and distribution of weight. The constant throughout is Eustache's anguished mental attitude.

In the final *Burghers* Eustache de Saint-Pierre remains the central figure. Led by Eustache, the *Burghers* take "a short step to the contemporary anti-hero."[33] Rodin not only challenged nineteenth-century dogmas, he transformed the hero of a medieval ordeal into a modern man.

23. *Eustache de Saint-Pierre, Grand Model*
1885–86, cast 1983
Bronze, 85 x 30 x 48 in.

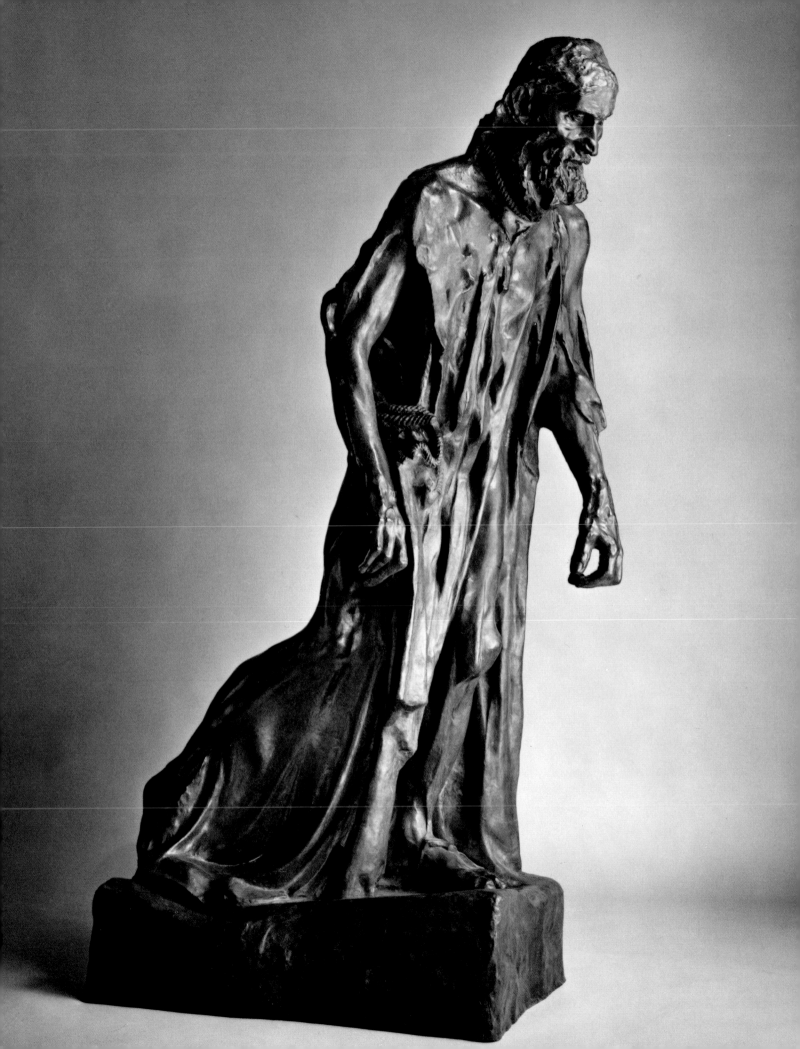

Jean d'Aire, 1886. Nude study in clay.
(Photo by Charles Bodmer, Musée Rodin)

Jean d'Aire

The second burgher to volunteer was Jean d'Aire. According to Froissart, he was a "greatly respected and wealthy citizen, who had two beautiful daughters."[34] In *The Second Maquette,* Jean d'Aire holds the keys to the city on a cushion. His feet are planted firmly on the ground, and his arms are straight, just as his torso is rigid. He is the most determined of the burghers, but his bald head is bowed. In 1886 Rodin continued to work on the head, as seen in the *Bust of Jean d'Aire.* Here, the gesture differs from that in *The Second Maquette:* the head is held high and looks straight ahead, the attitude defiant. This head is of an older man, his eyes betraying sadness, yet the firm, turned-down mouth and forceful jaw expose an angry strength. When placed on the figure in the final *Burghers,* the head appears even more powerful. The exaggerated and swollen feet, hands, and oversize key seem barely to contain his energy and in so doing complement the resolute head.

The plaster bust is the same size as the upper portion of the Jean d'Aire figure in the *Burghers* monument. By the end of 1888 Rodin had finished the final versions of the individual figures for the monument and had had them cast in plaster. They were then exhibited at the Galerie Georges Petit in the Monet/Rodin exhibition of 1889. Plasters like these were made in a number of sections. In the *Bust of Jean d'Aire,* for example, the line caused by the joining of the head and neck sections is visible.[35]

Rodin always made several plasters of each of his works and often gave them to colleagues and friends. The Belgian sculptor Victor Rousseau (1865–1954) received the *Bust of Jean d'Aire* exhibited here.[36]

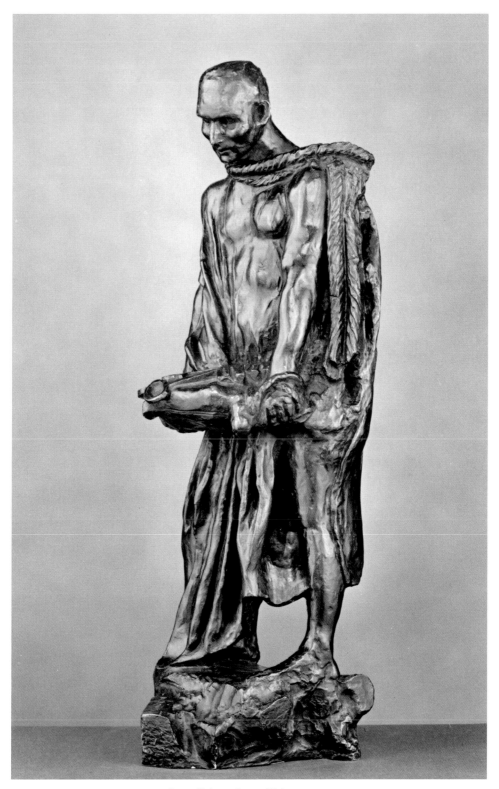

24. *Jean d'Aire, Second Maquette*
1885, cast 1970
Bronze, 27½ x 9½ x 9¾ in.

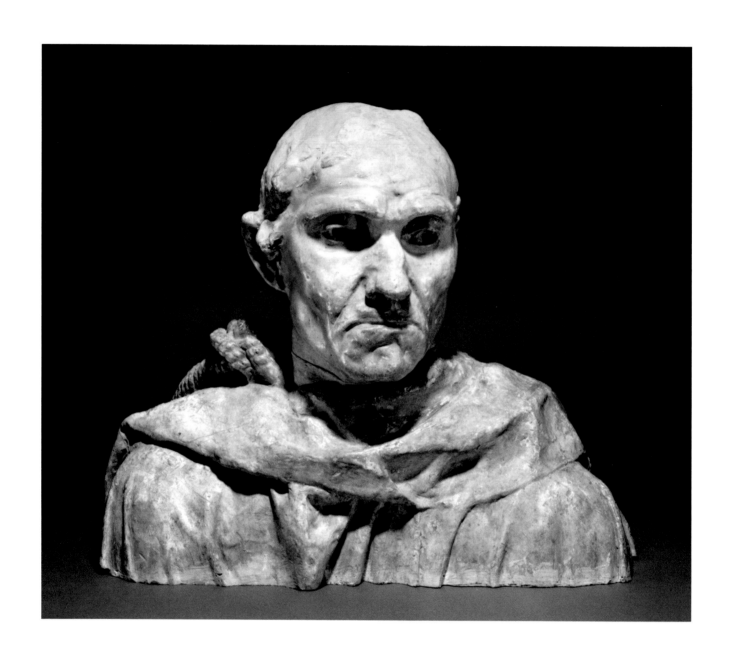

25. *Bust of Jean d'Aire*
By 1887
Plaster, 19 x 23½ x 16 in.

Pierre de Wiessant

Following his older brother Jacques, Pierre de Wiessant was the fourth burgher to volunteer and one of the two youngest. The *Nude Study* of Pierre de Wiessant became the basis for his figure in *The Second Maquette* of 1885. The *Pierre de Wiessant, Head, Type A* was done later, in 1885 or at the latest 1886, along with several other heads, but its characteristics are essentially those that appear in the final figure for the completed monument. Through Pierre de Wiessant, Rodin explores youth confronting death.

In *The First Maquette* Rodin portrays Pierre de Wiessant as a young adolescent, his soft face topped with a full head of curly hair. His expression is quizzical, and he raises his right arm, pointing to himself as if to question his fate. This attitude is altered in the *Nude Study*, which presents an older adolescent, looking down over his right shoulder; his lifted arm no longer points but shields.

For *The Second Maquette* Rodin clothes Pierre de Wiessant in simple drapery, the rope coiled around his neck. Pierre de Wiessant, in the *Nude Study* and in *The Second Maquette*, shows his agony and acknowledges his fate. In the *Pierre de Wiessant, Head, Type A* the curly haired adolescent is replaced by an older youth with short hair, his brow knitted, eyes half-shut, and mouth parted. The expression is tormented, as in the final *Burghers*. Rodin's great interest in depicting the head of Pierre de Wiessant is evidenced by the number of heads existing in different sizes, media, and finishes.[37] Rodin's son, Auguste Beuret, and the actor Coquelin Cadet have both been cited as possible models for Pierre de Wiessant.[38]

Rodin did not fully resolve the character of Pierre de Wiessant until the final figure. This he achieved by physical changes: the neck, unencumbered by rope as in *The Second Maquette*, is elongated, with tendons strained; muscles are more developed and defined; expressive hands and arms show protruding veins. The simple drapery of the earlier study is gone,

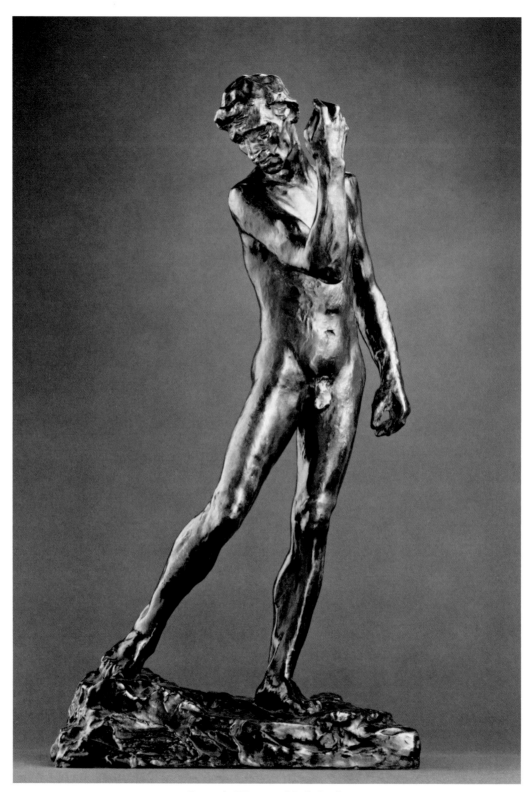

26. *Pierre de Wiessant, Nude Study*
1885, cast before 1952
Bronze, 26⅝ x 14½ x 11¾ in.

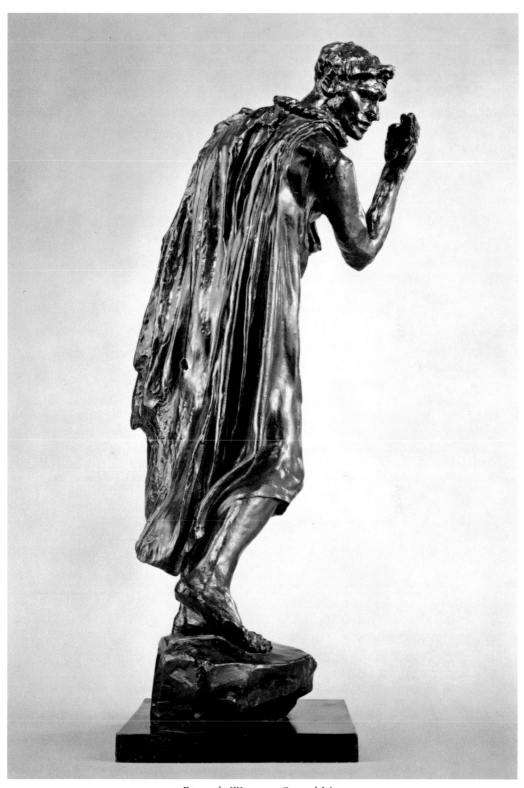

27. *Pierre de Wiessant, Second Maquette*
1885, cast 1970
Bronze, 28 x 12⅜ x 12⅜ in.

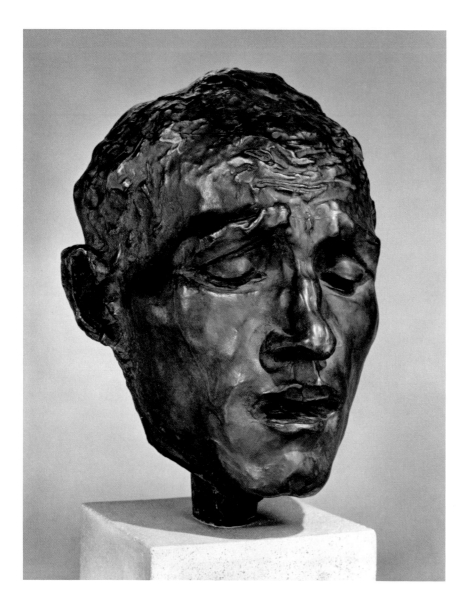

replaced by broad planes of cloth with deep recesses to capture shadow. The drama and movement thus created underscore Pierre's anguish. Rilke, reflecting on the youthful hero, no longer full of terror but now resigned, wrote, "This figure, if placed by itself in a dim, old garden, would be a monument for all who have died young."[39]

28. *Pierre de Wiessant, Head, Type A*
Ca. 1885–86
Bronze, 11⅜ x 8½ x 10 in.

Jean de Fiennes

The name Jean de Fiennes does not appear in Froissart's *Chronicles,* where only four of the burghers are mentioned specifically by name. The names of the two unidentified burghers, Jean de Fiennes and Andrieu d'Andres, were discovered in the Vatican Library in 1863.[40] Rodin assumed that Jean de Fiennes was the youngest of the burghers, and in *The Second Maquette* he portrays Jean as such, his boyish torso exposed, his arms extended palms up. Tattered drapery falls down his arms and around his feet, concealing his movement. With lips parted and brow furrowed, he, like his fellow adolescent Pierre de Wiessant in *The First Maquette,* questions his fate. Unlike the figure in *The Second Maquette,* the 1885 *Jean de Fiennes, Study* has an irregularly shaped base and is covered with heavy drapery from shoulder to foot. The *Grand Model* for the final monument does not change the stance or the arms of the earlier studies. His head, however, is now covered with long, wavy hair, and the drapery is lighter, its folds vertical, revealing feet about to step forward.

Of all the burghers, Jean de Fiennes seems to have undergone the greatest number of physical changes, as shown in the preliminary studies. Perhaps that is why he is the subject of some controversy among some historians.[41] What remains consistent throughout the dramatic evolution of this figure is Jean's doubting disposition as he looks back toward the town he may never see again. If Pierre de Wiessant has acknowledged his fate, the younger Jean de Fiennes has not quite come to terms with it.

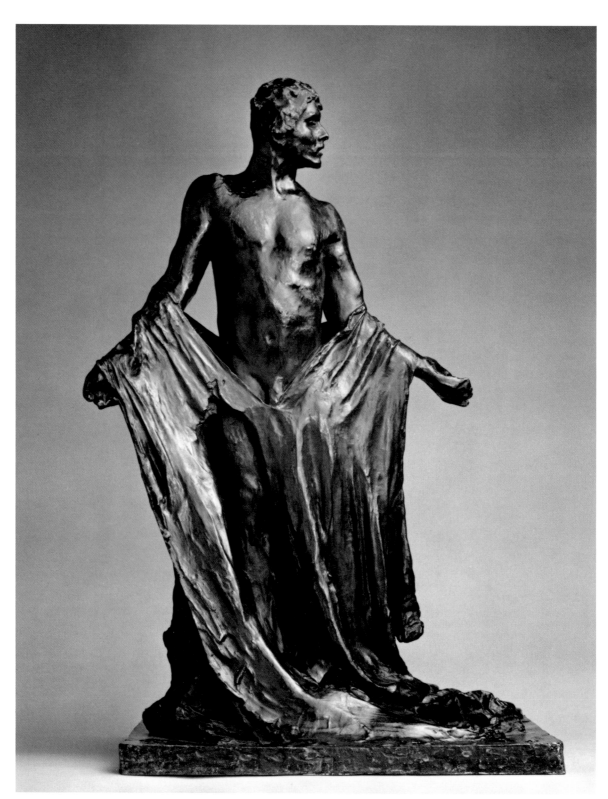

29. *Jean de Fiennes, Second Maquette*
1885, cast 1969
Bronze, 28 x 18¼ x 17⅛ in.

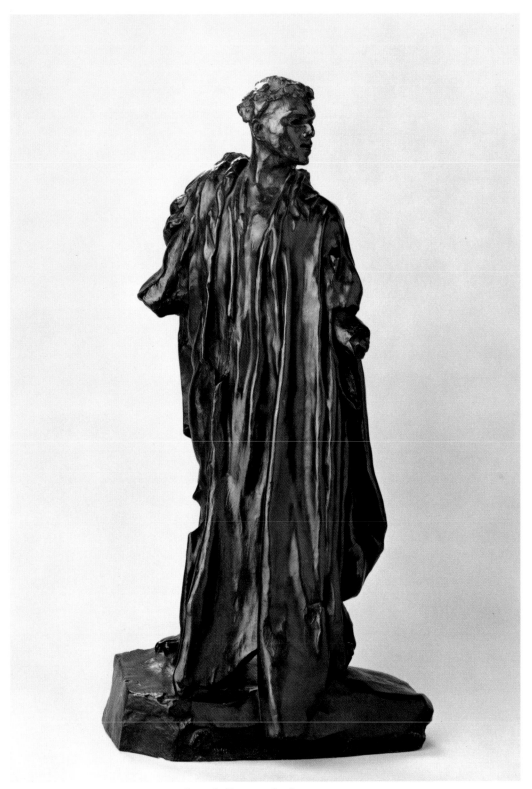

30. *Jean de Fiennes, Study*
1885, cast 1979
Bronze, 28⅝ x 10¼ x 14⅛ in.

67

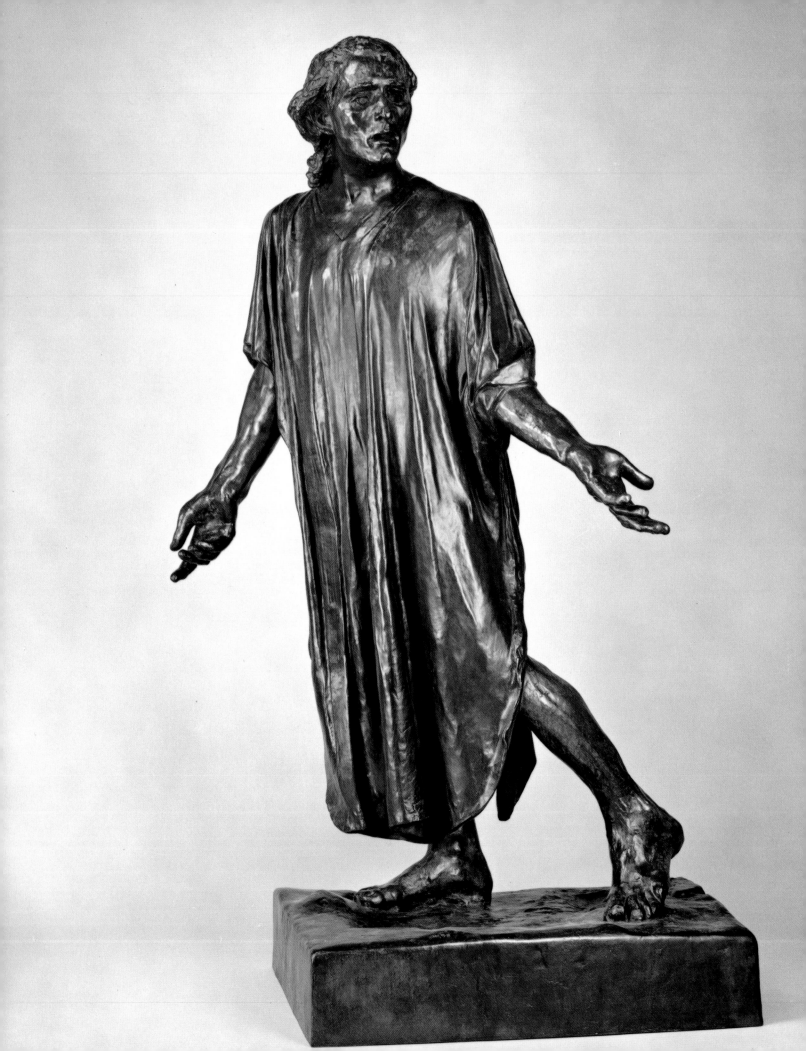

Final Monument for the Burghers of Calais

The Burghers of Calais was installed at Calais on June 3, 1895, eleven years after Rodin had begun working on the project. It was erected in front of the Richelieu Garden, atop a pedestal just over five feet high and enclosed by a Gothic-style iron fence. The monument that had generated so much passionate controversy became the focal point of the city.[42]

The composition of the *Burghers* reconciles the individuality of each figure with the unity of the whole. "Each figure," observed Mary Jo McNamara, "is allotted the amount of space he physically and psychologically needs and no more." Thus Rodin has made each burgher "live again the last concentrated moment of life," according to Rilke. Yet, he continues, "The entire impression of the group is precise and clear."[43] As one studies the gestures of each figure, one must move around the burghers counterclockwise to best see their movement and appreciate the relationship of each to the other and to the whole.[44]

Rodin, in conversation with Paul Gsell, described his intention for *The Burghers of Calais:*

> I did not hesitate to make them as thin and as weak as possible. If, in order to respect some academic convention or other, I had tried to show bodies that were still agreeable to look at, I would have betrayed my subject. These people, having passed through the privations of a long siege, no longer have anything but skin on their bones. The more frightful my representation of them, the more people should praise me for knowing how to show the truth of history.
>
> I have not shown them grouped in a triumphant apotheosis; such a glorification of their heroism would not have corresponded to anything real. On the contrary, I have, as it were, threaded them one behind the other, because in the indecision of the last inner combat which ensues, between their devotion to their cause and their fear of dying, each of them is isolated in front of his conscience. They are still questioning themselves to know if they have the strength to accomplish the supreme sacrifice—their soul pushes them onward, but their feet refuse to walk. They drag themselves along painfully, as much because of the feebleness to which famine has reduced them as because of the terrifying nature of the sacrifice. . . .

31. *Jean de Fiennes, Grand Model* 1885–86, cast 1983
Bronze, 82 x 48 x 38 in.

69

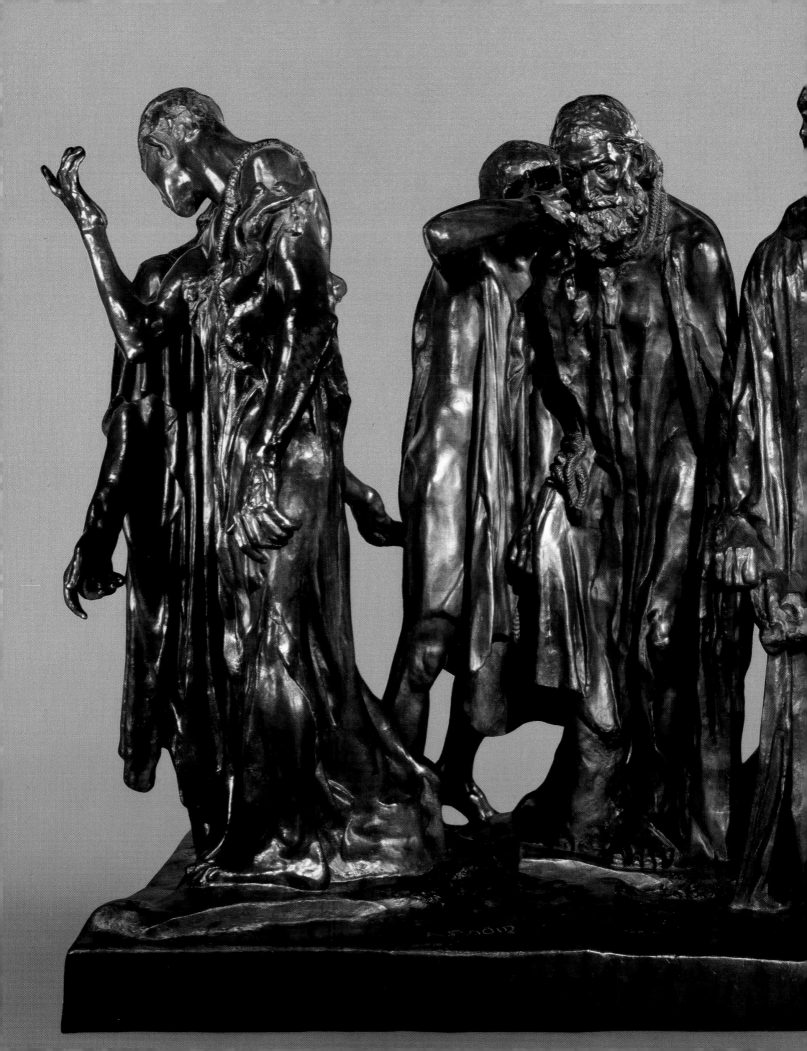

And certainly, if I have succeeded in showing how much the body, weakened by the most cruel sufferings, still holds on to life, how much power it still has over the spirit that is consumed with bravery, I can congratulate myself on not having remained beneath the noble theme I dealt with. I did not want a pedestal for these figures. I wanted them to be placed on, even affixed to, the paving stones of the square in front of the Hôtel de Ville in Calais so that it looked as if they were leaving in order to go to the enemy camp. In this way they would have been, as it were, mixed with the daily life of the town: passersby would have elbowed them, and they would have felt through this contact the emotion of the living past in their midst; they would have said to themselves: "Our ancestors are our neighbors and our models, and the day when it will be granted to us to imitate their example, we would show that we have not degenerated from it." . . . But the commissioning body understood nothing of the desires I expressed. They thought I was mad. . . . Statues without a pedestal! Where had that ever been seen before? There must be a pedestal; there was no way of getting around it.[45]

But there was a way of getting around it. "Comprehension of the sculptor's intention," wrote Judith Cladel, "ripened slowly in the minds of the Calaisians and they grew proud of their monument."[46] In 1925 the *Burghers* were moved to the front of the town hall, on a low pedestal, the excluding grille eliminated.

32. *The Burghers of Calais*
1884–95, cast 1985
Bronze, 82½ x 94 x 75 in.

71

The plaster *Monument to Claude Lorrain* in a work shed in Nancy, 1889(?). Ink marks on the pedestal forecast changes Rodin incorporated in the final monument. (Photo by D. Freuler, Musée Rodin)

Study for Claude Lorrain

During his work on *The Burghers of Calais*, Rodin sought the commission for a monument to the seventeenth-century French "painter of light," Claude Gellée, generally referred to as Claude Lorrain in honor of his native province. The idea for the monument came to Rodin rapidly, and he produced a rough model in the studio of Jules Desbois within forty-five minutes. Rodin "represented [Claude Lorrain] walking, palette in hand, toward the landscape he is about to paint. With a spirited gesture he faces the rising sun, and as an accompanying comment upon his vigorous attitude the horses of Apollo are seen springing up from the stone base, urged on by the young god who, like them, is intoxicated with his task of bringing light to the earth."[47]

The competition for the commission was held in April 1889 at the Galerie Durand-Ruel; Rodin just barely secured the commission from the jury. It was "the fine idea of putting, on the pedestal itself, the motif to which Claude consecrated his life, light, that won him the majority of the votes," declared M. Français, president of the committee.[48]

After the acceptance of his maquette, Rodin made numerous studies, nude and clothed, from a model who resembled the artist. This *Study for Claude Lorrain* depicts the youthful artist dressed in the type of costume he might have worn when painting in the countryside. His stance is casual—one leg bent at the knee with the foot on a hillock, the right leg firmly balancing the body, the face gazing upward into the sun. It is a fine portrayal that, as with the burghers, does not represent the subject in an idealized, heroic pose.[49]

Rodin finished the pedestal but was never completely satisfied with the figure of Claude Lorrain. Rodin's execution of the monument may have been affected by the grueling *Burghers of Calais* affair; although the figure of Claude Lorrain resists convention, it does not express the psychological meaning of the subject, and the pyramidal pedestal as well as the lush

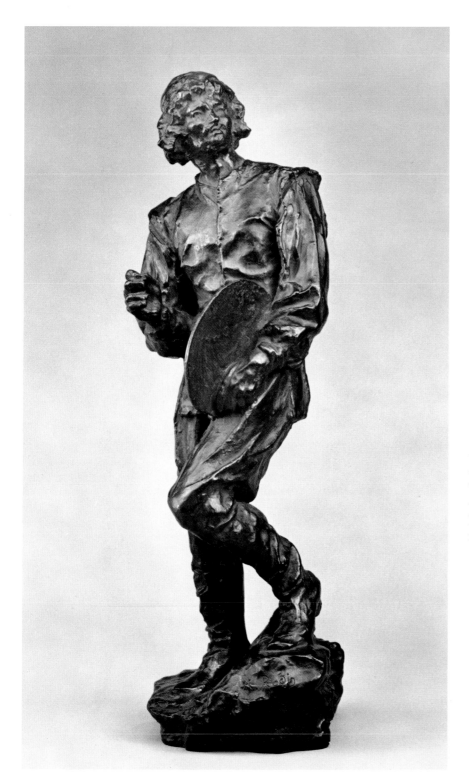

allegory of Apollo and his horses emerging from clouds at the base of the column conform to accepted conventions. Rodin, at least for a time, may have had his fill of controversy.[50] The *Monument to Claude Lorrain* was unveiled in the Pépinière Garden in Nancy, the provincial capital of Lorraine, on June 6, 1892.

33. *Study for Claude Lorrain*
1889, cast 1981
Bronze, 20 x 7½ x 8½ in.

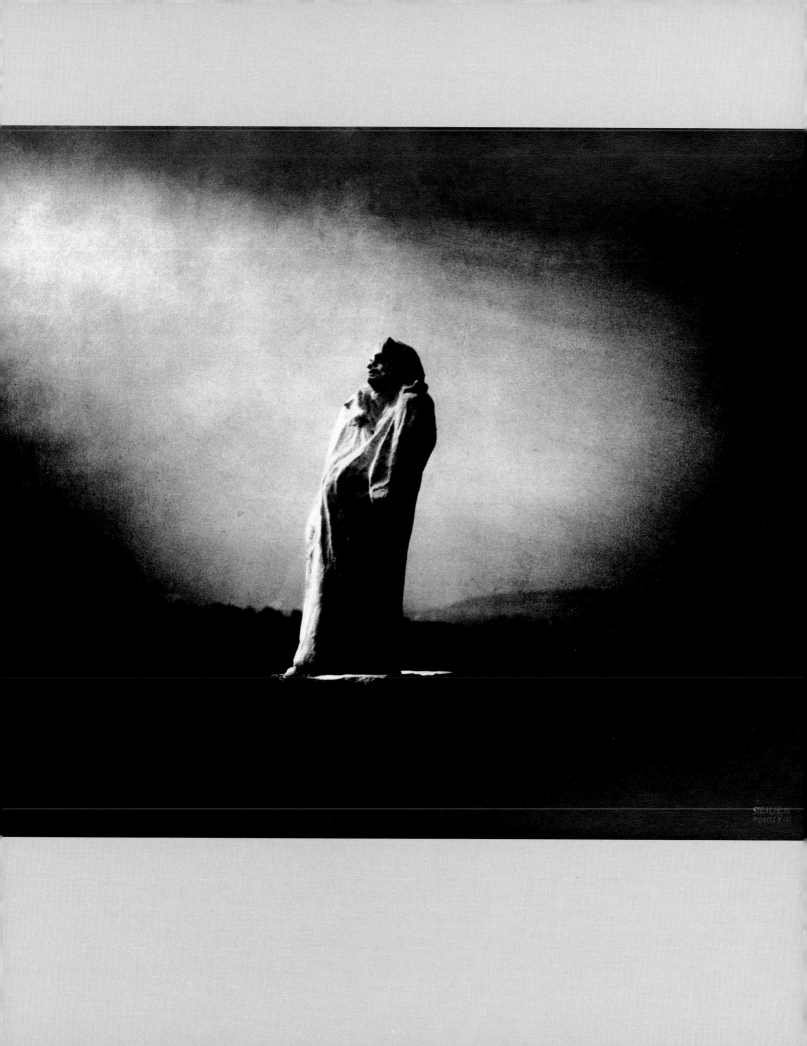

Balzac

Honoré de Balzac, extraordinary French author of the series of novels *The Human Comedy*, was a figure of vast influence, and each of the major nineteenth-century French literary movements—notably Naturalism and Symbolism—claimed him as their own. For Rodin, the creation of a monument to this astounding personality and literary genius inspired the full realization of his own aesthetic genius. That achievement, a work that is in itself a virtual manifesto for modern sculpture, unleashed the most furious artistic controversy in fin-de-siècle French life. "This work that has been laughed at," said Rodin, "is the logical outcome of my whole life, the very pivot of my aesthetics."[1]

A monument to Balzac had been planned since his death in 1850 at the age of fifty-one. It took until 1891 for the Société des Gens de Lettres de France to offer the commission to Rodin. The offer was agreed to at once, and Rodin wrote Emile Zola, the president of the society, that he would deliver the statue in January 1893, only eighteen months later. Rodin placed himself in an impossible situation.

Rodin immersed himself in the study of Balzac, trying to capture the physical appearance as well as the soul of the man. Balzac was a man of passions—an insatiable lover, a careless debtor, an unabashed social climber, a reckless speculator, an avid art collector—and a compulsive literary worker who would exhaust himself from writing for sixteen hours a day for several weeks at a stretch. His great literary study of French society, *The Human Comedy*, was composed of some ninety books, peopled by over two thousand characters.

Daguerreotype of Balzac by Etienne Carjat. (Photo, Roger-Viollet)

Rodin studied Balzac's life, read his books and stories, reflected on photographs, sculptures, paintings, drawings, and lithographs of him. No detail escaped Rodin. He found Balzac's old tailor and had him make a pair of trousers and a waistcoat in Balzac's measurements. He visited Balzac's native Tours, trying to capture a sense of the environment and sculpting the features of its inhabitants.

Rodin had turned to the medieval chronicler Froissart to guide him in his execution of the *Burghers;* for direction he now turned to the poet Lamartine and was moved by his description of Balzac's head as "the embodiment of an elemental force." That phrase, wrote Judith Cladel, "was the watchword he obeyed, for it corresponded with his own realistic lyricism, it confirmed his own ideas of spiritual greatness and nobility."[2] In Balzac Rodin found a sympathetic hero and discovered an elemental force comparable to the one that fired his own artistic genius.

Studies for *Balzac*, both clothed and nude, appear to have been sculpted simultaneously; Rodin continued to experiment. Visitors to his studio described several sculptures of Balzac, including the *Balzac in Dominican Robe*, the *Balzac in Frock Coat*, and the *Naked Balzac with Folded Arms*.

By 1893 several members of the society expressed concern that Rodin would not finish the statue in time for the Balzac Centenary in 1899. In July a committee of the society visited Rodin's studio. They were shocked, according to Charles Chincholle, who chronicled the entire *Balzac* affair in *Le Figaro*, by "a strange Balzac in the attitude of a wrestler."[3] Zola calmed the critics and persuaded them to give Rodin another year, postponing delivery of the completed bronze cast until the spring of 1895. In May 1894, however, the committee again visited the studio and declared the statue "artistically inadequate"[4] and Rodin in poor health. To the astonishment of Jean Aicard, the new president of the society, a motion for Rodin to deliver the statue within twenty-four hours or cancel his agreement was approved. Aicard, together with Rodin's friends, persuaded the committee to give the artist another year, and Rodin agreed to return ten thousand francs of his commission as insurance for the completion of the statue. The opposition persisted; legal actions against Rodin were pressed. Jean Aicard, followed by other members of the society, resigned in protest. Aurelian Scholl then became presi-

Overleaf:
Upon seeing Edward Steichen's 1908 photographs of his *Balzac* in the moonlight, Rodin remarked, "You will make the world understand my Balzac through these pictures. They are like Christ walking in the desert." (Photo, B. Gerald Cantor Art Foundation)

dent of the society and worked out still another compromise.

The scandal had become public. From 1894 until the final explosion in 1898, the *Balzac* affair was the passionate artistic issue among Parisian intellectuals. Other sculptors—notably J.-J.-M. Marquet de Vasselot, who was closely tied to dissident members of the society—conspired to take the commission away from Rodin. The attacks against Rodin grew vicious.

In 1898 Rodin finished the *Monument to Balzac* and exhibited it in May, along with *The Kiss,* which had been completed fifteen years earlier, at the Salon of the Société Nationale des Beaux-Arts in Paris. The *Monument to Balzac,* recorded Cladel, which stood like a "towering phantom, sheathed in its robe of white plaster, raised its magnificent grief-stricken head almost seventeen feet above the crowds—its mouth twisted with irony and pity."[5]

It attracted a huge crowd, producing "in some a wordless astonishment, and in others indignation, or laughter, and for the most part a complete misunderstanding."[6] The next morning the press was strident with mean criticism. Opponents labeled the statue a seal, a sack of potatoes, a pile of flour, a lump of plaster, a pig. Rodin was described variously as impudent, boring, a lunatic, and a German agent. People gathered at the salon to make fun of the statue, cartoons lampooned it, and an art dealer gave a masked ball and greeted his guests dressed in a seal costume, disguised as the *Balzac.*[7] Rodin's defenders were equally vociferous in their attacks on his critics and in proclamations of Rodin's genius and vision.

The scandal cut so deeply and was so extensive, both in 1894 and again in 1898, as to seem symptomatic of deeper problems in French life. Judith Cladel has documented that Rodin's difficulties with his patrons were immediate and continuous, but academic opposition or financial concerns alone do not adequately explain the terrible anger of the confrontation. The more profound causes, as Jacques de Caso has argued, were created by a deep breach between the Naturalists and the Symbolists, especially an extreme Symbolist cult group called the Rosicrucians.[8] As early as 1859 the poet Baudelaire predicted that the Balzac legend would be bifurcated by the Naturalists, who admired his sociology and materialism, and by the Symbolists, who admired his vision and occult doctrines. This literary struggle was caught up in the larger political issues of the day, particularly the famous Dreyfus Affair. Dreyfus, an officer in the French Army during the Franco-Prussian War, was being made a scapegoat to explain and assuage the French defeat; Dreyfus was Jewish, and the struggle involved an ugly anti-Semitism. Zola, a Naturalist and leading defender of Dreyfus, was associated with Rodin and despised by the Rosicrucians. Thus, the *Balzac* was appraised politically: like the Dreyfus Affair, it was a contest between the Right and the Left, and where one stood on the *Balzac* usually corresponded to where one stood on Dreyfus.

Rodin, an admirer of both Naturalists and Symbolists, did not want to choose artistic sides; his *Balzac* fused the aesthetics of both schools. "It is curious to think that this sculpture should have pleased the Naturalists and displeased the Symbolists instead of the reverse,"[9] wrote Albert Elsen with some irony. In his embracing fidelity to Balzac, his culminating aesthetic, his break with tradition on form and finished surfaces, his revelation of the psychological sources of creativity—in all of these Rodin was neither on the Right nor on the Left, but in the vanguard, where he sought to be despite his moments of doubt and hesitation.

The *Monument to Balzac* was rejected by the society. Rodin withdrew from the controversy with dignity, refusing to sell it, wanting to keep it for himself. He took the statue to Meudon and placed it in an open meadow, where Edward Steichen photographed it in moonlight. In 1939, twenty-two years after Rodin's death, the first bronze cast of the *Balzac* was erected in Paris.

Portrait of Rodin in the Pose of Balzac, 1914. Inscribed in ink, "A Gustave Coquiot l'auteur du vrai Rodin—Auguste Rodin 1914." (Photo by Eugène Druet, B. Gerald Cantor Art Foundation)

Balzac in Frock Coat

Rodin had been informed that Balzac's old tailor, Bion, was still alive, residing outside Paris. Rodin ordered a pair of trousers and waistcoat in Balzac's measurements and produced studies of the writer in contemporary street clothes. *Balzac in Frock Coat* shows the writer casually dressed, arms folded, legs and ankles crossed, leaning against a support with a manuscript at its base. The head and body are those of a trimmer, albeit still portly, younger Balzac, and on the whole the figure appears self-satisfied. This is not the mature, powerful writer of the legendary *Human Comedy*—and even the idea of a nonchalant Balzac in rumpled clothing runs against the formalism conventionally prescribed for monumental sculpture. Rodin pursued this conception of Balzac no further.

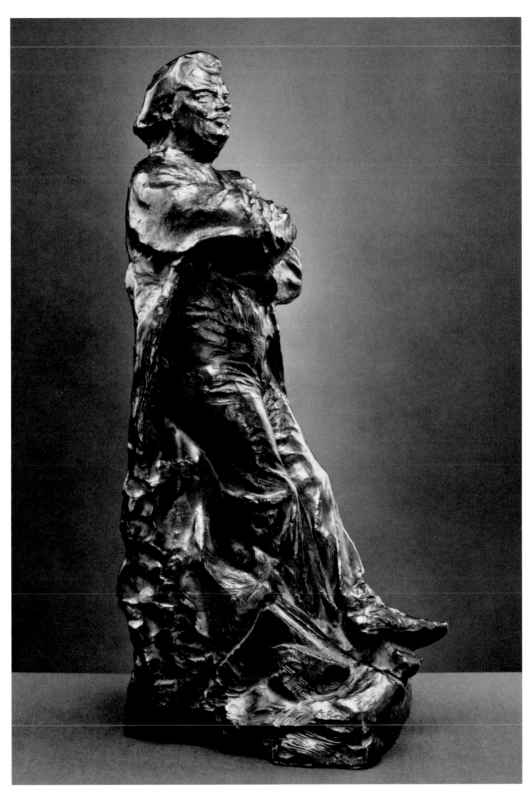

34. *Balzac in Frock Coat*
1891–92, cast 1980
Bronze, 23½ x 9½ x 11¾ in.

Balzac in Dominican Robe

In his copy of Lamartine's *Balzac et ses oeuvres*, published in 1866, Rodin had underlined a passage entitled *Balzac en négligé:* "At home one always found him dressed in an ample robe of white cashmere lined with white silk, cut like a monk's habit and tied with a belt of knotted silk."[10] Rodin apparently created several studies of Balzac in a Dominican robe, for not only was it the writer's working garb but also a solution to the difficult problem of portraying Balzac's unattractive physique, particularly his short, fat legs and massive potbelly. The robe concealed, timelessly. Balzac's "habit of working in a sort of dressing-gown . . .," wrote Rodin, "gave me the opportunity of putting him into a loose flowing robe that supplied me with good lines and profiles without dating the statue."[11] One of the earliest surviving robed studies, *Balzac in Dominican Robe* shows the writer with his hands on his waist and a pile of manuscripts by his right foot. Although Rodin would continue to experiment on how to portray and dress Balzac, he here created the fundamental version of the clothing he would use on the final figure.

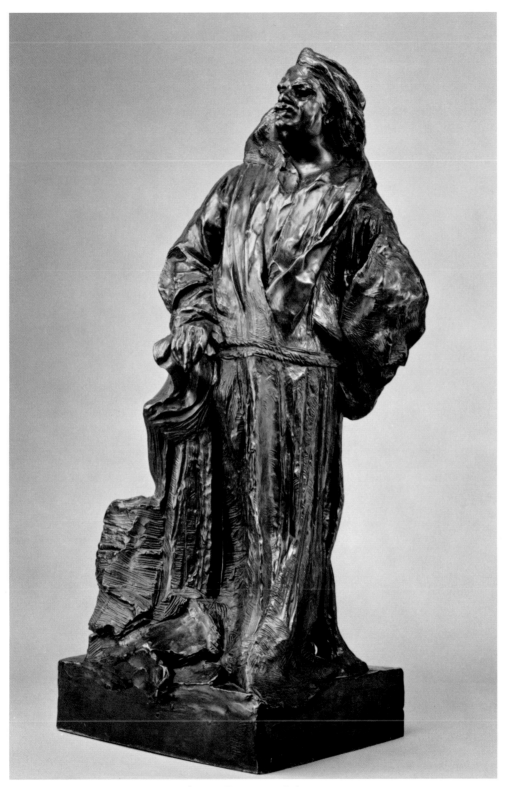

35. *Balzac in Dominican Robe*
1891–92, cast 1971
Bronze, 41¾ x 20⅛ x 20 in.

Naked Balzac with Folded Arms

Rodin sculpted the assertive *Naked Balzac with Folded Arms* in late 1892 or 1893. This remarkable work shows an older Balzac, the writer at the height of his creative potency. Strong legs, much longer proportionally than those of the great author, are firmly set wide apart, supporting a hard, protruding stomach that builds to a powerful chest and square shoulders. A short, thick neck easily carries a large, square, confident head—"I shall carry a world in my head,"[12] Balzac once proclaimed. Muscular, defiant arms are folded across the chest. The torso and legs appear to be buttressed by an enormous tree-trunk shape that merges into the genitals, which suggests "the earth-fed creativity of Balzac's genius."[13] Judith Cladel described this figure as one "in the attitude of a warrior marching into battle," and certainly it is the work described by Chincholle in 1894 as the Balzac portrayed "in the attitude of a wrestler."[14] This depiction, noted Albert Elsen, is a distortion, since not only was Balzac not an athlete, he was incontestably grotesque and flabby: "Balzac's most strenuous physical activities were in bed." But Elsen's real point is that the *Naked Balzac with Folded Arms* was an inspired symbol and should be seen as "a convincing metaphor of Balzac's spirit as a creative artist"[15] rather than a literal representation of the man's physique. Here Rodin brilliantly fused Naturalism and Symbolism—which, because of the complicated politics of intellectual envy and adulation, his own generation could not grasp—and allows us to apprehend that he was indeed a visionary.

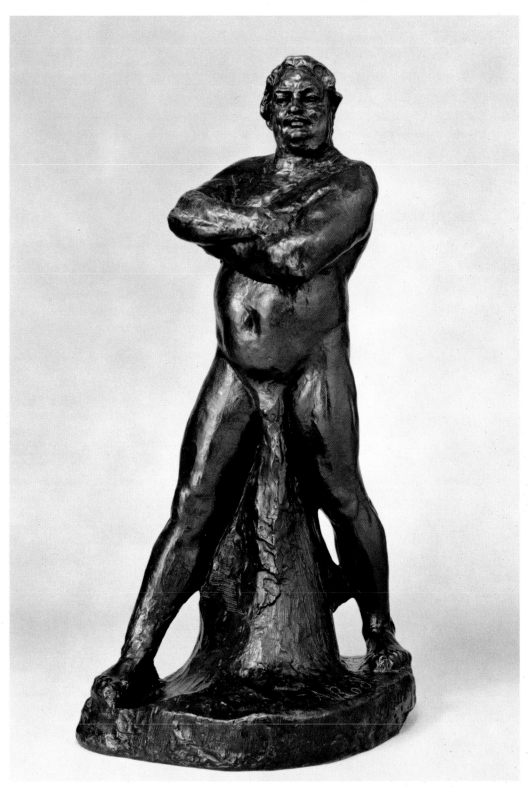

36. *Naked Balzac with Folded Arms*
1892 or 1893, cast 1972
Bronze, 50¼ x 27¾ x 22¾ in.

83

Naked Balzac

The *Naked Balzac*, executed in 1896, is a conventional study, but it brings Rodin to an explicit representation and a symbolic expression of the connection between Balzac's consuming sexuality and his relentless creative genius. This headless athlete is posed in standard studio form, the left foot forward by half a step and the broad shoulders leaning back, curving the spine. Here convention ceases and impropriety begins: the crossed wrists conceal the groin, but, as Albert Elsen observed, the left hand "firmly grasps the figure's virility in an autoerotic gesture."[16] This clasping of the penis should not be interpreted as a statement of sheer virility alone, for it is also a "fitting tribute to Balzac's potency as a creator from the sculptor most obsessed with the life-force!"[17] Essentially, it was the *Naked Balzac*, robed and headed, that became the *Monument to Balzac*. Judith Cladel, angered by the meanspirited, sarcastic reception given the final *Balzac* at the salon, felt that she might reply "with a single gesture, that of breaking the frock in which Balzac was clad and thereby revealing the ruthlessly exact modeling of the pulsating figure beneath."[18]

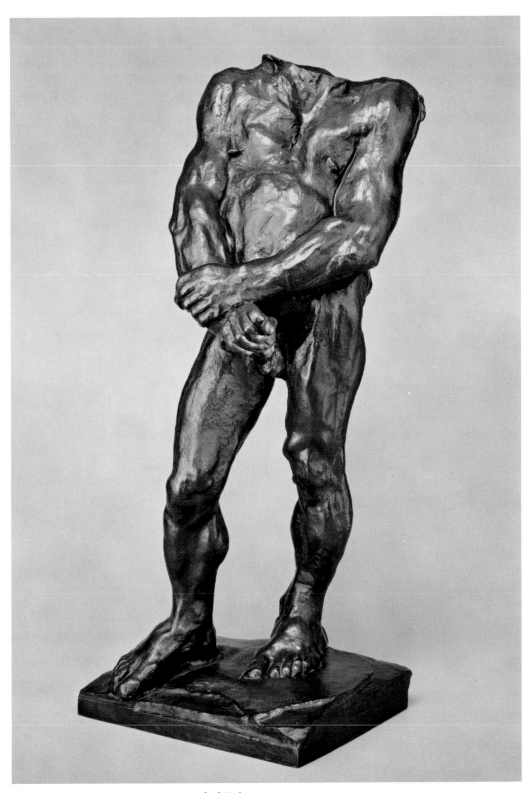

37. *Naked Balzac*
1896, cast 1979
Bronze, 36¾ x 14⅜ x 14¾ in.

Balzac Heads

There are over fifty studies for the Balzac monument,[19] most of them heads. This disparity is a result of Rodin's belief that it was the head that should be emphasized in a statue of a man of intellect. Rodin told Camille Mauclair of the significance he assigned to the head of a figure:

> Rodin explains that in his opinion the statue of a man celebrated for his heart and mind should not be a representation of his body, but a sort of construction whose lines should express the soul of the man. . . . It is illogical, he says, to give the feet and the dress the same value as the head, which is alone important, unless you want to make a photograph and not a work of homage.[20]

Rodin's view was reinforced by Lamartine's metaphor of Balzac's head being like an "elemental force."

The *Balzac Head R*[21] and the *Monumental Head of Balzac,* although executed about five years apart, the former in 1892 or 1893 and the latter in 1897, are remarkably similar. In each the features are distorted to capture the inner meaning, power, passions, and intellect of the man.

Jacques de Caso and Patricia B. Sanders concisely described head studies such as these:

> The deeply gouged eyes beneath jutting eyebrows suggest a superhuman depth of vision; they allude to Balzac's prophetic powers and superior insights. The huge, sneering lips reflect Balzac's cynicism and sensuous nature. The bloated face . . . is the inevitable result of a life lived to excess and of disregard for the body of a mind on fire. This tumultuous life, the constant struggle with artistic creation, is also reflected in the wild shock of hair.[22]

The agitated eyebrows and moustache diminish and the goatee disappears, but in the main the features of the *Balzac Head R* are exaggerated and extended into the *Monumental Head.* With that head upturned and tilted back, Rodin would capture its "elemental force" in the final monument.

86

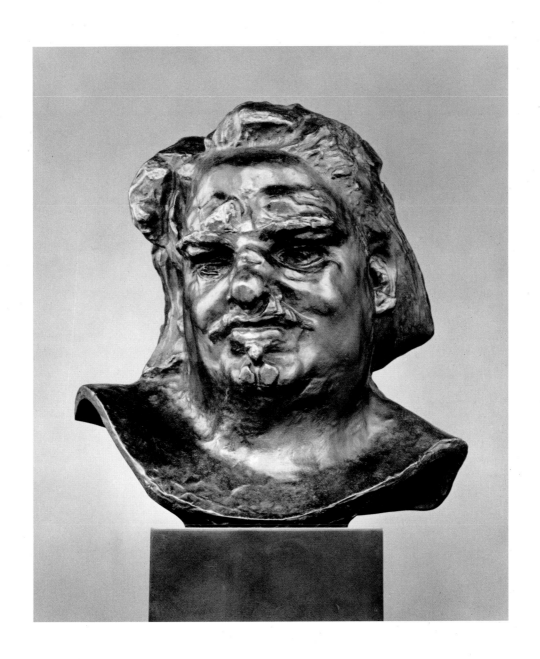

38. *Balzac Head R*
1892–93, cast 1980
Bronze, 12 x 12¼ x 9¼ in.

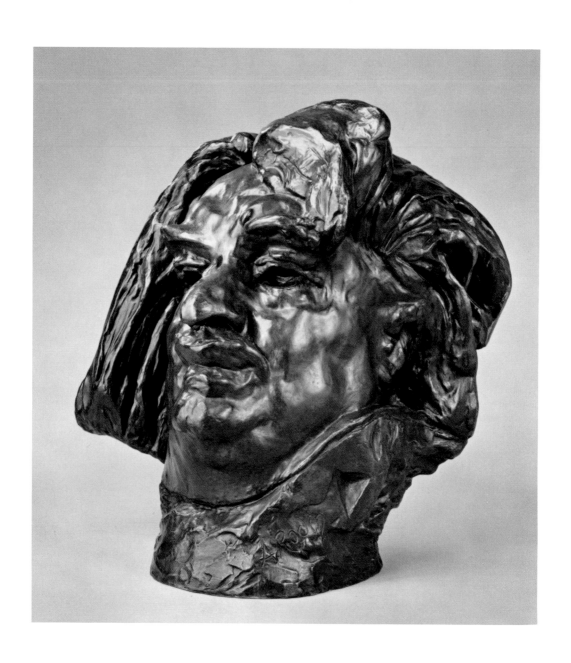

39. *Monumental Head of Balzac*
1897, cast 1978
Bronze, 20¼ x 20⅞ x 16⅜ in.

Final Study for the
Monument to Balzac

Rodin took seven years to develop the *Monument to Balzac*, an enlargement of the *Final Study*. Rodin had decided upon the figure but continued to work on the head and clothing. Although the evolution of the monument is complex, the *Final Study* appears to join the *Naked Balzac* with the *Monumental Head*, together with a drastic reworking of the monk's garb of the *Balzac in Dominican Robe*. Rodin tried numerous arrangements for the drapery until he hit upon a solution— a smoother drapery with hanging sleeves, moving upward to the massive head.[23] The Société des Gens de Lettres announced in April 1897 that the maquette was finished, just awaiting enlargement before the public exhibition.

Rodin was not yet satisfied. "Rodin is working constantly with love," recorded a journalist, "retouching a detail, strengthening a feature of the physiognomy." Even as late as March 1898, two months before its scheduled exhibition, another journalist reported that Rodin "wants to make Balzac's robe suppler and to make the smile . . . more profound."[24]

Judith Cladel, who was present in the studio courtyard on the rue de l'Université when the artist took the enlarged plaster into the sunlight, disclosed that Rodin was distressed. He was "submitting it to a rigorous examination. . . . It was a painful ordeal; the bright daylight diminished the importance of the volumes, flattened the planes, and played havoc with the modeling. . . . 'They're taking away my statue,' he muttered complainingly. 'Sculpture requires a lot of time; the artist ought to be able to forget his work, to go for months without seeing it, and then return to judge it as though it was someone else's.'"[25]

Rodin regained his composure before the exhibition and survived the controversy over the monument with his dignity intact. Years later, in 1907, in an interview with Paul Gsell, Rodin explained his *Balzac*:

. . . by what right do they reproach this dressing gown with its hanging, empty sleeves? Does an inspired writer dress

Plaster study of the robe for the *Monument to Balzac,* 1897. (Photo by D. Freuler, Musée Rodin)

otherwise when at night he walks feverishly in his apartment in pursuit of his private visions? This just wasn't done before. By convention, a statue in a public place must represent a great man in a theatrical attitude which will cause him to be admired by posterity. But such reasoning is absurd. I submit that there was only one way to evoke my subject. I had to show a Balzac in his study, breathless, hair in disorder, eyes lost in a dream, a genius who in his little room reconstructs piece by piece all of society in order to bring it into tumultuous life before his contemporaries and generations to come; Balzac truly heroic who does not stop to rest for a moment, who makes night into day, who drives himself in vain to fill the gaps made by his debts, who above all dedicates himself to building an immortal monument, who is transported by passion, whose body is made frenetic and violent and who does not heed the warnings of his diseased heart from which he will soon die. It seems to me that such a Balzac, even, seen in a public place would be greater and more worthy of admiration than just any writer who sits in a chair or who proudly poses for the enthusiastic crowd. In sum, there is nothing more beautiful than the absolute truth or real existence.[26]

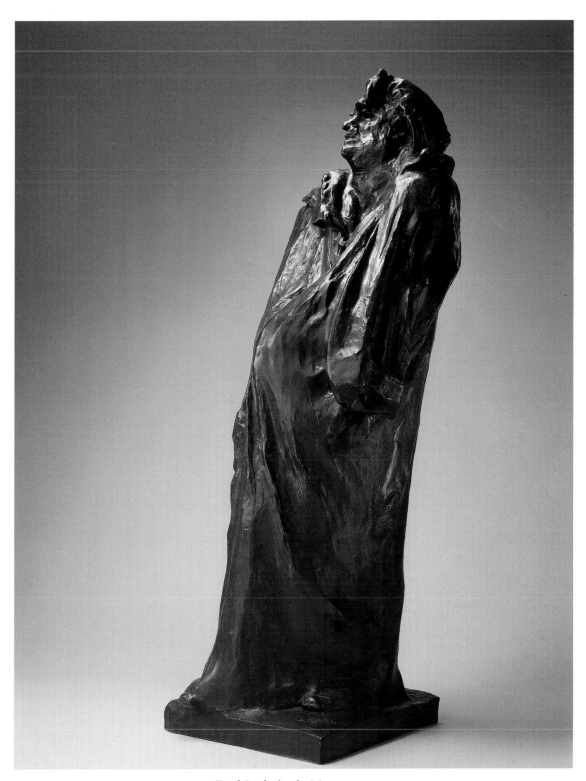

40. *Final Study for the Monument to*
 Balzac
1897, cast 1972
Bronze, 41¾ x 17½ x 16½ in.

91

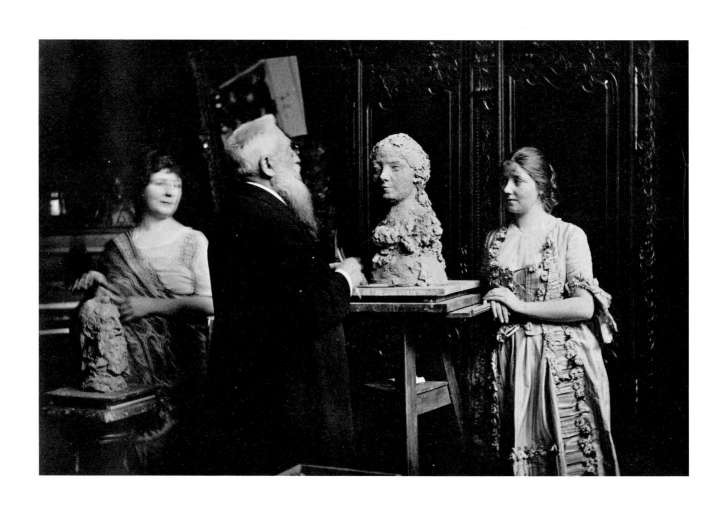

Portraits

Rodin was a master modeler of the physiology of the head, and he gradually learned how to express his subject's biography by capturing his or her character in the portrait of the face. "To tell the truth, there is no artistic work which requires as much penetration as the bust and the portrait," he said.[1]

The importance Rodin ascribed to the head can be appreciated in his numerous studies for monumental works, such as those for *The Burghers of Calais* and particularly the *Balzac,* but his development as a sculptor of the head can best be seen through his portraits. Rodin did not start as a superior sculptor of portraits, despite his precocious technical skills. Yet he became the supreme sculptor of human psychology—an impressive achievement for Rodin as an expressive artist, though a quality not always pleasant for his patrons. "I have done my best, and I never lied," said Rodin, "and never flattered."[2]

Rodin's portrait style initially derived from three sources: first, the fragments of heads from Greek antiquity and the formal busts of Roman antiquity; second, eighteenth- and early nineteenth-century interpreters of the classical bust, as represented by such sculptors as David d'Angers, Jean-Baptiste Carpeaux, and Jean-Antoine Houdon; and third, the work of Albert-Ernest Carrier-Belleuse, one of the most highly esteemed and successful decorative sculptors of the mid-nineteenth century. Rodin spent hours in the Louvre studying the ancient sculptures and the neoclassical masters. Unlike the academicians in the Ecole des Beaux-Arts, who developed formulas for the imitation of classical sculpture, Rodin saw in the ancients and their eighteenth- and early nineteenth-century interpreters a fidelity to nature and therein the essence of art. "Even the most insignificant head is the dwelling-place of life, that magnificent force, and so offers inexhaustible matter for the masterpiece."[3]

From these sources he learned how to model profiles and physiognomy, but it was from Carrier-Belleuse that Rodin learned decoration, scale, and versatility. Seeking regular pay, Rodin entered the employ of Carrier-Belleuse, who produced an extensive line of portraits, decorative façades, porcelains, monuments, figurines, candelabra, and *bustes de fantaisie.* Rodin shared Carrier-Belleuse's tastes in eighteenth-century decorative art, which differed from the accepted neoclassical conventions of the nineteenth century.[4] Rodin's tenure with Carrier-Belleuse increased Rodin's awareness of the commercial possibilities of his work, even as he continued to develop his own personal style of expression and move into the vanguard. In addition, his employment with Carrier-Belleuse taught him to work in a broad range of media—in fact, Rodin may have been "the last sculptor to be trained as a polymath."[5]

The best description of Rodin's method of portrait sculpture comes from the poet Rainer Maria Rilke, who, in a letter to his wife, wrote the following account of the creation of Rodin's portrait of George Bernard Shaw:

> . . . I was present at the first sittings and saw for the first time how Rodin sets about his work. First there is a firmly-kneaded lump of clay which consists of nothing but a globe placed on a shoulder-like support. This globe is prepared for him and contains no armature, only firm kneading keeps it together. He begins his work by standing the model at a very short distance from him, about half a pace from his easel. With big iron calipers he takes the measurement from the top of the head to the tip of the beard and immediately fixes this proportion on the clay lump by the addition of more clay. Then in the course of his work he takes two more measurements: nose to back of head and ear to ear from behind. After he has made a quick incision for the eyebrows so that something resembling a nose is formed, and has determined the position of the mouth by a slit such as children make in a snowman, he begins, with the model standing quite close, to shape four profiles, then eight, then sixteen, making the model turn after every three minutes. He began with the front view and the two full profiles, as though he were modelling four different sketches in the clay on top of one another, then inserted

intermediate profiles between these contours. Yesterday at the third sitting, he placed Shaw in a cunning little baby-chair (all of which afforded this satirist and really not uncongenial scoffer an exquisite pleasure) and cut off the head of the bust with a wire (Shaw, whom the bust resembled in an almost supercilious way, so to speak, witnessed this decapitation with indescribable joy) and began working at the head reclining on two wedge-shaped supports, viewing it from above in roughly the same position as the model sitting at arm's-length below him. Then the head was set upright again, and the work now continues in the same way. To begin with Shaw stood, often quite close to the easel so that he was a little taller than the bust. But now he sits directly beside it at exactly the same height as the clay and parallel with it. At some distance a dark curtain has been hung so that the profiles always stand out sharply. The Master works quickly, compressing hours into minutes, it seems to me, carrying out strokes and touches after short pauses in which he assimilates tremendously, filling himself with form. You feel somehow that his lightning, hawk-like swoops only fashion one of all the faces that pour into him, and you only grasp his technique of work in your memory, long after the sitting is done. . . .[6]

Despite the lightning swoops, Rodin's procedure was painstaking. He studied his subjects' movements and expressions with extraordinary care and demanded numerous sittings from them. "It was a process that seemed to belong to the study of an embryologist and not an artist," wrote Shaw, who, as a sitter, did not share Rilke's sense of Rodin's speed.[7] Rodin had casts made of a bust at varying stages, until he was thoroughly satisfied with the sculpture. Malvina Hoffman, who studied with Rodin between 1910 and 1914, described his technique:

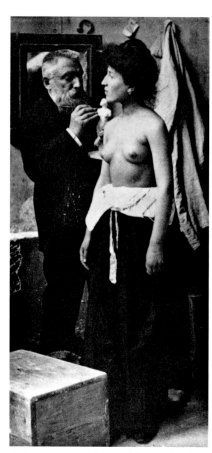

Rodin scrutinized his models closely, observing them from different angles. He would then, as shown here, record each profile successively, turning his stand and the model until he had circled the body. (Photo, Musée Rodin)

> Frequently I knew him to start a portrait, and after a few sittings, to call in a plaster-caster and have a mould made as a record; then he would make a "squeeze," that is, the fresh clay would be pressed into the negative of the piece-mould and with this stage of the portrait safely registered, he would feel more free to make bold changes or experiments, without the fear of losing what had been achieved up to that point. The first plaster was a guide to which he could always refer if he felt himself in doubt during the subsequent sittings.[8]

Only then was a final bust executed, generally in bronze or marble but sometimes in wax, silver, ceramic, or glass.

Rodin explained what he was attempting to capture through his multiphased method of profiling in these words:

> The sculptor must learn to reproduce the surface, which means all that vibrates on the surface: spirit, soul, love, passion—life. . . . Sculpture is thus the art of hollows and mounds, not of the smoothness of even, polished planes.
> . . . To model shadows is to create thoughts. . . . The public mistakes smoothness for art, whence springs the current neo-Greek style to which we owe so much bad statuary. . . . By working at profiles we reach the depths. These cannot be made by superimposing on the surface; that would produce dull and insipid works, that could be looked at from only one side. . . . Who sells himself to a style turns his statues into bad literature. . . . Sculpture is man's grasp of nature in three-dimensional art.[9]

The successful "grasp of nature," filtered through passionate empiricism, endowed Rodin with originality and greatness.

From the onset Rodin excelled at modeling, as exemplified in his earliest surviving sculpture, the bust of Jean-Baptiste Rodin. The most famous of his early portraits, *The Man with the Broken Nose*, shows Rodin's ability to capture nature and character, even though he had not yet reached his full powers. "Rodin," wrote Albert Elsen, "matured as a craftsman before he attained maturity as a person."[10]

Rodin neither selected nor approached artistically his male and female sitters in the same way. He selected male subjects for their achievement and character, his female sitters for their beauty or sensuality. He usually chose bronze for male portraits, marble for female portraits. Rodin's male-female distinction was not superficial but profound, and it may have inhibited his development as an artist.[11] "In portraits of our own sex," he told an assistant,

> . . . we must pierce without pity the innermost crannies of their souls, must strip them

of disguise, lay bare the intemperate, even vicious passions that surge in their daily struggle to have and to hold. . . . But a portrait of a woman is another thing. Their nature is not ours, we are far from grasping it; we must therefore be respectful and discreet. We must be circumspect, in unveiling their tender and delicate mystery. Even with them, always the truth—but not always all the truth; sometimes we may, just a little, drop the veil.[12]

Thus, the *Young Girl with Flowers in Her Hair,* a pretty object produced for the commercial market, utterly fails as a work of insight, but in the later *Mask of Rose Beuret* the veil begins to drop. By the time he executed the bust of Mrs. Russell, Rodin was in possession of his full powers, although the subject remains confined to the appearance of a beautiful woman, however brilliant and determined. In the many studies of Hanako, as seen in the *Mask of Hanako,* Rodin at last reaches his maturity; perhaps it took a woman from another culture and race to emancipate him.

His style with men was always frank and mature, even though his early works were limited by the convention of portraying them as formal, latter-day Romans. By the time of the *Balzac* and *Baudelaire* his progress toward capturing a deeper psychological meaning in his male portraits is notable, and his supreme abilities are evident in his busts *Clemenceau* and *Pope Benedict XV.* Because of his deeply rooted male bias, Rodin excelled as a sculptor of his sex but rarely achieved such heights with his female portraits.

Rodin with his plaster bust of Father Pierre-Julien Eymard, founder of the Order of the Fathers of the Holy Sacrament. (Photo by Charles Aubrey, Musée Rodin)

After 1900 Rodin was an international celebrity, and it is widely believed that he readily attracted the patronage of the rich and famous and could ask what he liked for a commissioned bust. Sums of up to 40,000 francs, many contend, were commonplace. Recent research suggests, however, that these are exaggerations, that most of Rodin's portraits were of his colleagues and friends, done for free, and that fees of 40,000 francs remain undocumented. Between 1877 and 1917 Rodin made portrait busts of fifty-seven living contemporaries, but only fourteen appear to have been commissioned, the majority for between 2,000 to 25,000 francs. The most Rodin is known to have been paid was 35,000 francs for each of three busts—of the Americans Thomas Fortune Ryan, Joseph Pulitzer, and Edward H. Harriman, all after 1907.[13]

It may be a myth that portraits made Rodin rich, but it is certain that they made him acceptable and independent. Rodin himself preferred to do portraits of his friends and of those he admired. His instincts were not pecuniary; rather, they drove him to the creative challenge. Rodin possessed a genius for portraying the psychological dimensions of personality, and as a portrait sculptor he was unmatched by his contemporaries.

Jean-Baptiste Rodin

The portrait of Jean-Baptiste Rodin is the earliest known sculpture by Rodin, executed in 1860 when the artist was twenty years old. It is a bust of the artist's father.

Jean-Baptiste Rodin, the son of an obscure cotton merchant, came to Paris with his wife, Marie, from a small town in Normandy. He came to make his fortune but settled for an undistinguished career in the civil service, starting as a clerk in the Paris police department, going on to a post at a Paris prison, rising to the rank of inspector, and then retiring at the age of fifty-nine. One year before his retirement Rodin painted his portrait, representing him with a moustache, a full beard, and long hair.

The *Jean-Baptiste Rodin* bust illustrates the influence of classical portrait sculpture on young Rodin. His father is portrayed not as a nearly impoverished civil servant but as a Roman legislator or official. It is a severe face, clean-shaven; the moustache, beard, and long hair of the painting are gone.[14] The thin lips are pressed together, the eyes expressionless, the surface skin pulled tight against the skull. The overall impression is one of strength and concentration.

The young Rodin was restrained and limited himself to a recording of physical characteristics within the conventions of ancient portrait sculpture. His modeling is masterful, but he was not yet able to experiment with revealing the inner soul or psychology of his subject; he had not yet learned how to express himself through his sculpture.

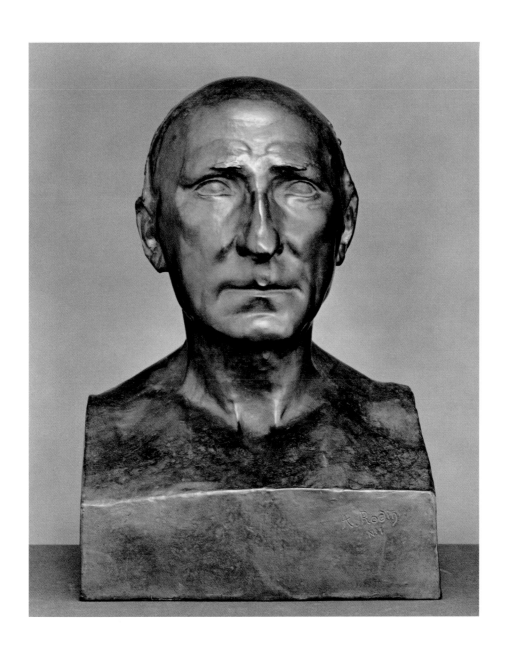

41. *Jean-Baptiste Rodin*
1860, cast 1980
Bronze, 16⅛ x 11¼ x 9½ in.

42. *Young Girl with Flowers in Her Hair*
Ca. 1868
Terra-cotta, 14 x 7¼ x 8 in.

Young Girl with Flowers in Her Hair

As a young man Rodin worked for Albert-Ernest Carrier-Belleuse, whose atelier was a commercial enterprise where Rodin learned to be versatile and produced pretty, polished, and elegant busts, many of which Carrier-Belleuse sold as his own. *Young Girl with Flowers in Her Hair* is an excellent example of this type of commercial portraiture, which is reminiscent of eighteenth-century prototypes. Such busts were done by formula: the obligatory tilt of the head, the realistic but longing eyes, the direct gaze, the soft smile, the partially open mouth, the picturesque treatment of heavy hair and ornaments.[15]

This terra-cotta bust is finely modeled, with a finished appearance. Its breathlessness and airiness are in sharp contrast to the classical male bust of Jean-Baptiste Rodin but typical of Rodin's early female busts, which were of coquettish, idealized girls, frequently adorned with bows, flowers, and ribbons. "For me to make the bust of a woman, she had to seem pretty,"[16] he said. Rodin produced many such busts, which he signed, and he tried to sell them in shops to augment his income, even after his employment with Carrier-Belleuse ended. "I was well punished for it, for I could not sell them," he told his assistant Léonce Bénédite. Later, Rodin reflected on his work for Carrier-Belleuse and declared, "Nothing I ever did for him interested me."[17]

43. *Mask of Rose Beuret*
1880–82
Plaster, 11 x 6⅜ x 6⅝ in.

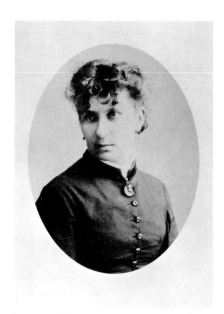

Portrait of Rose Beuret, ca. 1880–82, between thirty-six and thirty-eight years old. (Photo, Musée Rodin)

Mask of Rose Beuret

Rodin met Rose Beuret in 1864, when she was twenty years old, illiterate, and working as a seamstress in Paris. She became his mistress and bore his only child, a son. Rose remained Rodin's companion for life. She worked to supplement his meager income, stood by him during hard times, looked after his sculpture, kept his clay moist, cooked his meals, and modeled for him in the evenings. He worried about her constantly, showed concern for her welfare, and expressed tenderness, affection, and love for her. He referred to her in letters as Madame Rodin and called her his wife in conversation, but they were not married until 1917, two weeks before she died of bronchial pneumonia. It was a difficult, sometimes stormy, relationship, and Rose suffered most from his frequent infidelities. She was beautiful in her youth and was always industrious, loyal, jealous, and quick to anger.

Rodin's earliest portrait of Rose, executed in 1870 and titled *Mignon*, shows her beautiful and introspective. During the late 1870s and early 1880s

Rose posed for the heads *Call to Arms* and *Bellona* as well as a bust called *The Alsatian Woman*. The *Mask of Rose Beuret* may have been an intermediate abbreviated study for *The Alsatian Woman*.[18] The *Mask* presents the face of an older woman and was made when Rose was thirty-six or thirty-eight years old. In it she appears quiet and contemplative. This may have been the last figure he modeled of Rose, for he made no portraits of her after she reached early middle age.

In the *Mask of Rose Beuret*, Rodin decided to concentrate on the "sculptural quality of her features rather than describe her volatile nature."[19] Nevertheless, she appears more embittered and haggard than the younger Rose of *Mignon*, and the realistic modeling, the ragged edges and contours, and the absence of polished finish are radical departures from the pretty, formulaic *Young Girl with Flowers in Her Hair*. Rodin had not fully freed himself from convention, yet on the path to his own expressive emancipation he was beginning to drop the veil from his women.

Mrs. Russell

Mrs. Russell was of Italian origin, born Mariana Mattioco della Torre. An artist herself, she married the Australian painter John Pole Russell. Both of the Russells were associated with the Impressionists and were friendly with Vincent van Gogh, Henri de Toulouse-Lautrec, Paul Gauguin, Claude Monet, and Gustave Geffroy. The Russells probably met Rodin in 1886 through their mutual friends Monet and Geffroy. Mariana Russell's classic features must have inspired Rodin, who had her pose for sculptures of several ancient deities, including *Ceres, Minerva with a Helmet,* and *Pallas with the Parthenon.*

In *Mrs. Russell,* Rodin captures her beauty, aloofness, and quiet reverie. She does not appear passionate, yet the modeling of her flesh reveals her sensuousness. There are few surface irregularities except for the roughened forehead, which plays with light and shadow. The hair is pulled back, emphasizing her strong, angular features, her nose is bent to the left, and her right cheek is fuller than the left. The portrait penetrates beyond the understated surface, however, and reveals the subject's intelligence and character.[20]

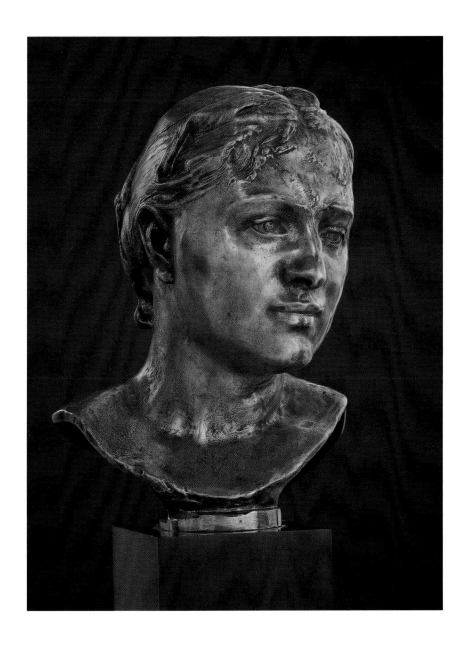

44. *Mrs. Russell*
1888
Bronze, 13¾ x 10 x 10¼ in.

Edward Steichen's 1908 photograph of the plaster *Mask of Hanako* documents Rodin's interest in the dancer's fierce expressions and gestures. "With the force of will which the Japanese display in the face of death, Hanako was enabled to hold this look for hours," wrote Judith Cladel. (Photo, Musée Rodin)

Mask of Hanako

Hanako was the stage name of the Japanese actress and dancer Ohta Hisa. Hanako was trained as a geisha, and about 1904 the American dancer Loïe Fuller invited her to join her company in Paris as a mime. Rodin met Hanako in 1906 and was immediately impressed with the range of her Kabuki-inspired expressions, from fury and anguish to restraint and impassivity. Between 1907 and 1911 she posed for Rodin, who produced more studies of Hanako than of any other model; there are fifty-three sculptures—busts, heads, and masks—recorded at the Musée Rodin. "Hanako did not pose like other people," explained Judith Cladel, because she was able to hold difficult poses for very long periods of time.[21]

The *Mask of Hanako* has a calm visage, accentuated by the convex forehead, the fleshy mouth, and the remote gaze. It is a formal but psychologically expressive head. Hanako's heads by Rodin, wrote Albert Elsen, were "unprecedented in either Western or Eastern sculpture as a revelation of the changes that can be enacted upon one woman's face. The series gains additional interest in the choice of a woman whose culture and training had taught her facial control and the masking of feeling, but whose mask disintegrated under the sculptor's searching inquiry."[22] With Hanako, Rodin dropped the veil.

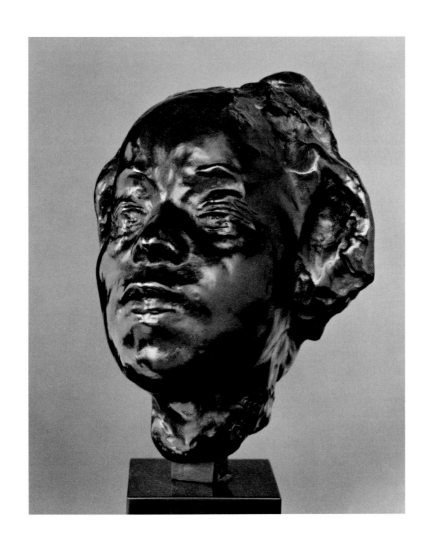

45. *Mask of Hanako*
Ca. 1908, cast ca. 1950
Bronze, 6 x 3¾ x 4½ in.

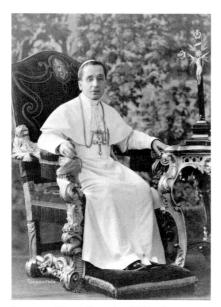

Portrait of Pope Benedict XV, whose papacy spanned the years 1914–22. (Photo, Musée Rodin)

Pope Benedict XV

Italian-born Giacomo della Chiesa studied for the priesthood, entered the papal diplomatic corps, became archbishop of Bologna, then cardinal, and was elected pope in 1914, taking the name Benedict XV. Although his papacy spanned the First World War, he initially tried, for diplomatic reasons, to conceal his thoughts about the war.[23] Nonetheless, Francophiles in the Vatican gained Benedict's consent to sit for the painter Albert Besnard and for Auguste Rodin. The pope told Besnard that he dreamed of restoring the papacy to a position of supremacy in the arts. Besnard also reported that the pontiff "wanted something grand, even sumptuous" from Rodin and that he would insist on a decorative bust in the baroque manner of Coysevox or Bernini.[24] Rodin was enthusiastic about the commission—and eager to speak with the pope about the war.

Rodin was quickly discouraged. The pope refused to talk of the war and would not sit still for the sculptor to study his profiles. Some scholars suggest that the pope was agitated because

Rodin violated protocol by literally looking down at him. But John Tancock also suggests that the pope became "alarmed at the intense physical and psychological scrutiny to which Rodin was subjecting him."[25] By the end of the third sitting the pope indicated that the fourth would be their last session.

Pope Benedict XV was sixty-one years old when he sat for Rodin. Although his training in the papal diplomatic corps had taught Benedict how to conceal his thoughts and feelings, Besnard perceived the pope's cunning, and Rodin interpreted the pope's austere face as a kind of mask, albeit one that reveals the strength and cleverness of the man behind it. Comparisons with contemporary photographs of Benedict XV show that while Rodin softened the lines of the face and hollowed the cheeks, in general he did not shy away from depicting imperfections. Rodin, of course, considered the bust neither complete nor finished, but in only four sittings he "came away with his most private

image of a public figure."[26] The bust of Pope Benedict XV carries no sense of the grandeur the pontiff had desired, and Rodin did not give the head a formal base but instead stood it on the clerical collar. "It was a portrait of Giacomo della Chiesa that Rodin executed and not one of the Supreme Pontiff," Tancock concluded.[27]

46. *Pope Benedict XV*
1915, cast before 1952 (possibly as
 early as 1927)
Bronze, 9⅞ x 7⅜ x 10 in.

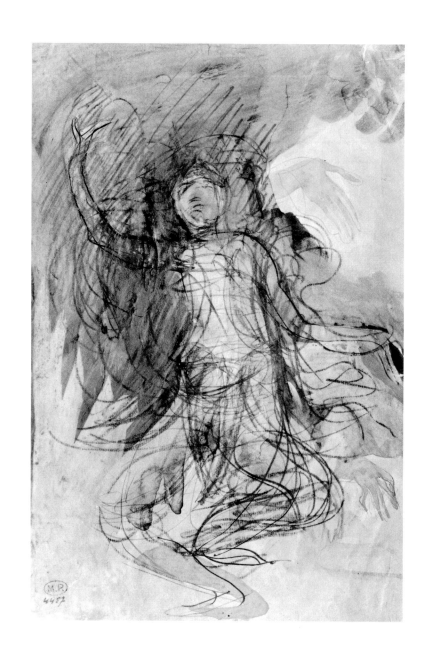

The Dance

Dancers have long inspired visual artists, particularly painters and sculptors. Rodin discovered dance late in life, when he was in his sixties. Perhaps Rodin did not care for the dance earlier because he saw in the classical ballet performed in the official Paris opera the same formalism he despised in the Ecole des Beaux-Arts. Perhaps he came to the dance because he was caught up in the contemporary intellectual climate—Herbert Spencer's theme of "rhythm" in *First Principles* (1869), Darwin's interest in spontaneous body symbols and movements in *The Expressions of the Emotions in Man and Animals* (1872), Nietzsche's celebration of Dionysian dance in *Thus Spake Zarathustra* (1883). More likely the new forms of dance, such as the titillating cancan performed in the uninhibited cabarets of late nineteenth-century Paris, simply captured his artistic imagination, as they had for Toulouse-Lautrec and Georges Seurat. Certainly, once Rodin discovered the movement of dance, he became an enthusiast, seeing in dance the very spirit he had always sought to create in his sculpture.[1]

Rodin grew excited about modern dance in 1892, when the Illinois-born Loïe Fuller became the rage of Paris at the Folies-Bergère. Having perfected her craft in American burlesque, "La Loïe," dressed in shimmering silk costumes, gracefully waved huge veils in imitation of moths and flames. Her movements were made spectacular by her grand sense of staging, lighting, and theater. Fuller "epitomized the spirit of Art Nouveau" and became a friend and collaborator of Rodin. "Loïe Fuller," he said, "opened the way to the art of the future."[2]

If Loïe Fuller opened the way to the art of the future, another American, Isadora Duncan, fulfilled it. Isadora Duncan, a far greater artist than Fuller, arrived in Paris in 1900, proclaiming a revolution in freedom for the human body. Dancing in short tunics, Duncan played down histrionics and used body movement to express the beauty of the spirit. The young American dancer frequented the Louvre, plunging herself into the study of classical Greece. She admired Rodin, sensed his affinity with the Greeks, and visited him at his Paris studio.

After the visit they went to her studio, where she danced for him and he made advances to her. Duncan describes the probably apocryphal scene in her autobiography: "From him emanated heat that scorched and melted me. My whole desire was to yield to him my entire being and, indeed, I would have done so if it had not been that my absurd upbringing caused me to become frightened and I withdrew, threw my dress over my tunic and sent him away bewildered. . . . How often I have regretted this childish miscomprehension which lost me the divine chance of giving my virginity to the Great God Pan himself, to the Mighty Rodin. Surely Art and all Life would have been richer thereby!"[3]

Rodin and Duncan became friends. Rodin visited her frequently at the dancing school she established at Bellevue, across the river from his Meudon. He spent afternoons sketching the movements of Isadora and her young dancers and listening to her theories. "Ah," he sighed to Isadora, "if I had only had such models when I was young. Models who move and whose movement is in close harmony with nature." "In my youth," Rodin said, "when I saw our Opéra ballets, I was unable to understand how the Greeks could have exalted the dance to a supreme position in the arts."[4]

Rodin was also captivated by dancers from other cultures. He saw the Javanese ballet in 1896 and the Cambodian ballet in 1906. When Rodin, at the age of sixty-six, saw the Cambodian ballet at the Bois de Boulogne, he was thrilled; he accompanied them to Marseilles, where he executed innumerable drawings of the exotic Eastern movements. He returned to Meudon three days later and could talk of little else but the grace of the dancers. In 1906 he met the Japanese dancer and actress Ohta Hisa, better known as Hanako, and was immediately impressed with

Overleaf:
Auguste Rodin, *Dancing Figure*, ca. 1900–1905. Pencil and gouache, 12¾ x 9⅔ in. Musée Rodin, Paris

Opposite:
Auguste Rodin, *Cambodian Dancer*, 1906. Pencil, ink, watercolor, and gouache, 12 x 8 in. Musée Rodin, Paris

Hanako in costume, ca. 1908. (Photo, Musée Rodin)

her remarkable powers of expression.[5]

But it was Vaslav Nijinsky, the incomparable star of Russian ballet, who deeply moved Rodin, revealing to him the ultimate power and purity of dance as well as its profound identity with sculpture. In 1912 Nijinsky first performed his ballet *L'Après-midi d'un faune* at the Théâtre du Châtelet in Paris. Rodin sat in a box close to the stage; when the curtain fell, he stood up and shouted bravos at the top of his voice. With tears in his eyes, Rodin visited Nijinsky in his dressing room and took the dancer in his arms: "The fulfillment of my dreams. You brought them to life."[6]

In the morning the newspapers expressed delight with the premier performance, with the exception of *Le Figaro*, which castigated the performance and attacked Nijinsky for public immorality: "We have a faun, incontinent with vile movements of erotic bestiality and gestures of heavy shamelessness." The next morning Paris took notice of an article on the editorial page of *Le Matin*, signed by Rodin:

> During the last twenty years, dancing seems to have set for itself its task of making us love the beauty of the body, movement and gesture. First there came to us from the other side of the Atlantic the famous Loïe Fuller, who has been justly called the rejuvenator of dancing. Then came Isadora Duncan, teacher of an old art in a new form, and to-day we see Nijinsky, who possesses at the same time talent and training. The intelligence of his art is so rich and so varied that it approaches genius.
>
> In dancing, as well as in sculpture and painting, flight and progress have been smothered by routine laziness, and inability to rejuvenate. We admire Loïe Fuller, Isadora Duncan, and Nijinsky, because they have recovered again the soul of tradition, founded on respect and love of nature. This is the reason why they are able to express all the emotions of the human soul.
>
> The last of them, Nijinsky, possesses the distinct advantage of physical perfection, harmony of proportions, and a most extraordinary power to bend his body so as to interpret the most diverse sentiments. The sad mime in *Petrouchka* seems, in the last bound of the *Spectre de la Rose,* to fly into the infinite space, but in no part is Nijinsky as marvelous and admirable as in *L'Après-midi d'un Faune.* No jumps, no bounds, nothing but attitudes and gestures of a half-conscious animal creature. He stretches himself, bends, stoops, crouches, straightens himself up, goes forward and retreats, with movement now slow, now jerky, nervous, angular: his eyes search, his arms extend, his hands open and close, his head turns away and turns back. The harmony between his mimicry and his plasticity is perfect. His whole body expresses what his mind dictates. He possesses the beauty of the antique frescoes and statues; he is the ideal model for whom every painter and sculptor has longed.
>
> You would think Nijinsky were a statue when he lies full length on the rock, with one leg bent and the flute at his lips, as the curtain rises, and nothing could be more soulstirring than his movement when, at the close of the act, he throws himself down and passionately kisses the discarded veil.
>
> I wish that every artist who truly loves his art might see this perfect personification of the ideals of the beauty of the ancient Greeks.[7]

In gratitude, Nijinsky posed for Rodin in the nude. The statue was never completed, but Rodin's small, potent *Nijinsky* is magnificent, embodying the spirit and movement of the dancer.

Even before he discovered the dance, Rodin possessed an "instinctive comprehension of dance—and, by extension, sculpture—as continuous motion in space."[8] Rodin's *Walking Man* exemplifies individual movement, and the composition of *The Burghers of Calais* suggests a keen sense of choreography. Rodin studied movement in space and preferred his models, frequently recruited from among the performers of the Moulin de la Galette and the Moulin Rouge, to move about his studio, limbering up, exercising, kicking, jumping. As the dancers performed, Rodin would rapidly work pieces of clay in his fingers, capturing the immediacy of their continuing movements.

"Movement," said Rodin, "is the soul of all things."[9] Rodin's notion of movement in sculpture called for fusing different phases of movement over time into a single work. Rodin thus rejected the instantaneity of two of his contemporaries: Edgar Degas, who brilliantly captured ballet in oil, pastel, and bronze; and Eadweard Muybridge, whose photographs of galloping horses pioneered stop-motion sequential photography. "Rodin," observed Kirk Varnedoe, "seeks to show gestures that lift the figure out of time into universal psycho-emotional states."[10]

The dance contributed to Rodin's comprehension of his sculptural ideal. "There was no dancer of repute who did not want to dance for Rodin, the sculptor of movement," wrote Judith Cladel, "and he was grateful to them for the unusual opportunities for study which they afforded him."[11]

American-born dancer Loïe Fuller enthralled the Parisian public with her performances at the Folies-Bergère. (Photo, Musée Rodin)

Dance Movements

In his passion to capture movement, Rodin studied dancers. These were usually extemporaneous personal studies not connected with commissions, the "result of serious play and improvisation."[12] Hundreds of such studies, called *Dance Movements,*[13] were stored in the basement at Meudon. It was the Musée du Louvre's 1962 exhibition of them, entitled *Rodin inconnu,* that explicitly revealed the sculptor's intention: to show continuous movement in nature, not figures frozen in space.[14]

As dancers performed in his studio, Rodin would rapidly mold clay in an attempt to break the frozen image. His challenge was to achieve animation in a single sculpture. Rodin's secretary, Anthony Ludovici, noted that the sculptor believed that "provided the two positions are sufficiently close in time for the last to follow naturally out of the first, their fusion will give the impression of movement."[15] Rodin did not always realize this ideal; *Dance Movements A, B, D, E, F, G, H* are examples of Rodin's attempts to put his theory into practice. The majority of these figures were not cast in bronze until after the artist's death, and *Movement A* is the only one that exists in an enlarged version.[16]

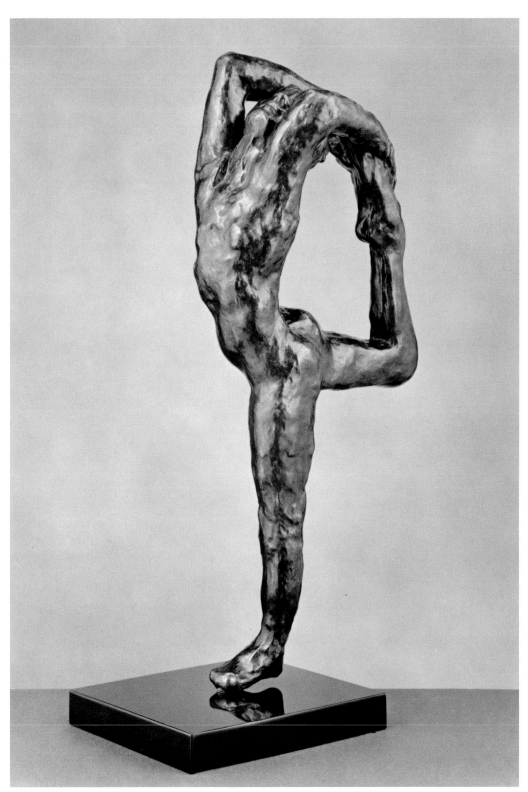

47. *Dance Movement A*
Ca. 1910–11, cast before 1952
Bronze, 26 x 6¾ x 12¼ in.

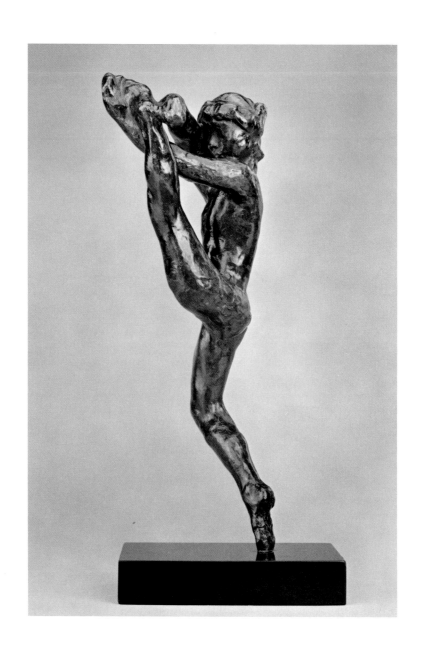

48. *Dance Movement B*
Ca. 1910–11, cast 1956
Bronze, 12½ x 3½ x 4¾ in.

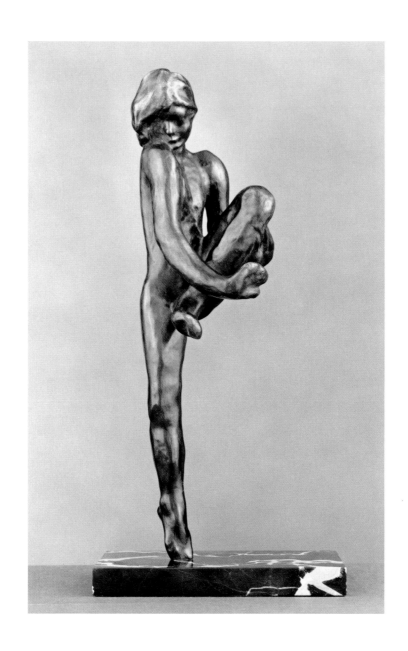

49. *Dance Movement D*
Ca. 1910–11, cast before 1952
Bronze, 13 x 7¾ x 5 in.

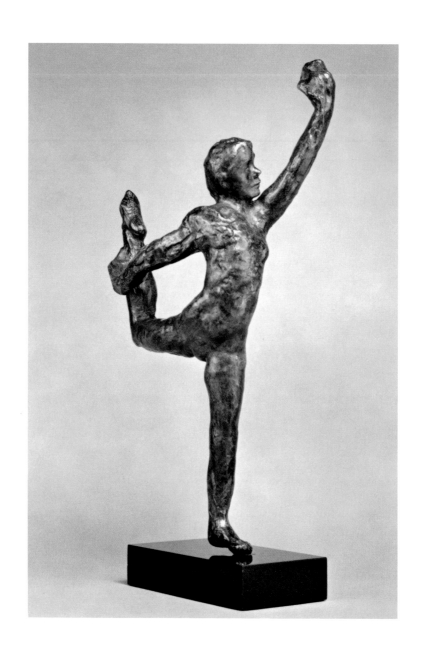

50. *Dance Movement E*
Ca. 1910–11, cast 1956
Bronze, 14 x 4½ x 8 in.

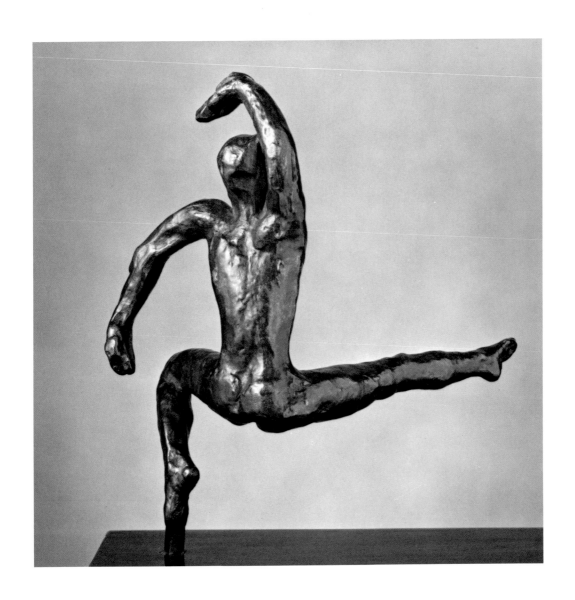

51. *Dance Movement F*
1911
Bronze, 11 x 10½ x 5½ in.

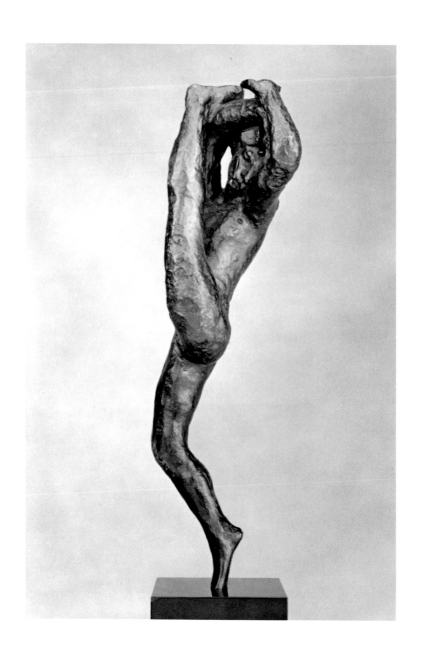

52. *Dance Movement G*
Ca. 1910–13, cast before 1952
Bronze, 13 x 4⅛ x 3⅝ in.

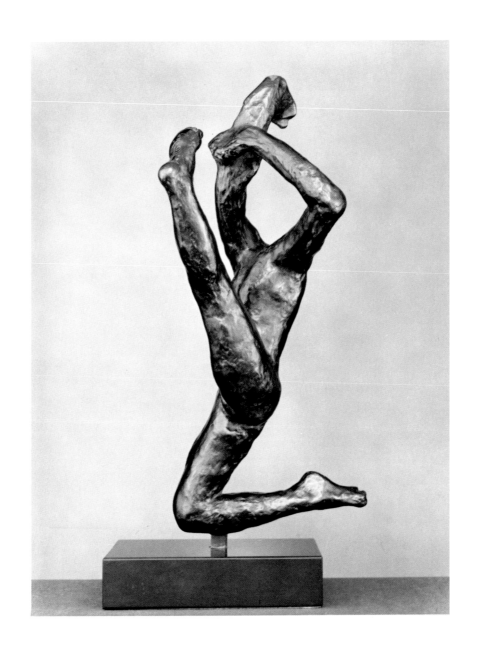

53. *Dance Movement H*
Ca. 1910, cast before 1952
Bronze, 11 x 5¼ x 5½ in.

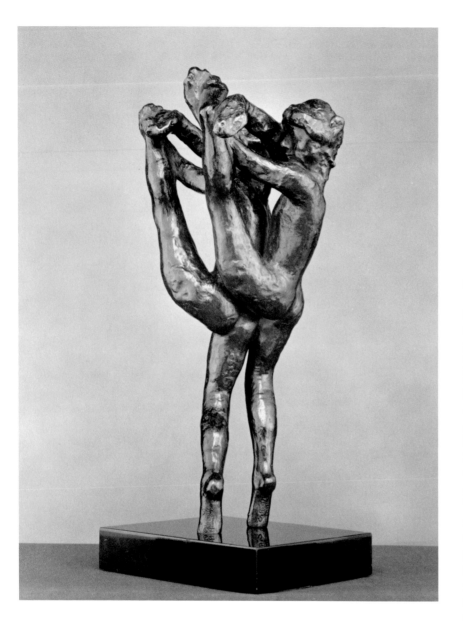

54. *Pas de Deux B*
Ca. 1910–11, cast 1965
Bronze, 13 x 7 x 5 in.

Pas de Deux

Rodin, following the tradition of Western sculpture since medieval times, sculpted couples together, bodies and limbs intertwined, generally expressing love, sympathy, anguish, or common fate. He was especially intrigued by combining figures or parts of figures originally conceived separately. In Rodin's experimentation with the *Dance Movements*, however, his couples were not intertwined, nor were parts conceived separately. As prefigured in *The Three Shades*, the *Pas de Deux* were composed of identical figures coupled to achieve new movement. For example, the figures in *Pas de Deux B* are identical to the figure in *Dance Movement B*, but placed one in front of the other; the figures in *Pas de Deux G* are identical to the figure in *Dance Movement G*, but juxtaposed with their backs touching and with one figure slightly elevated. Unlike photographers, Rodin was not at all seeking to represent frozen or serial movement; instead, he ingeniously sought to capture a choreography of motion—identical figures dance with each other.[17]

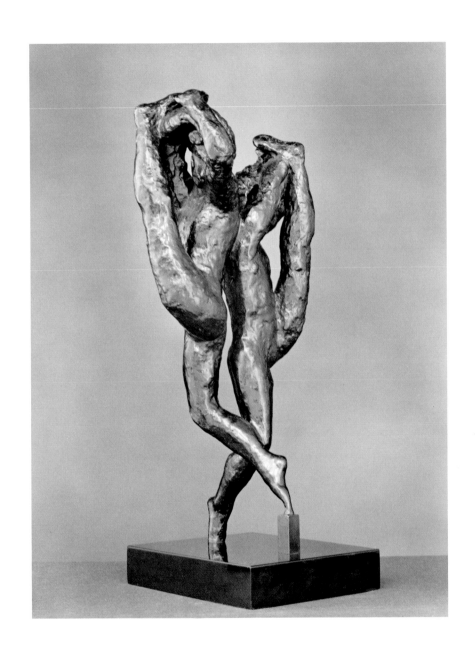

55. *Pas de Deux G*
Ca. 1910–13, cast 1967
Bronze, 13½ x 6½ x 6½ in.

125

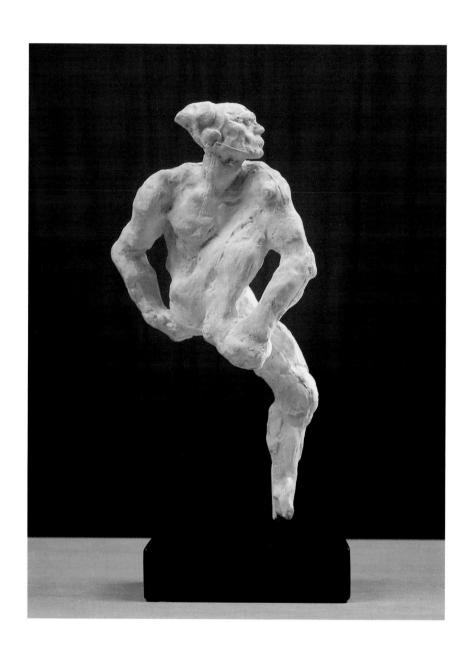

56. *Nijinsky*
1912
Plaster, 7½ x 3¾ x 3½ in.

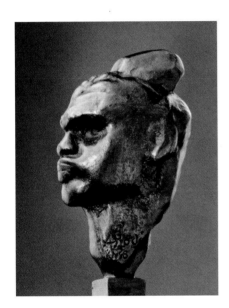

Nijinsky

Rodin's defense of Nijinsky led to a visit from Diaghilev, the Russian ballet impresario, and an arrangement for the great dancer to pose nude for the great sculptor. According to Romola Nijinsky's biography of her husband, the two artists communicated in their own media—Rodin by drawing, Nijinsky by gesturing. Every morning after practice the dancer motored to Meudon; the sittings were interrupted only by lunch. Diaghilev, who arrived early one afternoon, found Nijinsky asleep on a couch with Rodin asleep at his feet. Having heard rumors of Rodin's passions and perhaps concluding that the two had engaged in homosexual love, Diaghilev flew into a rage and prevented any further sittings. Romola Nijinsky concludes that the sculpture was never finished and that Diaghilev "undoubtedly robbed the world of a masterpiece."[18]

The *Nijinsky*, however, *is* a masterpiece. Rodin captured the dancer's legendary physical traits: the Oriental face, strong neck, muscular torso, powerful legs. The entire sculpture bursts with the animal potency of the rapacious faun that Nijinsky projected on stage. *Nijinsky*, of all the dancing figures, comes the closest to achieving Rodin's ideal of sculpture in movement. The *Head of Nijinsky*, like the *Nijinsky*, is compact and powerful, expressing a primitive purposefulness.[19] In these works, among the last he executed, Rodin hinted at a new, more abstract direction for modern sculpture.

57. *Head of Nijinsky*
1912, cast after 1967
Bronze, 2⅞ x 1¼ x 1½ in.

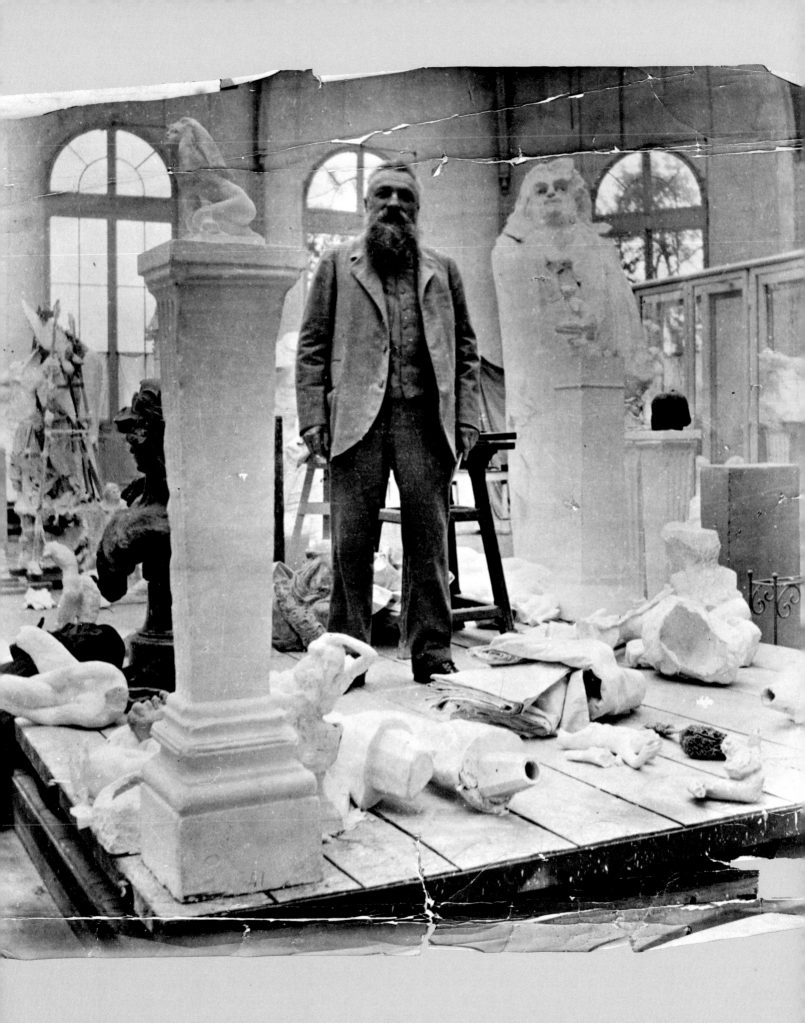

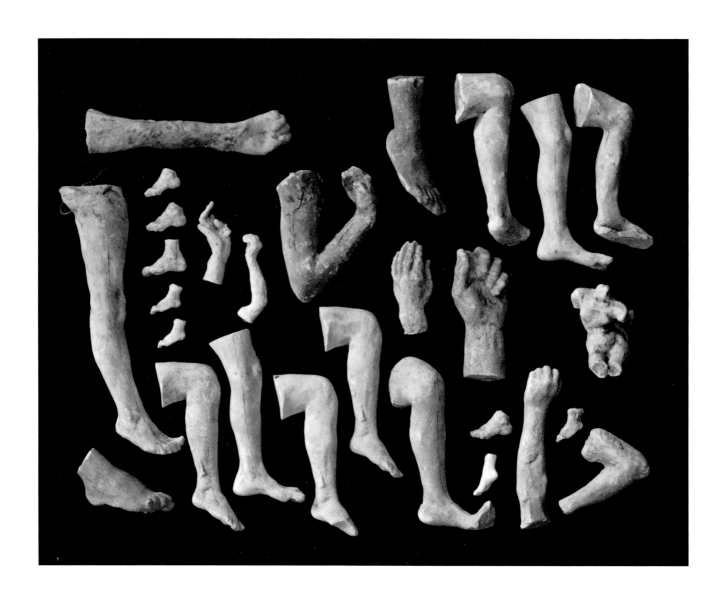

Fragments

Rodin was a pioneer in his promotion of the fragment as a complete, independent work of art. Rodin himself concentrated on hands and torsos, but arms, legs, and feet were also prominent among his partial figures. With the academic tradition still dominant, Rodin's fragments were first criticized as morbid, mutilated, ugly, and incomplete—perverse violations of established standards. Rodin was described as a sadist and a butcher. Some of his contemporaries, however, saw in the fragments a confirmation of his genius, and they celebrated Rodin for the significance of his innovation. Today critics and scholars generally concur that the fragments represent a critical breakthrough, a virtual reassessment of the meaning of art that opened the way for artists to concentrate on essential qualities and unique statements of expression and beauty. Perhaps this is Rodin's greatest legacy and claim to relevance in modern art.[1]

Fragments were not new to Rodin's contemporaries. Greek and Roman fragments, such as the *Belvedere Torso,* had been admired at least since the Renaissance and were cherished for their historical importance and antiquarian interest. Fragments were also familiar from early Christian art. Reliquaries, for example, were often crafted in the shape of whatever part of the saint's anatomy they were intended to contain, and medieval reliefs and manuscripts abounded with the hands of God and the Devil. Partial figures were frequent in European decorative architecture, and nineteenth-century European artists were curious about the partial figures and designs—in the form of artifacts and textiles—arriving from Africa, the Pacific, and Precolumbian America.

Ancient fragments occupied a critical position in the curriculum of nineteenth-century art schools. Students of the Ecole des Beaux-Arts studied and learned to model from them. But they viewed the fragment as incomplete, the result of accidental and unintended breakage, and actually in violation of the Greek ideal of the wholeness and beauty of the human form. Rodin himself was exposed to this neoclassical ambivalence between admiration and deficiency while a student at the Petite Ecole in the 1850s.

The first work of art that Rodin ever exhibited was a partial figure, *The Man with the Broken Nose.* One winter day, in the freezing temperature of his inadequately heated studio, the back of the head broke off. Nevertheless Rodin decided to cast the front portion and submit it to the Paris Salon of 1864. It was rejected by the jury, but Rodin declared later that it "determined all my future work."[2] The piece not only led Rodin to experiment with partial figures, but it also opened his eyes to the serendipitous artistic effects of accidents as well as of purposeful fragmentation.

Rodin continued to experiment with partial figures during the 1870s; his *Torso of the Walking Man,* for example, displays the influence of ancient fragments. It was not until his work on *The Gates of Hell,* in the 1880s, that Rodin became preoccupied with partial figures and fragments. His assistant, Victor Frisch, described Rodin's studio as crowded with "fragments of sculptures in work, casts of all sorts, heads, torsos, arms and legs" lying on "tables, benches, chairs, on window sills, on the floor." Rodin combined and recombined partial figures until he achieved the form he desired. Frisch recorded Rodin's method: "Again he had several plaster casts made. One was kept intact, the others were cut apart, and the sections numbered and catalogued, so that they might be drawn out of their cupboards to serve in other figures, perhaps years later. Thus dissected, limb from torso, they would be set, again and again, in new arrangements and further considerate groupings. Until at last the work had his full-hearted consent."[3]

Rodin's partial figures were not just spare parts to be joined together "when the God of the region, Auguste Rodin, signals the hour of resurrection with his

tremendous clarion," as the Comte Robert de Montesquiou wrote after a visit to the artist's studio.[4] For, more and more, Rodin began to conceive of partial figures and fragments as complete, independently beautiful works of art. In the drawers at his studio lay hundreds of fragments, without pedestals, fragments that were meant to be held and moved freely, thereby allowing the observer to see them from all positions and angles.

By 1889 Rodin was exhibiting partial figures, and by the 1890s he was modeling acrobatic partial figures influenced by the cancan dancers, such as *Iris, Messenger of the Gods* and *Flying Figure*. By the late 1890s his exhibition of the *Seated Woman* (*Cybelle*) and *Meditation Without Arms* had sounded a clear challenge to the academy's canons of aesthetics, particularly to the academic notion of wholeness and completeness. During the 1890s Rodin directed his assistant, Henri Lebossé, in the enlargement of fragments for sale, which certainly suggests that Rodin believed them to be complete, whole, and beautiful.[5] The retrospective exhibition presented in his pavilion during the Universal Exposition of 1900 contained the largest number of partial figures he had ever shown at one time. Of the naked, fragmented *Pierre de Wiessant*, which was displayed in the pavilion's portico, Rodin wrote in a private letter: "It is complete even if the exhibited *morceau* is without head and hands."[6] (The underlining is Rodin's.)

The partial figures at the Exposition Rodin, like nearly everything else the artist exhibited, generated controversy. Judith Cladel describes the criticism and suggests Rodin's defense of his partial figures:

> The master has exhibited his *morceaux* and they have evoked from his critics the rudest criticism. These critics have never wanted to comprehend that he has not delivered to them works that were properly decorative but were rather the unique beauty of métier which appear[s] here more thrilling than in his more finished sculptures. . . . Nothing veils or covers them, neither the interest of the subject, nor the expression of sentiment or feeling. All that is there is the quality of modelling, the raw result of work. In reality it is not Iris, The Earth, The Muse, but torsos which appear to be fragments of a destroyed movement: It is the sum of art, a certificate that the sculptor gives himself, the total of his efforts and researches concentrated in plastic formulas. Therefore, of what importance is it to him to achieve details or a seductive arrangement? Who contemplates these works must do it with the *esprit du savant* before a *morceau* of nature to be studied and not with the attitude of a dilettante looking for esthetic pleasure and the emotion of the subject that does not exist. Like an historian, Rodin names them his essays, and they are truly pages from the history of his art.
>
> The misunderstanding that they establish between the public and the artist is enormous. The crowds having lost the sense of the value of modelling, take Rodin for a mystifier, obstinately or perversely cutting off the limbs of his statues. I have heard a young sculptor announce with the serene conviction of a fool, "This year I exhibited the body of a woman à la Rodin. I squarely cut off the arms and legs."[7]

To the charge that his figures were not finished, Rodin himself once replied, "And the cathedrals, are they finished?"[8]

As Rodin grew older, he worked increasingly, almost exclusively, on partial figures, and he exhibited them along with his full figures at the salons. He was now at the height of his reputation, gaining for the fragment a proper place in the public's appreciation of art. As early as 1903 the poet Rilke understood that the part was the whole:

> The same completeness is conveyed in all the armless statues of Rodin; nothing necessary is lacking. One stands before them as before something whole. The feeling of incompleteness does not rise from the mere aspect of a thing, but from the assumption of a narrow-minded pedantry which says that arms are a necessary part of the body and that a body without arms cannot be perfect. . . . With regard to the painter, at least, came the understanding and the belief that an artistic whole need not necessarily coincide with the complete thing, that new values, proportions and balances may originate within the pictures. In the art of sculpture, also, it is left to the artist to make out of many

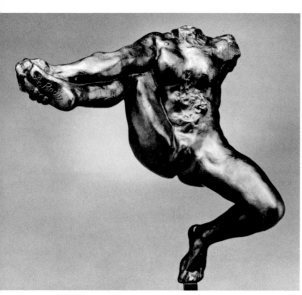

Iris, Messenger of the Gods, ca. 1890–91, cast 1969. Cat. no. 60

things one thing, and from the smallest part of a thing an entirety.[9]

The critic Roger Fry remarked in 1910, "Every part of the figure is instinct with the central idea, every detail of hand and foot is an epitome of the whole. . . ."[10]

Rodin was cautious about exhibiting his fragments, but as he endured the controversies surrounding his other works, he gradually dedicated his later years to promoting them. "The criteria which today make Rodin's partial figures acceptable as total entities—criteria which these same figures would help call into being—did not then exist in official art," writes Leo Steinberg.[11] Other artists and sculptors experimented with fragments, and scholars seek the antecedents to Rodin, but, as Albert Elsen asserts, "It was he who willed their status as complete works of art."[12] Rodin directly influenced a generation of younger artists, including Maillol, Matisse, Brancusi, Lehmbruck, Archipenko, Duchamp-Villon, Gaudier-Brzeska, and Lipchitz. If some latter-day artists and critics perceive Rodin as a reactionary figure of the nineteenth century, it is because they stand on his shoulders, pretending to fight the battle he has already won.

Rodin with the *Large Clenched Left Hand with Imploring Figure*, 1906. (Photo, B. Gerald Cantor Collections)

Torsos

Rodin's daring torsos, with heads or without heads, with limbs, partial limbs, or no limbs at all, were difficult for his public to accept. A sculpture of the human figure should be complete, believed the nineteenth-century artist and critic, and completeness presupposed an entire figure. Anything less was considered mutilation and evoked nightmarish images of violations of our corporeal integrity. Fred Wellington Ruckstull, a leader of the National Sculpture Society in the United States, as late as 1925 expressed this view in his popular text, *Great Works of Art:*

> But why any man should, today, *deliberately model* a human body and then *mutilate it* and then *hack it,* and exhibit it, except as a revelation of his sadistic soul, passes our comprehension. The first man . . . to do this was Rodin—who was regarded in Paris as a moral sot.[13]

Such denunciations were widespread, and Rodin's critics submitted his incomplete figures as evidence that Rodin was incapable of finishing a commission—a common suspicion during the *Balzac* project. Even some of Rodin's friends, who evidently subscribed to the view that completeness was coterminous with the full figure, tried to defend Rodin by explaining that the artist indeed planned to complete the figures. Rodin made no such apologies.

His omissions were purposeful and represented a "powerful shift . . . away from traditional ground."[14] Feet and arms, or heads, were never intended. Such reductions or economies arose from a different aesthetic—and new criteria for the measurement of that aesthetic. Rodin was attempting to edit form to its irreducible core to reveal the essence of motion, gesture, act, mood, or statement. Degas asked Rodin, "Why did you make your *Man That Walks* [*Walking Man*] without head or arms?" Rodin replied, "Have you ever seen a man walk on his head? As for the arms, I preferred to have him walk on his legs like ordinary mortals—like you and me."[15] Said Rodin of another partial figure, "Don't you see that I left it in that state inten-

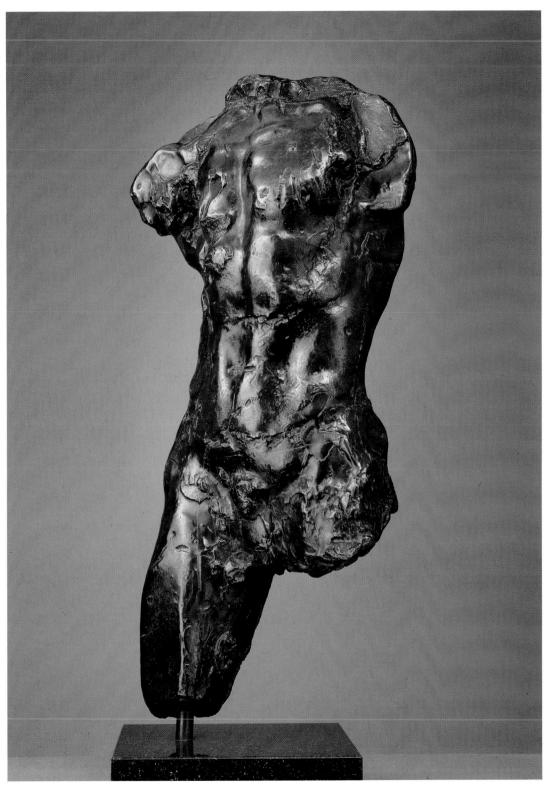

58. *Torso of the Walking Man*
Ca. 1877–78, cast 1979
Bronze, 21⅛ x 9¾ x 8½ in.

tionally? My figure represents *Meditation*. That's why it has neither arms to act nor legs to walk."[16] "Beauty is like God; a fragment of beauty, is beauty complete," he said on yet another occasion.[17] In the partial figure, according to Leo Steinberg, Rodin developed the modern "principle of dispensability," which "determines the limits of fragmentation."[18]

Thus, an entirely new standard of sufficiency, absolutely critical for modern art, was established. Could Brancusi have produced *Bird in Space* without the precedent of Rodin? Was Rodin a necessary precursor for the fragments of Matisse, Picasso's *Head of a Woman*, Henry Moore's *Reclining Figure*, Umberto Boccioni's *Unique Forms of Continuity in Space*, or Jacques Lipchitz's *Reclining Nude with Guitar?* Rodin's torsos, wrote Lipchitz in 1962, were "endowed with a sense of mystery . . . [and] surpassed anything done in his time, either in painting or sculpture."[19] "Twentieth-century paradigmatic figural sculptures . . . are inconceivable without the prior history of

the partial figure and its influence on imaginative conceptualizing," wrote Elsen.[20] The seminal figure behind the modern partial figure was Rodin.

The *Torso of the Walking Man*, presented as a scarred ancient ruin, is one of Rodin's earliest partial figures, completed shortly after his 1875 trip to Italy. Some controversy clouds the origins of this torso. It is thought to be a study for *Saint John the Baptist Preaching*, but its mutilated surface, in severe contrast to that of the highly polished *Saint John*, has raised the question of whether Rodin intended it to have an independent existence. Rodin's complex work method of revision and reassembly over an extended period of time adds to the confusion. Recent finds at Meudon, however, suggest that the *Torso* was a preliminary study. It was much later, in 1900, that Rodin added the legs from *Saint John the Baptist Preaching* to the torso to create the remarkable *Walking Man.*[21]

The *Torso of the Walking Man* may have been exhibited at the 1889 Monet/Rodin show. This torso was

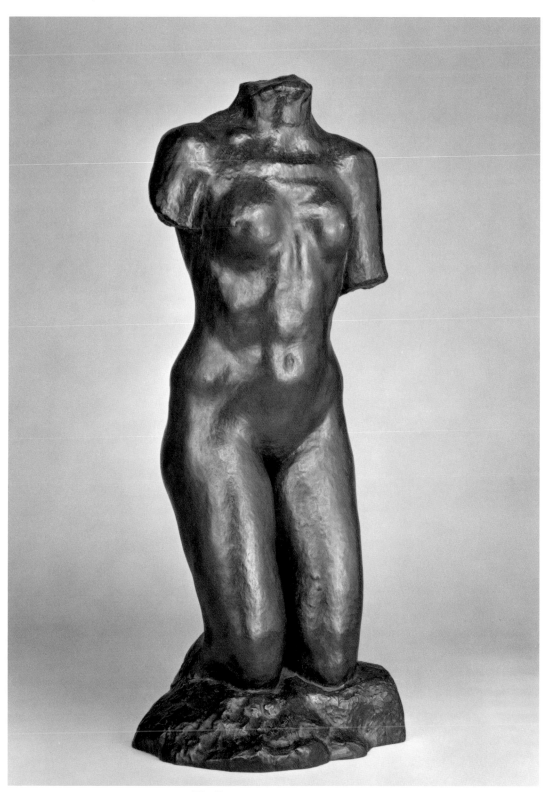

59. *The Prayer*
1909, cast 1980
Bronze, 49½ x 21⅝ x 19⅝ in.

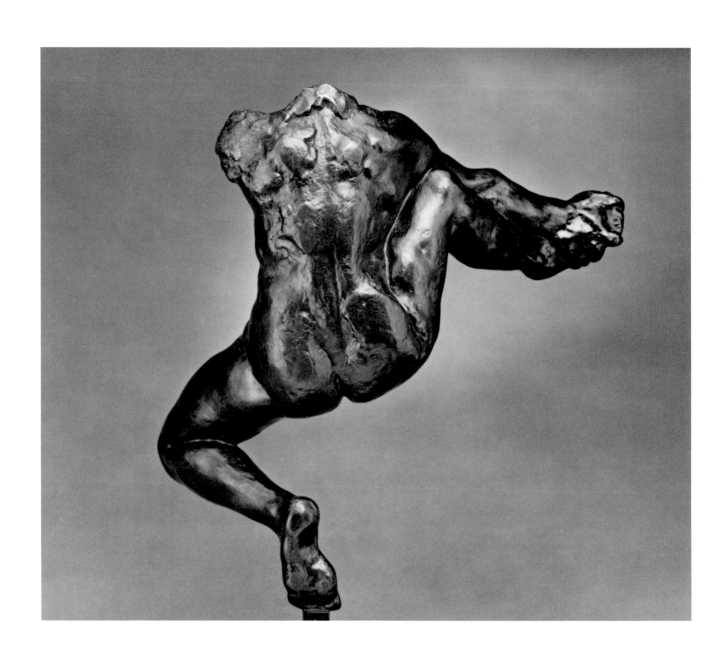

60. *Iris, Messenger of the Gods*
Ca. 1890–91, cast 1969
Bronze, 38 x 35½ x 17 in.

61. *Iris, Messenger of the Gods, with Head*
1890 (?), cast before 1981
Bronze, 6⅛ x 3⅝ x 2¾ in.

neglected, however, until Rodin's influence on partial figures was recognized in the mid-twentieth century. The B. Gerald Cantor bronze, an exquisite, detailed cast with rich patina, is the third in an edition made by the Coubertin Foundry from the model preserved in the Rodin collection at Meudon.

The Prayer, too, resembles works of antiquity. However, this armless, headless female torso, in contrast to the *Torso of the Walking Man*, is not marked by the dabs of clay and gashes used by Rodin to capture a sense of ruined antiquity. Instead, it is smooth and retains a fidelity to the Greek ideal. Georges Grappe, former curator of the Musée Rodin, believed that *The Prayer* derived from a study for *The Gates of Hell*, but, like *The Kiss*, was not considered suitable for inclusion.[22]

Iris, Messenger of the Gods, like *The Walking Man*, captures movement. This figure of a woman, headless and without a left arm, is unabashedly sexual and energetic and was inspired by Rodin's intense interest in dance.

The fragment is suspended by a pole, which holds it vertically even as its mass moves to the left. According to Grappe, a winged version of this figure was originally intended for the Victor Hugo monument as the personification of glory and was to hover above the great writer.[23] The monument, planned for the Panthéon in Paris, was never completed, but a similar *Iris* was exhibited at the Exposition Rodin of 1900.

Another version of the figure, titled *Iris, Messenger of the Gods, with Head*, is probably connected with a series of similar figures found in the Meudon Reserve in various states of dismemberment.[24] *Iris, Messenger of the Gods, with Head* has all limbs amputated and captures the compact energy of the torso.

The *Flying Figure* derives from an enlargement and modification of the female figure of *Avarice and Lust* that can be found in the bottom-right panel of *The Gates of Hell*. In the isolation of the torso and removal of the head and portions of an arm and legs, the *Flying*

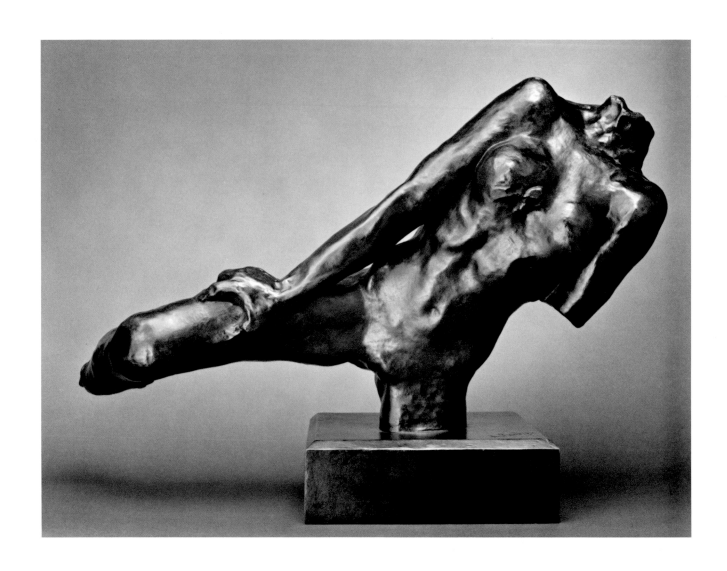

62. *Flying Figure*
Ca. 1890–91, cast 1975
Bronze, 20½ x 29½ x 12 in.

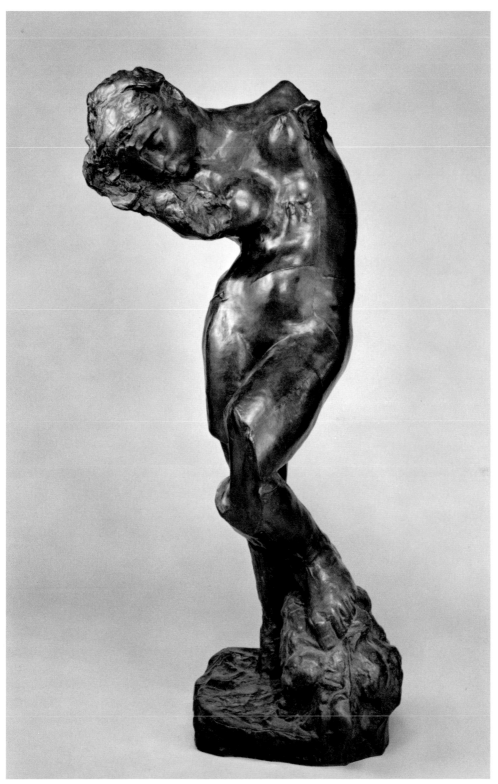

63. *Meditation Without Arms*
1896–97, cast 1983
Bronze, 57½ x 30 x 20 in.

In this later stage of the *Monument to Victor Hugo,* Rodin amputated the arms and portions of the legs of *Meditation.* When exhibited at the Salon de la Société Nationale in 1897, it was called by one critic "a dislocated and incoherent *maquette* on which it would be premature to pronounce a judgment." (Photo, Musée Rodin)

Figure resembles *Iris, Messenger of the Gods.* The *Flying Figure,* however, attached to its base by the stump of its thigh, ascends at a forty-five-degree angle into space. "Rodin has not so much modeled a body in motion," commented Steinberg, as "clothed a motion in a body."[25] The rear of the figure has been hacked by Rodin, down the entire back to the buttocks. This mutilation recalls *The Man with the Broken Nose,* except that this contusion was no accident but staged by Rodin, who was purposefully breaking with convention.

Meditation Without Arms was originally conceived as a full figure for *The Gates of Hell;* it appears in the tympanum. Rodin removed it in 1885, then enlarged and modified it as an independent sculpture. He revived it again in 1889 in connection with the *Monument to Victor Hugo.* As part of the third project for the monument, *Meditation* was called *The Inner Voice,* after a collection of lyrical poems by Hugo called *Les Voix intérieures.* In the final stage of the Hugo monument the

Meditation figure suffered its most severe transformation, when Rodin amputated both arms and a portion of the right knee.[26] The classical curves and truncated form enhance her introspective mood. "Never," wrote Rilke of *Meditation,*

> was a human body assembled to such an extent about its inner self. . . . The neck, bent sideways on the lowered body, rises and stretches and holds the listening head over the distant roar of life; this is so impressively and strongly conceived that one does not remember a more gripping gesture or one of deeper meaning. It is striking that the arms are lacking. Rodin must have considered these arms as too facile a solution of his task, as something that did not belong to that body which desired to be enwrapped within itself.[27]

In 1899 Rodin obtained the commission for a monument to Puvis de Chavannes, the painter of the Panthéon frescoes and the artist Rodin most admired.[28] The composition called for a dignified bust of the painter, guarded by a funerary figure. Camille Mauclair, considered one of the best critics of his time, described

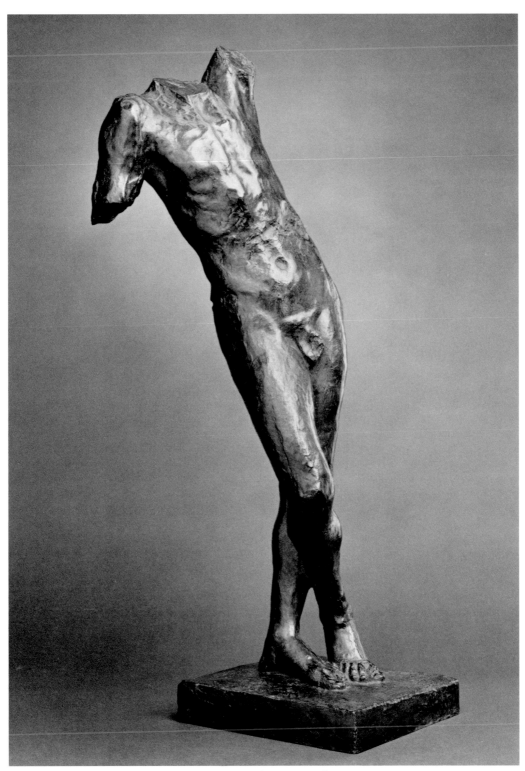

64. *Spirit of Eternal Repose Without
 Head and Arms*
1899, cast 1980
Bronze, 33¼ x 15½ x 13¼ in.

The proposed *Monument to Puvis de Chavannes*, 1899–ca. 1907, as depicted in this photograph, closely resembles the one described by Camille Mauclair. (Photo, Musée Rodin)

Rodin's plans for the monument:

> . . . Instead of making the customary statue, he considered the purely Greek quality of Puvis' genius and chose to pay homage to him in a form reproduced from the antique. The bust of the great painter is placed on a plain table, as the ancients placed those of their dead upon little domestic altars. A fine tree loaded with fruit bends over and shades the head. Leaning on the table behind the bust is a beautiful naked youth, who sits dreaming in a well-chosen supple attitude. . . .[29]

The fragmented *Spirit of Eternal Repose Without Head and Arms* is a variation of the nude described by Mauclair. The figure is firmly based in the classical Greek tradition to which both Puvis de Chavannes and Rodin were committed. The figure's crossed legs symbolize sleep and death, yet its rich body lines and supple flesh are sensuous, and in this respect it is an Apollo prototype.[30] A full-length plaster of the *Spirit of Eternal Repose* was exhibited at the Exposition Rodin of 1900 and was described as "one of the most recent works, of an intense melancholy, of a penetrating and funereal grace."[31] This armless and headless torso of a male, with its resemblance to ancient fragments, is a dignified and proper tribute.

Hands

Rodin was preoccupied with hands, for they are the creative, shaping force between the world of nature and the world of artistic vision. Hands in Rodin's oeuvre are living, full of expression, power, emotion. The poet Rilke likened Rodin's hands to the stirring force of a delta, and the Symbolist writer Gustav Kahn declared that Rodin was "the sculptor of hands." Henri Bergson, the philosopher of *élan vital,* saw in Rodin's sculptures of hands the "genius of Rodin himself," as well as the spontaneous, vital source of his life: "He that lives *in the intention,* lives free, lives creating, lives like a very god."[32]

The mastery of sculpting hands did not come easily to Rodin, however. Apparently he first worked intensely on hands in the 1850s as a young student at the Petite Ecole, where he was taught to model from parts of figures. Still later, without commissions or sales, he felt uncertain and lacked encouragement. "I went to the Salon and admired the works of Perraud and other sculptors," recalled Rodin,

and thought, as ever, that they were great masters. . . . In looking at the hands they made, I thought them so fine that I never should be able to equal them. I was all this time working from nature, but could not make my hands as good as theirs, and I could not understand why. But when I got my hands all right from life, I then saw that theirs were not well made, nor were they true. I know that those sculptors worked from plaster casts taken from nature. Then I knew nothing about casting from nature; I only thought of copying my model. I don't believe those sculptors knew what was good modeling and what was not, or could get out of nature all there was in it.[33]

By trial and error, then, by hard work, and by developing his technique on his own, he mastered his craft and gained a supreme confidence. With his major commissions, particularly *The Gates of Hell* and *The Burghers of Calais,* Rodin had the opportunity to explore the manifold expressions of hands in all conceivable attitudes and combinations. Rilke wrote in 1903:

There are among the works of Rodin hands, single, small hands which, with-

out belonging to a body, are alive. Hands that rise, irritated and in wrath; hands whose five bristling fingers seem to bark like the five jaws of a dog of Hell. Hands that walk, sleeping hands, and hands that are awakening; criminal hands, tainted with hereditary disease; and hands that are tired and will do no more, and have lain down in some corner like sick animals that know no one can help them.[34]

Rodin's interest in hands may have been influenced by Eadweard Muybridge's 1887 publication of *Animal Locomotion*, which reproduced dramatic photographs of hands, and by a drawing of a particularly expressive hand by Victor Hugo entitled *The Dream*.[35] Rodin was probably familiar with these works, which could have taught him what he knew intuitively: that hands express character, evoke symbols and meanings, and could be presented as independent works of art.

It was precisely because he understood the power of hands that he also knew how best to use them or, for that matter, not to use them. The hands of *Balzac* are covered by a gown because they could have detracted from the commanding presence of the body culminating in the massive, expressive head. Hands are prominent in *The Burghers of Calais* because they help to capture the agony of the complex psychological moment. The hands of *Eve* are soft and sensuous; the hands of *Saint John the Baptist Preaching* are ascetic. Pignatelli, Rodin's model, told Henri Matisse how Rodin would walk around a figure, experimenting with a hand on a peg, until he found the most effective way of attaching it to the body.[36]

The theme of hands expressing creation is exemplified in the *Hand of God*. This is the hand of the creator, the builder, and an analogy with the creative hand of the artist is intended. "What is modeling?" Rodin asked. "When God created the world, it is of modeling He must have thought first of all."[37] According to studio assistant Victor Frisch, Rodin, recognizing his presumptuousness in comparing the artist to God, "allowed none save his collaborators and closest friends to see it."[38]

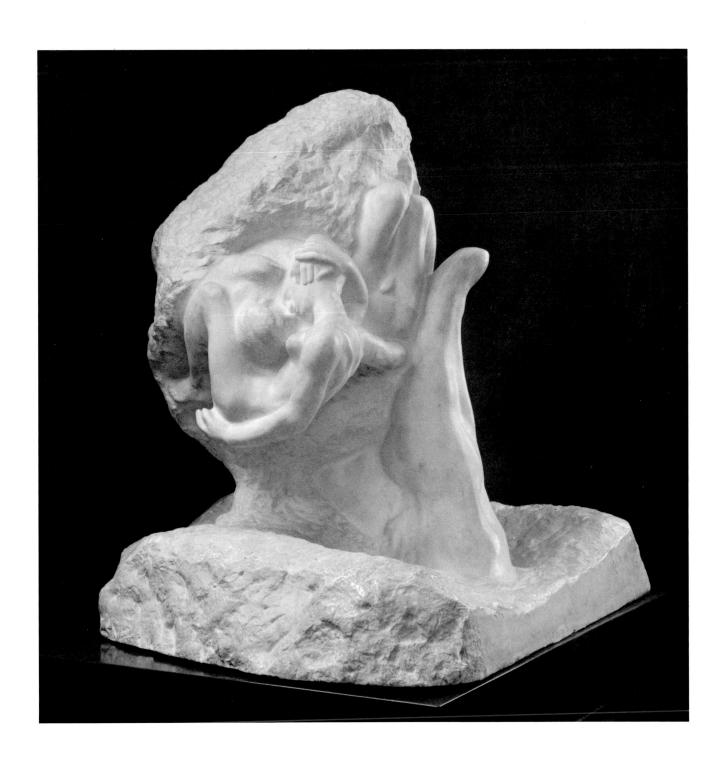

65. *Hand of God*
1898
Plaster, 28¾ x 25 x 26 in.

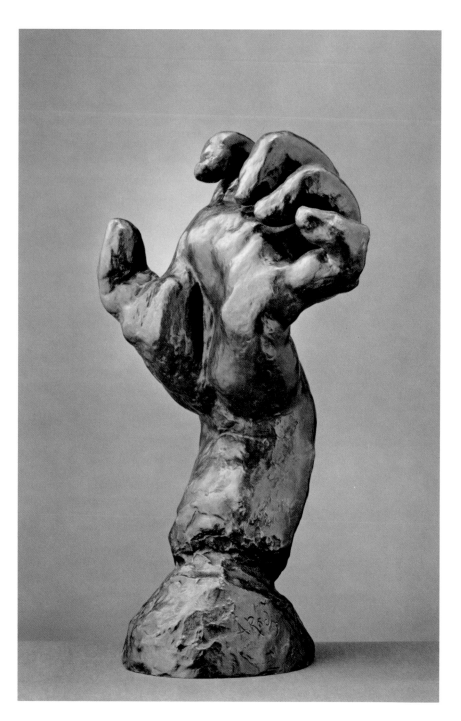

66. *Large Clenched Left Hand*
Ca. 1885, cast 1974
Bronze, 18¼ x 10⅜ x 7⅝ in.

Inside the *Hand of God* is a mass of primeval matter, resembling quarried stone and recalling the "unfinished" works of Michelangelo. From the mass emerges a couple embracing, perhaps Adam and Eve. Their destiny can be that of the bliss of *The Kiss* or the misery of *The Gates of Hell*. The *Hand of God* was Rodin's first and most ambitious enlargement of a study of a hand, and it may have derived from the right hand for Pierre de Wiessant of *The Burghers of Calais*.[39] The large plaster *Hand of God* on exhibit here was given to B. Gerald Cantor by the Musée Rodin in recognition of his efforts to encourage the appreciation of Rodin.

The *Large Clenched Left Hand* gropes upward from a bent wrist, with fingers twisted in agony, pain, or anger. It, like the *Hand of God,* may have been derived from a study of a hand for *The Burghers of Calais*. Its distended form exposes a terrible tension; not surprisingly, it has been photographed and reproduced in medical textbooks as an example of deformity.[40]

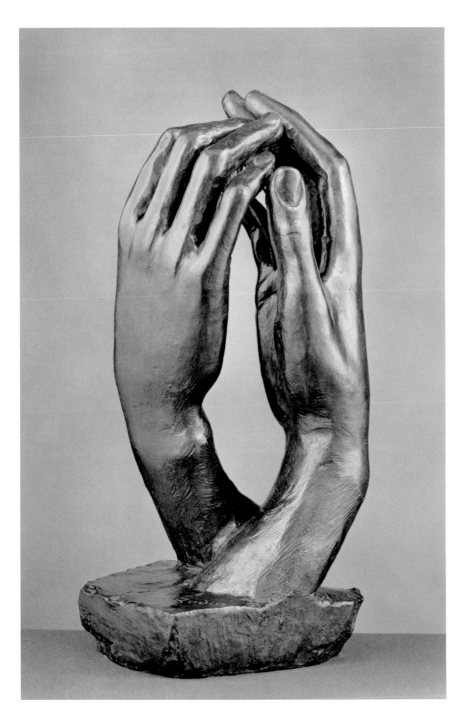

67. *The Cathedral*
1908, cast 1955
Bronze, 25¼ x 12¾ x 13½ in.

The Cathedral and Study for the Secret
are similar in composition and mys-
tical effect. In each, two hands extend
outstretched fingers upward, joining at
the tips. Both are simple symbols: the
hands in prayer form a cathedral, while
the hands held tight grasp a secret.[41]
Although each work was made before
it was titled, it has been suggested that
The Cathedral grew out of Rodin's
intense interest in Gothic architecture,
which culminated in the publication of
his *Cathedrals of France,* and that the
Study for the Secret derived from a
probable interest in the images of a
Renaissance book of emblems.[42] The
pair of hands in each composition are
formed not by two corresponding hands
but by a replication of right hands.
Thus, notes Leo Steinberg, these
sculptures are "forever caught in mar-
veling reciprocal self-contemplation."[43]

Three weeks before Rodin died in
November 1917, one of his assistants,
Paul Cruet, made a life cast of Rodin's
right hand. Into the hand was placed
the small torso of a female, a fragment
most likely connected with *The Gates*

of Hell. The *Hand of Rodin with Torso* recalls both Rodin's *Hand of God* and *Hand of the Devil Holding Woman*. Elsen suggests that the female torso may have been placed in his hand not only as a final vindication of the old charge of casting from life but also as an eloquent statement in support of the fragment as a complete work of beauty.[44] Judith Cladel, in commenting on the circumstances of the casting, says, "Cruet excelled, but unfortunately . . . the feeling of life and thinking were missing."[45] Rodin's modeling was indeed truer than life, and perhaps no better tribute can be paid to him than the observation that his sculpture always possessed "life and thinking."

68. *Study for the Secret*
Ca. 1910, cast 1956
Bronze, 4¾ x 2¼ x 2 in.

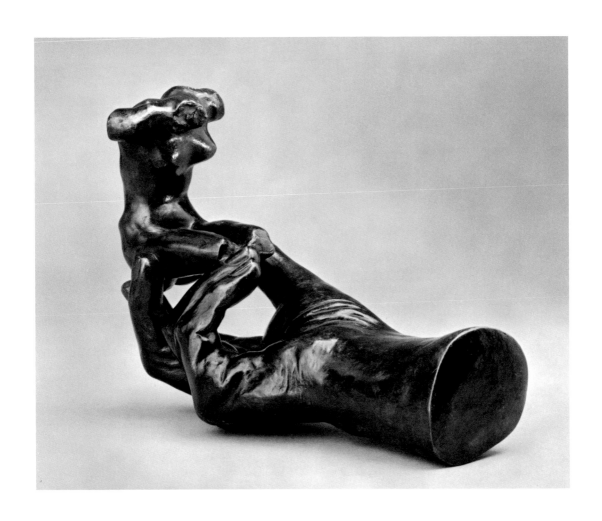

69. *Hand of Rodin with Torso*
1917, cast 1971
Bronze, 8⅞ x 7¹⁄₁₆ x 3¾ in.

Notes

Introduction

1. There is a rich and extensive literature on Rodin. Useful biographical information is contained in Frederick Lawton, *The Life and Work of Auguste Rodin* (1907); Anthony M. Ludovici, *Personal Reminiscences of Auguste Rodin* (1926); Judith Cladel, *Rodin* (1937); Victor Frisch and Joseph T. Shipley, *Auguste Rodin: A Biography* (1939); Auguste Rodin, *On Art and Artists* (1957); Albert E. Elsen, *Rodin* (1963); Robert Descharnes and Jean-François Chabrun, *Auguste Rodin* (1967); William Harlan Hale, *The World of Rodin 1840–1917* (1969); John Tancock, *The Sculpture of Auguste Rodin: The Collection of the Rodin Museum, Philadelphia* (1976); Ruth Butler (ed.), *Rodin in Perspective* (1980).

2. Rodin quoted in Ionel Jianou, *Rodin* (1970), p. 41; for discussion of the influence of Michelangelo on Rodin's work, see Albert Alhadeff, "Michelangelo and the Early Rodin," *Art Bulletin* (December 1963), pp. 363–67.

3. In 1984 the Musée Rodin held a retrospective exhibition of her works; see the exhibition catalogue, Monique Laurent and Bruno Gaudichon, *Camille Claudel (1864–1943)* (1984); and Joseph Fitchett, "France Celebrates a Forgotten Sculptor, a Buried Life," *International Herald Tribune* (23 March 1984), pp. 7–8.

4. Rodin, *On Art and Artists*; Cladel, *Rodin*; Rainer Maria Rilke, *Rodin* (1946).

5. Albert E. Elsen, *In Rodin's Studio: A Photographic Record of Sculpture in the Making* (1980); Kirk T. Varnedoe, "Rodin and Photography," in Albert E. Elsen (ed.), *Rodin Rediscovered* (1981).

6. Albert E. Elsen, "Rodin's 'Perfect Collaborator,' Henri Lebossé," in Elsen (ed.), *Rodin Rediscovered*; Albert E. Elsen, "The Sculpture of Auguste Rodin: Reductions and Enlargements," in Joan Vita Miller (ed.), *The Sculpture of Auguste Rodin: Reductions and Enlargements* (1983); Monique Laurent, "Observations on Rodin and His Founders," in Elsen (ed.), *Rodin Rediscovered*, pp. 285–93.

7. The Musée Rodin was given the right to cast Rodin's works posthumously. Until 1982 the editions of the Musée Rodin were limited to twelve casts, numbered 1/12–12/12, which bore the mark of the foundry, the copyright of the Musée, and, obligatory only after 1968, the date of the casting. Since 1982 the first eight casts, numbered 1/8–8/8, have been available to the public at large and may be sold freely; the last four casts, numbered I/IV–IV/IV, have been reserved for French and foreign cultural institutions. For these rules, see the statement of the Musée Rodin, "Conditions of the Edition of Bronze Works of Art by the Musée Rodin, Dated 30 April 1982." In the United States, the 1974 *Statement of Standards on the Reproduction of Sculptures*, developed by the College Art Association and subscribed to by the Art Dealer's Association of America, the Association of Art Museum Directors, and Artists Equity, established standards of authenticity: posthumous casts by the Musée Rodin are considered authentic, legal, and ethical; unauthorized casts are considered counterfeit. For a full discussion of these issues, including the question of originality, see also Sylvia Hochfield, "Flagrant Abuses, Pernicious Practices and Counterfeit Sculpture Are Widespread," originally published in *Art News* (November 1974), pp. 21–29. The Hochfield essay, together with several other interesting case studies, are reproduced, along with commentary, in chapter 6 of John Henry Merryman and Albert E. Elsen, *Law, Ethics, and the Visual Arts*, vol. 2 (1979).

8. Rodin quoted in Descharnes and Chabrun, *Auguste Rodin*, p. 265.

9. Ionel Jianou and Cécile Goldscheider, *Rodin* (1967), p. 6.

10. Jacques de Caso and Patricia B. Sanders, *Rodin's Sculpture: A Critical Study of the Spreckels Collection* (1977); Jiří Frel and Harvey West, *Rodin: The Maryhill Collection* (1976); Clare Vincent, "Rodin at The Metropolitan Museum of Art: A History of the Collection," *The Metropolitan Museum of Art Bulletin* (Spring 1981); Charles Newton Smiley, "Rodin in the Metropolitan Museum," *Art and Archaeology* (January–June 1916), pp. 107–14. Rodin's sculpture was collected by American museums as early as 1893: the Art Institute of Chicago acquired the plaster *Jean d'Aire*, and the Metropolitan Museum purchased the *Bust of Saint John the Baptist*. See Tancock, *Sculpture of Auguste Rodin*, p. 11.

11. Tancock, *Sculpture of Auguste Rodin*, pp. 11–14; Léonce Bénédite, *Rodin* (1926), p. 60; Jianou and Goldscheider, *Rodin*, p. 6; Soichi Tominaga, *Catalogue du Musée National d'Art Occidental Tokyo* (1961).

12. Fry quoted in Leo Steinberg, "Rodin," in *Other Criteria: Confrontations with Twentieth-Century Art* (1972), p. 323; Clark quoted in Hale, *World of Rodin*, p. 173; Steinberg, *Other Criteria*, p. 325.

13. Peter Selz, "Postscript: Rodin and America," in Elsen, *Rodin*, pp. 191–202; Steinberg, *Other Criteria*, p. 324; editorial, "Rodin in Paris and Meudon," *Burlington Magazine* (November 1967), pp. 605–606.

14. Selz, "Postscript: Rodin and America," in Elsen, *Rodin*; Steinberg, *Other Criteria*, p. 328.

15. Steinberg, *Other Criteria*, p. 328.

16. Ibid., pp. 325, 330.

17. Tancock, *Sculpture of Auguste Rodin*, p. 18.

18. Joan Vita Miller, "The B. G. Cantor Sculpture Center," in Joan Vita Miller and Gary Marotta (eds.), *Auguste Rodin: The B. G. Cantor Sculpture Center* (1981).

19. Cécile Goldscheider, "Introduction," in Kenneth Donahue (ed.), *Homage to Rodin: Collection of B. Gerald Cantor* (1967), p. 9.

20. Peter Fusco, "The Sculpture of Rodin," *Museum Magazine* (July/August 1981), p. 32; Robin Duthy, "Rodin Redeemed," *Connoisseur* (March 1985), pp. 72–76.

21. Fusco, "Sculpture of Rodin," p. 34; Albert E. Elsen, "A Major Gift of Rodin Sculpture," *Art News* (April 1974), p. 28–34.

22. For another perspective on Rodin's revival, see John Russell, "Rodin's 'Gates': Hell Was His Dish," *New York Times* (20 June 1982); in response to Russell, see letters by Varnedoe, Elsen, and Marotta, "In Defense of Rodin's 'Gates of Hell,'" *New York Times* (18 July 1982), p. 26.

The Gates of Hell

1. Albert E. Elsen, *The Gates of Hell by Auguste Rodin* (1985), p. 3.

2. Ibid.

3. Rodin speaking to Bartlett as quoted in Truman H. Bartlett, "Auguste Rodin, Sculptor," reprinted in Albert E. Elsen (ed.), *Auguste Rodin: Readings on His Life and Work* (1965), p. 69: "I had no idea of interpreting Dante, though I was glad to accept the *Inferno* as a starting point, because I wished to do something in small, nude figures. I had been accused of using casts from nature in the execution of my work, and I made the 'St. John' to refute this, but it only partially succeeded. To prove completely that I could model from life as well as other sculptors, I determined, simple as I was, to make the sculpture on the door of figures smaller than life. . . ."

4. Rodin quoted in Bartlett, "Auguste Rodin, Sculptor," in Elsen (ed.), *Auguste Rodin: Readings*, p. 69.

5. Excerpts from the Ballu reports cited in Elsen, *Gates of Hell*, pp. 66, 61; Descharnes and Chabrun, *Auguste Rodin*, p. 82.

6. Camille Mauclair, *Auguste Rodin: The Man—His Ideas—His Works* (1905), p. 22.

7. Elsen, *Gates of Hell*, p. 144.

8. Ibid., p. 147.

9. Anatole France quoted in Sommerville Story, *Rodin* (1939), p. 25.

10. Dante, *The Inferno*, Canto XVI. It has been suggested that *The Three Shades* is the embodiment of Dante's warning, "All hope abandon ye who enter in." See de Caso and Sanders, *Rodin's Sculpture: The Spreckels Collection*, p. 139, and Bartlett, "Auguste Rodin, Sculptor," in Elsen (ed.), *Auguste Rodin: Readings*, p. 70.

11. Tancock, *Sculpture of Auguste Rodin*, p. 129.

12. For further discussion of the history of *The Three Shades* and its derivation from *Adam*, see ibid., pp. 129–35, and Elsen, *In Rodin's Studio*, p. 168.

13. Hale, *World of Rodin*, p. 89.

14. Dante, *The Purgatorio*, Cantos X and XI. For further discussion of Dantesque associations of the *Fallen Caryatid*, see de Caso and Sanders, *Rodin's Sculpture: The Spreckels Collection*, p. 156, n. 4.

15. Gustave Geffroy quoted in Daniel Rosenfeld, "Rodin's Carved Sculpture," in Elsen (ed.), *Rodin Rediscovered*, p. 89; Rilke, *Rodin*, p. 35. For further interpretation of the *Fallen Caryatid*, see Rosalyn Frankel Jamison, "Rodin's Humanization of the Muse," in Elsen (ed.), *Rodin Rediscovered*, pp. 107, 114.

16. De Caso and Sanders, *Rodin's Sculpture: The Spreckels Collection*, p. 155.

17. Bartlett, "Auguste Rodin, Sculptor," in Elsen (ed.), *Auguste Rodin: Readings*, p. 79.

18. Rosenfeld, "Rodin's Carved Sculpture," in Elsen (ed.), *Rodin Rediscovered*, p. 88.

19. Villani quoted in Story, *Rodin*, p. 19.

20. Dante, *Inferno*, Canto XXXIII, cited in Story, *Rodin*, p. 19.

21. Elsen, *Gates of Hell*, p. 28. The majority of the drawings depict Ugolino seated, a few show him standing, and only two drawings have Ugolino down on his hands and knees.

22. Claudie Judrin, "Rodin's Drawings of Ugolino," in Elsen (ed.), *Rodin Rediscovered*, p. 197. According to Judrin, this drawing was published in the *French Magazine* of April 1899.

23. A possible influence on Rodin's vertical composition was Jean-Baptiste Carpeaux's *Ugolino and His Starving Sons*, of which Rodin owned a preliminary bronze model. Judrin, "Rodin's Drawings," in Elsen (ed.), *Rodin Rediscovered*, p. 191.

24. Steinberg, *Other Criteria*, pp. 339–41.

25. Tancock, *Sculpture of Auguste Rodin*, p. 158; see de Caso and Sanders, *Rodin's Sculpture: The Spreckels Collection*, p. 160, for further discussion of the *Head of Sorrow*.

26. De Caso and Sanders, *Rodin's Sculpture: The Spreckels Collection*, p. 165. Other titles given to this couple—*La Sphinge, Dream, Love that Passes, Chimera*, and *Evocation*—also suggest the uncertainty of love and the incomprehensibility of women. Elusive female figures appear later, in Rodin's 1896 works entitled *The Hero* and *The Poet and Love*. The 1890s were turbulent years for Rodin: the Balzac affair, a deteriorating relationship with Camille Claudel, and failing health all depleted the artist. Tancock suggests that these fleeting female figures are symbolic of Rodin's emotional turmoil. See Tancock, *Sculpture of Auguste Rodin*, pp. 304–306.

27. For a detailed history of this work, see Athena Tacha [Spear], "The Prodigal Son: Some New Aspects of Rodin's Sculpture," *Allen Memorial Art Museum Bulletin* (Fall 1964), pp. 23–39.

28. Rodin, *On Art and Artists*, p. 48.

29. Lawton, *Life and Work of Auguste Rodin*, p. 110.

30. Rilke, *Rodin*, p. 32.

31. Elsen, *In Rodin's Studio*, p. 167.

32. The *Falling Man*, with its muscular, expressive back, was a figure of great inspiration for Rodin. With slight modifications, the figure is used in numerous compositions, including *Man with a Serpent, Two Struggling Figures*, and *Torso of the Falling Man*. In a fragmented form, it reappears on the *Gates* in the lower-right panel, clutching a woman and forming the couple known as *Avarice and Lust*, and again, clinging to the underside of the lintel to the left of *The Thinker*. See Tancock, *Sculpture of Auguste Rodin*, pp. 163–67, and Elsen, *Rodin*, p. 62.

33. Armand Sylvester writing for *L'Indépendance Belge*, quoted by Bartlett, "Auguste Rodin, Sculptor," in Elsen (ed.), *Auguste Rodin: Readings*, p. 63.

34. Tancock, *Sculpture of Auguste Rodin*, p. 163. Known by many titles—*The Kiss, The Rape, Carnal Love*, and *The Cat*—the *I Am Beautiful* composition probably derives from a vase designed by Rodin while working at the Manufacture de Sèvres; see Roger Marx, *Auguste Rodin: Céramiste* (1907), pl. VI.

35. Frel and West, *Rodin: The Maryhill Collection*, p. 26.

36. Tancock discusses a group of despairing figures produced in the mid-1880s when Rodin worked intensively on the *Gates*; included are *Andromède, Danaïd*, and its male counterpart, *Despairing Man*. See Tancock, *Sculpture of Auguste Rodin*, p. 238, and Rosenfeld, "Rodin's Carved Sculpture," in Elsen (ed.), *Rodin Rediscovered*, pp. 94–96.

37. Rilke, *Rodin*, p. 34.

38. Frisch and Shipley, *Auguste Rodin: A Biography*, p. 426.

39. Current research has produced a series of photographs by Druet that show *Despair* masked by a blanket in various states of concealment. Elsen proposes that these photographs were inspired by Rodin's drawings for Baudelaire's *Les Fleurs du mal*, in which figures are sometimes seen in caves. Rodin often used photographs of his works to assist in finalizing composition and placement of his sculpture. See Elsen, *In Rodin's Studio*, pp. 24–25, 178, and pls. 93, 94; Kirk T. Varnedoe, "Rodin and Photography," in Elsen (ed.), *Rodin Rediscovered*, pp. 203–47.

40. Elsen, *In Rodin's Studio*, p. 178.

41. See Marx, *Auguste Rodin: Céramiste*, for reproductions of these works. The presence of mothers, children, and loving couples suggests both Dante's Limbo and Circle of Lovers as inspirations for this pilaster. See Elsen, *Gates of Hell*, p. 216.

42. For discussion of these innovations, see Elsen, *Gates of Hell*, p. 110.

43. Ibid.

44. For an analysis of this problem, see Tancock, *Sculpture of Auguste Rodin*, pp. 228–30.

45. Elsen, *Gates of Hell*, p. 216.

46. Athena Tacha Spear, *Rodin Sculpture in the Cleveland Museum of Art* (1967), pp. 62–63; see also Tancock, *Sculpture of Auguste Rodin*, p. 228–30.

47. Spear, *Rodin Sculpture in Cleveland*, pp. 63–64; Tancock, *Sculpture of Auguste Rodin*, p. 230, n. 4.

48. Albert E. Elsen, *Rodin's Gates of Hell* (1960), p. 68; Albert Alhadeff, "Rodin: A Self-Portrait in *The Gates of Hell*," *Art Bulletin* (September, December 1966), pp. 393–95; Elsen, *Gates of Hell*, p. 221.

49. Rodin in a letter to the critic Marcel Adam, published in *Gil Blas* on July 7, 1904, as quoted in Alhadeff, "Rodin: A Self-Portrait," p. 394.

The Burghers of Calais

1. Jean Froissart, *Chronicles* (1968), pp. 106–109.

2. Rodin in conversation with Paul Gsell, quoted in the April 1914 issue of *L'Art et Les Artistes*, in Mary Jo McNamara and Albert E. Elsen, *Rodin's Burghers of Calais* (1977), p. 79.

3. This historical account is based on McNamara and Elsen, *Rodin's Burghers of Calais* (1977), pp. 7–9.

4. Froissart, *Chronicles*, p. 106.

5. Cladel, *Rodin*, pp. 86, 88, 93. The commissioning of *The Burghers of Calais* monument is documented in 159 letters written by Rodin and Omer Dewavrin, who was mayor of Calais when Rodin worked on the project. The originals are in the Calais archives; copies exist in the Museum of Modern Art library, New York, and the Philadelphia Museum of Art. The Rodin-Dewavrin correspondence was published in Claudie Judrin, Monique Laurent, and Dominique Viéville, *Auguste Rodin: Le Monument des Bourgeois de Calais (1884–1895) dans les collections du Musée Rodin et du Musée des Beaux-Arts, Calais* (1977), pp. 37–95.

6. For accounts of this stage in the commission, see Tancock, *Sculpture of Auguste Rodin*, p. 382; Elsen, *Rodin*, pp. 73–75; de Caso and Sanders, *Rodin's Sculpture: The Spreckels Collection*, pp. 205–206.

7. The committee's reaction as quoted in Tancock, *Sculpture of Auguste Rodin*, p. 383.

8. Rodin quoted in Jianou and Goldscheider, *Rodin*, pp. 46–47.

9. De Caso and Sanders, *Rodin's Sculpture: The Spreckels Collection*, p. 206.

10. Octave Mirbeau quoted in Cladel, *Rodin*, p. 95.

11. Cladel, *Rodin*, p. 95.

12. McNamara and Elsen, *Rodin's Burghers of Calais*, p. 15.

13. Rodin, *On Art and Artists*, pp. 103–104.

14. Rodin in conversation with Paul Gsell, quoted in the April 1914 issue of *L'Art et Les Artistes*, in McNamara and Elsen, *Rodin's Burghers of Calais*, p. 79.

15. The patriotic appeal of the council is quoted in ibid., p. 13.

16. Ibid., p. 25.

17. Rodin in a letter to Dewavrin dated 20 November 1884, quoted in Tancock, *Sculpture of Auguste Rodin*, p. 382; original text published in Judrin, Laurent, and Viéville, *Auguste Rodin*, pp. 41–42.

18. Excerpt from the contract between the city of Calais and Rodin for *The Burghers of Calais* monument, McNamara and Elsen, *Rodin's Burghers of Calais*, p. 68.

19. Excerpt from a letter written by Rodin to Dewavrin, quoted in Tancock, *Sculpture of Auguste Rodin*, pp. 382–83, and Cladel, *Rodin*, p. 93; original text published in Judrin, Laurent, and Viéville, *Auguste Rodin*, p. 53.

20. For Goldscheider's reconstruction of *The Second Maquette*, see Cécile Goldscheider, "La Nouvelle Salle des Bourgeois de Calais au Musée Rodin," in *La Revue du Louvre et des Musées de France* (1971), pp. 165–74; McNamara and Elsen, *Rodin's Burghers of Calais*, p. 27; and Elsen, *In Rodin's Studio*, p. 173.

21. Cladel, *Rodin*, p. 91.

22. Rodin quoted in Tancock, *Sculpture of Auguste Rodin*, p. 383, and Cladel, *Rodin*, p. 93.

23. Rodin writing to the editor of *Le Patriote*, 19 August 1885, quoted in McNamara and Elsen, *Rodin's Burghers of Calais*, pp. 28–29.

24. Rodin in conversation with Paul Gsell, quoted in the April 1914 issue of *L'Art et Les Artistes*, ibid., p. 79.

25. Cladel, *Rodin*, p. 92.

26. Elsen, *In Rodin's Studio*, p. 173.

27. McNamara and Elsen, *Rodin's Burghers of Calais*, p. 30.

28. Rodin in a letter to Dewavrin, 20 November 1884, quoted in Tancock, *Sculpture of Auguste Rodin*, p. 382; original text published in Judrin, Laurent, and Viéville, *Auguste Rodin*, p. 42.

29. Rodin in a letter to Dewavrin, 26 October 1885, quoted in McNamara and Elsen, *Rodin's Burghers of Calais*, p. 30; original text published in Judrin, Laurent, and Viéville, *Auguste Rodin*, p. 58.

30. De Caso and Sanders, *Rodin's Sculpture: The Spreckels Collection*, p. 211.

31. Rodin, *On Art and Artists*, pp. 47–49.

32. McNamara and Elsen, *Rodin's Burghers of Calais*, p. 29.

33. Albert E. Elsen, "The Final Monument: Another View," in ibid., p. 64.

34. Froissart, *Chronicles*, p. 107.

35. Sotheby Parke Bernet, New York, *Modern Paintings and Sculpture* (19 May 1983), lot 324.

36. Ibid.

37. See Spear, *Rodin Sculpture in Cleveland*, p. 45; McNamara and Elsen, *Rodin's Burghers of Calais*, p. 43.

38. Judrin, Laurent, and Viéville, *Auguste Rodin*, p. 174, no. 35.

39. Rilke, *Rodin*, p. 51.

40. In Froissart's *Chronicles* only four burghers are named; Jean de Fiennes and Andrieu d'Andres were identified in 1863 by Baron Kervyn de Lettenhove with the discovery of a Vatican manuscript. See de Caso and Sanders, *Rodin's Sculpture: The Spreckels Collection*, p. 216, n. 4; McNamara and Elsen, *Rodin's Burghers of Calais*, p. 10.

41. With the 1971 reorganization of the Musée Rodin's *Burghers of Calais* collection (see Goldscheider, "Nouvelle Salle des Bourgeois de Calais"), a second maquette arrangement was proposed (see page 51) including *Jean de Fiennes, Second Maquette*. In a later Musée Rodin publication (Judrin, Laurent, and Viéville, *Auguste Rodin*, pp. 151–54), Laurent, curator of the museum, cites the *Study of Jean de Fiennes* as the figure Rodin most probably used in *The Second Maquette*, submitted to the monument committee in August 1885. Her theory is based on two premises: first, the irregularly shaped base of the *Study of Jean de Fiennes* "interlocks" with the other maquette figures; second, an inventory of Rodin's atelier undertaken in 1936–37 by Georges Grappe, former director of the museum, grouped this study with the second maquette figures and filed the other figure separately.

42. Cladel, *Rodin*, p. 97.

43. McNamara and Elsen, *Rodin's Burghers of Calais*, p. 47; Rilke, *Rodin*, pp. 51–52.

44. Elsen, "The Final Monument," in McNamara and Elsen, *Rodin's Burghers of Calais*, p. 63.

45. Rodin in conversation with Paul Gsell, quoted in the April 1914 issue of *L'Art et Les Artistes*, in ibid., p. 79.

46. Cladel, *Rodin*, p. 98.

47. Ibid., p. 102.

48. Français quoted in Tancock, *Sculpture of Auguste Rodin*, p. 403.

49. Ibid., p. 404.

50. Cladel, *Rodin*, p. 103; Lawton, *Life and Work of Auguste Rodin*, pp. 138–45; Hale, *World of Rodin*, p. 119.

Balzac

1. Rodin quoted in Jacques de Caso, "Balzac and Rodin in Rhode Island," *Rhode Island School of Design Bulletin* (May 1966), p. 1.

2. Lamartine as quoted and discussed in Cladel, *Rodin*, p. 124.

3. Charles Chincholle writing in *Le Figaro*, 25 November 1894, quoted in Spear, *Rodin Sculpture in Cleveland*, p. 20.

4. Cladel, *Rodin*, p. 129.

5. Ibid., p. 139.

6. Ibid., p. 140.

7. Some of these descriptions can be found in ibid., pp. 140, 144; Tancock, *Sculpture of Auguste Rodin*, p. 442; Albert E. Elsen with Stephen C. McGough and Steven H. Wander, *Rodin and Balzac: Bronzes from the Cantor, Fitzgerald Collection* (1973), p. 60; Descharnes and Chabrun, *Auguste Rodin*, p. 172.

8. De Caso, "Balzac and Rodin in Rhode Island," pp. 1–23; idem, "Rodin and the Cult of Balzac," *Burlington Magazine* (June 1964), pp. 279–84; Tancock, *Sculpture of Auguste Rodin*, p. 444.

9. Albert E. Elsen, "Rodin's 'Naked Balzac,'" *Burlington Magazine* (November 1967), p. 615.

10. Lamartine quoted in Cécile Goldscheider, *Auguste Rodin 1840–1917: An Exhibition of Sculpture/Drawings* (1963), p. 59.

11. Rodin quoted in Ludovici, *Personal Reminiscences*, p. 112.

12. Balzac quoted in Elsen, "Rodin's 'Naked Balzac,'" p. 615.

13. Spear, *Rodin Sculpture in Cleveland*, p. 20.

14. Cladel, *Rodin*, p. 126; Chincholle quoted in Spear, *Rodin Sculpture in Cleveland*, p. 20. Corresponding to these descriptions is a passage in Edmond Werdet's *Portrait intime de Balzac* (Paris, 1859), which portrays the novelist as a "courageous athlete." Rodin's copy of this book had this passage underlined; see Goldscheider, *Auguste Rodin 1840–1917*, p. 54.

15. Elsen, "Rodin's 'Naked Balzac,'" p. 615.

16. Elsen with McGough and Wander, *Rodin and Balzac*, p. 53.

17. Ibid., p. 58.

18. Cladel, *Rodin*, p. 140.

19. Numerous scholars have written on the complex evolution of the *Balzac*. Questions of chronology and sources of inspiration are the points most debated. See Cécile Goldscheider, "La Genèse d'une oeuvre, le Balzac de Rodin," *La Revue des Arts* (March 1952), pp. 37–44; Mathias Morhardt, "La Bataille du Balzac," *Mercure de France* (15 December 1934), pp. 463–89; Spear, *Rodin Sculpture in Cleveland*, pp. 9–30; Tancock, *Sculpture of Auguste Rodin*, pp. 425–59; Elsen with McGough and Wander, *Rodin and Balzac*.

20. Mauclair quoted from *International Monthly* 3 (1901), in de Caso and Sanders, *Rodin's Sculpture: The Spreckels Collection*, p. 237.

21. *Balzac Head R* has been referred to in past catalogues of the Cantor collection as *Balzac Head H*; see Miller and Marotta (eds.), *Auguste Rodin*, p. 49, and Lawrence Sickman, *Auguste Rodin from The B. Gerald Cantor Collection and The B. Gerald Cantor Art Foundation* (1971), p. 49. Using Cécile Goldscheider, *Balzac et Rodin* (1950), as a source, Spear, *Rodin Sculpture in Cleveland*, p. 13, titles this piece *Balzac Head R*; Elsen with McGough and Wander, *Rodin and Balzac*, illus. 22, title it *Bust*.

22. De Caso and Sanders, *Rodin's Sculpture: The Spreckels Collection*, p. 239.

23. In a visit to Rodin's studio, Mathias Morhardt recounts the existence of six plaster casts of the same model covered in cloth that had been cut and draped according to Rodin's instructions. Wet plaster was then thrown on the cloth for rigidity. From this experimentation came the drapery for the final *Balzac*; see Frisch and Shipley, *Auguste Rodin: A Biography*, pp. 219–20.

24. In "Petite Chronique," *L'Art Moderne*, 25 July 1897, quoted in de Caso, "Balzac and Rodin in Rhode Island," p. 10; and *Le Journal des Débats*, 20 March 1898, quoted in Tancock, *Sculpture of Auguste Rodin*, p. 441.

25. Cladel, *Rodin*, p. 139.

26. Rodin quoted in Elsen with McGough and Wander, *Rodin and Balzac*, p. 55.

Portraits

1. Rodin, *On Art and Artists*, p. 137; for detailed biographical descriptions of Rodin's sitters, see Marion Jean Hare, "The Portraiture of Auguste Rodin," vol. 2 (1984).

2. Rodin quoted in Story, *Rodin*, p. 15.

3. Rodin, *On Art and Artists*, p. 146.

4. For discussions of the relationship between Rodin and Carrier-Belleuse during the 1870s, see H. W. Janson, "Rodin and Carrier-Belleuse: The Vase des Titans," *Art Bulletin* (September 1968), pp. 278–80; Bénédite, *Rodin*, pp. 17–18; Ludovici, *Personal Reminiscences*, pp. 8–10, 13, 15, 17, 19.

5. Tancock, *Sculpture of Auguste Rodin*, p. 19.

6. Letter of 19 April 1906, in Rainer Maria Rilke, *Selected Letters of Rainer Maria Rilke 1902–1926* (1946), p. 87.

7. Shaw quoted in Elsen, *Rodin*, p. 126.

8. Malvina Hoffman, *Heads and Tails* (1936), p. 43.

9. Rodin quoted in Frisch and Shipley, *Auguste Rodin: A Biography*, p. 203.

10. Elsen, *Rodin*, p. 109.

11. For discussions of Rodin's male-female distinction, see Elsen, *Rodin*, pp. 111–31; Hare, "Portraiture of Auguste Rodin," vol. 1, pp. 191–92, 196, 208, 227; Rilke, *Rodin*, pp. 42–43.

12. Rodin quoted in Frisch and Shipley, *Auguste Rodin: A Biography*, pp. 359–60.

13. For a documented analysis of this controversy, see Hare, "Portraiture of Auguste Rodin," vol. 1, pp. 90–99.

14. Accounts of Jean-Baptiste Rodin's appearance as smooth-shaven or bearded vary during the period Rodin sculpted this bust. For discussion, see Cladel, *Rodin*, p. 17; Ruth Butler Mirolli, "The Early Work of Rodin and Its Background" (1966), pp. 96–97; Marcelle Tirel, *The Last Years of Rodin* (1925), pp. 80–81.

15. For further discussion and examples of Rodin's "decorative" early portraits, see Mirolli, "Early Work," pp. 116–20, 131; Tancock, *Sculpture of Auguste Rodin*, pp. 576–84.

16. Rodin quoted in Tancock, *Sculpture of Auguste Rodin*, p. 576.

17. Rodin quoted in Bénédite, *Rodin*, p. 18; Rodin quoted in Bartlett, "Auguste Rodin, Sculptor," in Elsen (ed.), *Auguste Rodin: Readings*, pp. 25–26—Rodin discusses his disillusionment with Carrier-Belleuse and his "reprehensible" modeling practices.

18. Dating of *The Mask of Rose Beuret*, sometimes referred to as *The Mask of Madame Rodin*, and its

relationship to *The Alsatian Woman* portrait, is controversial: Mirolli, "Early Work," pp. 123–24; Spear, *Rodin Sculpture in Cleveland*, pp. 1–3; Tancock, *Sculpture of Auguste Rodin*, pp. 480–87; Elsen, *In Rodin's Studio*, p. 164; Hare, "Portraiture of Auguste Rodin," vol. 2, p. 238.

19. Hare, "Portraiture of Auguste Rodin," vol. 2, p. 239.

20. Ibid., p. 347.

21. Monique Laurent in Claudie Judrin and Monique Laurent, *Rodin et l'Extrême-Orient* (1979), p. 23; Judith Cladel, *Rodin: The Man and His Art, with Leaves from His Note-book* (1917), p. 162; Hare, "Portraiture of Auguste Rodin," pp. 538–39.

22. Elsen, *Rodin*, p. 119.

23. Pope Benedict XV did not take a public position at the start of the First World War and was criticized for not condemning Germany for its invasion of neutral Belgium. Italy, however, had not yet entered the war, and the pope believed that to achieve diplomatic flexibility his silence was required. He had been Papal Nuncio in Paris, and his selection of Albert Besnard and Rodin, both French, to do his portrait and bust should properly be interpreted as a signal of his sympathies, for the pope's smallest gesture was seen as a revelation. Pope Benedict worked for peace and was later called the "Pope of Peace." See H. E. G. Rope, *The Pope of Peace* (1941), and Cladel, *Rodin*, p. 251.

24. Cladel, *Rodin*, p. 250.

25. On protocol, see Elsen, *Rodin*, p. 131; on the psychological objections of the pope to Rodin, see Tancock, *Sculpture of Auguste Rodin*, pp. 567–68; for further discussion of the pope's impatience, see Cladel, *Rodin*, p. 251.

26. Elsen, *Rodin*, p. 131.

27. Tancock, *Sculpture of Auguste Rodin*, p. 568.

The Dance

1. For an excellent analysis of the role of dance in art, see Marianne Martin, "Modern Art and Dance: An Introduction," in *Art and Dance* (1983), pp. 11–71, and Mario Amaya, "Rodin's Dancers," *Dance and Dancers* (March 1963), pp. 24–26.

2. Martin, "Modern Art and Dance," p. 14; *Rodin inconnu* (1962), p. 49. For general discussion see Descharnes and Chabrun, *Auguste Rodin*, pp. 244–26.

3. Isadora Duncan, *My Life* (1927), p. 91. Duncan describes herself as a virgin, but she already had two children at the time of her encounter with Rodin.

4. Rodin quoted in Descharnes and Chabrun, *Auguste Rodin*, p. 246.

5. For a discussion of Rodin and Eastern dance, see Judrin and Laurent, *Rodin et l'Extrême-Orient*.

6. Anita Leslie, *Rodin: Immortal Peasant* (1939), p. 241.

7. Ibid., pp. 243–44. This letter, although signed by Rodin, was actually written by his friend the critic Roger Marx; see Cladel, *Rodin*, p. 219.

8. Martin, "Modern Art and Dance," p. 17.

9. Rodin quoted in Hale, *World of Rodin*, p. 156.

10. Kirk T. Varnedoe, "The Ideology of Time: Degas and Photography," *Art in America* (Summer 1980), p. 99.

11. Cladel, *Rodin*, p. 218.

12. Elsen, *Rodin*, p. 141.

13. Titles, using alphabetical designations, vary with different sources; see Georges Grappe, *Catalogue du Musée Rodin* (1944), p. 136, no. 426; Elsen, *Rodin*, p. 147; idem, "When the Sculptures Were White," in Elsen (ed.), *Rodin Rediscovered*, p. 136; Descharnes and Chabrun, *Auguste Rodin*, pp. 250–51.

14. Elsen, *Rodin*, p. 141; Steinberg, *Other Criteria*, pp. 355–58, 398–402.

15. Ludovici, *Personal Reminiscences*, p. 158.

16. Cécile Goldscheider, "Rodin et la danse," *Art de France* 3 (1963), pp. 321–35.

17. Amaya, "Rodin's Dancers," pp. 24, 26; Steinberg, *Other Criteria*, pp. 355–58; John Tancock, "Rodin Is a Rodin Is a Rodin . . . ," in Butler (ed.), *Rodin in Perspective*, pp. 185–87.

18. Romola Nijinsky quoted in Amaya, "Rodin's Dancers," p. 26; see also Cladel, *Rodin*, pp. 218–21; Leslie, *Rodin: Immortal Peasant*, pp. 241–45.

19. Descharnes and Chabrun, *Auguste Rodin*, pp. 255–57.

Fragments

1. For general discussions of the reassessment of Rodin's fragments, see Steinberg, *Other Criteria*; de Caso and Sanders, *Rodin's Sculpture: The Spreckels Collection*, pp. 314–17.

2. Rodin quoted in Bartlett, "Auguste Rodin, Sculptor," in Elsen (ed.), *Auguste Rodin: Readings*, p. 21.

3. Frisch and Shipley, *Auguste Rodin: A Biography*, pp. 186, 113.

4. The Comte Robert de Montesquiou quoted in John Tancock, "Rodin Is a Rodin Is a Rodin . . .," in Butler (ed.), *Rodin in Perspective*, p. 184.

5. For discussions of the enlargement/reduction process, see Elsen, "Rodin's 'Perfect Collaborator,' " in Elsen (ed.), *Rodin Rediscovered*, pp. 249–59; Miller (ed.), *Sculpture of Auguste Rodin*.

6. Rodin in an excerpt from a letter to William Rothenstein dated 17 November 1900, in Elsen, *In Rodin's Studio*, p. 186.

7. Rodin quoted in Albert E. Elsen, *The Partial Figure in Modern Sculpture from Rodin to 1969* (1969), p. 25.

8. Ibid., p. 26.

9. Rilke, *Rodin*, p. 24.

10. Roger Fry quoted in Elsen, *Rodin*, p. 173.

11. Steinberg, *Other Criteria*, p. 370.

12. Elsen, *The Partial Figure*, p. 28.

13. Ruckstull quoted in Elsen, *Rodin*, p. 180.

14. Steinberg, *Other Criteria*, p. 363.

15. Edgar Degas and Rodin's conversation quoted in Frisch and Shipley, *Auguste Rodin: A Biography*, p. 311.

16. Rodin quoted in Rodin, *On Art and Artists*, p. 164.

17. Rodin quoted in Cladel, *Rodin*, pp. 249–50.

18. Steinberg, *Other Criteria*, p. 363.

19. Jacques Lipchitz in the preface entitled "Homage" in Elsen, *Rodin*. For discussions of Rodin's influence on modern art, see Elsen, *The Partial Figure*, pp. 29–46; Sidney Geist, "Rodin/Brancusi," in Elsen, *Rodin Rediscovered*, pp. 270–73; Steinberg, *Other Criteria*, p. 363; Alan Bowness, "Rodin: A Conversation with Henry Moore," in *Rodin: Sculpture and Drawings* (1970), pp. 9–12.

20. Elsen, *The Partial Figure*, pp. 98–99.

21. For further discussion on the origins of the *Torso of the Walking Man*, see Tancock, *Sculpture of Auguste Rodin*, pp. 360–65; Elsen, *Rodin*, pp. 31–32; de Caso and Sanders, *Rodin's Sculpture: The Spreckels Collection*, pp. 78–79, n. 21; Elsen, *In Rodin's Studio*, p. 187, nos. 132–34; Mirolli, "Early Work," pp. 191–94.

22. Grappe, *Catalogue du Musée Rodin*, p. 128, no. 391.

23. Ibid., p. 85, no. 248.

24. For further discussion of these figures, see Elsen, "When the Sculptures Were White," in Elsen (ed.), *Rodin Rediscovered*, p. 144.

25. Steinberg, *Other Criteria*, p. 363.

26. For a discussion of the transformations of *Meditation*, see ibid., pp. 371–75. *Meditation* as it appears in *The Gates of Hell* dates from ca. 1884. Tancock gives the date of 1896–97 to the fragmented version, *Meditation Without Arms*; see Tancock, *Sculpture of Auguste Rodin*, pp. 193–99. For further discussion, see Elsen, *In Rodin's Studio*, p. 169; idem, *Gates of Hell*, p. 215, fig. 196.

27. Rilke, *Rodin*, p. 23.

28. The last words spoken by Rodin on his deathbed were in praise of the painter Puvis de Chavannes; see Cladel, *Rodin*, p. 328.

29. Mauclair, *Auguste Rodin*, p. 89.

30. Jamison, "Rodin's Humanization of the Muse," in Elsen (ed.), *Rodin Rediscovered*, pp. 116–17.

31. Tancock, *Sculpture of Auguste Rodin*, p. 613.

32. Rilke, *Rodin*, p. 25; Gustav Kahn in "Les Mains chez Rodin" for *La Plume*, reprinted in Butler (ed.), *Rodin in Perspective*, p. 107; Henri Bergson quoted in Frisch and Shipley, *Auguste Rodin: A Biography*, p. 431.

33. Rodin quoted in Bartlett, "Auguste Rodin, Sculptor," in Elsen (ed.), *Auguste Rodin: Readings*, p. 27.

34. Rilke, *Rodin*, pp. 24–25.

35. Rodin was one of the original subscribers to Eadweard Muybridge's *Animal Locomotion*. For discussion of both Muybridge and Victor Hugo's influence on Rodin's hands, see Tancock, *Sculpture of Auguste Rodin*, pp. 616–17.

36. Pignatelli quoted in ibid., p. 360.

37. Rodin quoted in ibid., p. 622.

38. Frisch and Shipley, *Auguste Rodin: A Biography*, p. 431.

39. Tancock, *Sculpture of Auguste Rodin*, p. 622; Spear, *Rodin Sculpture in Cleveland*, p. 79.

40. See Elsen, *In Rodin's Studio*, p. 174, for mention of the *Large Clenched Left Hand* as possibly deriving from a study for *The Burghers of Calais*. For discussion of Rodin's hands and deformity, see Monique Laurent and Michel Merle (eds.), *Rodin, les mains, les chirugiens* (1983); William J. Littler, *The Hand and Upper Extremities* (1977), vol. 6 of John Marquis Converse (ed.), *Reconstructive Plastic Surgery*, p. 3267, fig. 78–1.

41. In the enlarged version of *The Secret* (33½ x 19 x 15¼ in.), the hands hold what appears to be a scroll or sacred tablets. In 1910 this version was exhibited in London under the title *Hands Holding the Sacred Tablets*; see Grappe, *Catalogue du Musée Rodin*, p. 133, no. 415.

42. For discussions of these sources, see Tancock, *Sculpture of Auguste Rodin*, pp. 628–29, 634–36; Frisch and Shipley, *Auguste Rodin: A Biography*, p. 19, for *The Cathedral*; Story, *Rodin*, pp. 17–18, for *The Cathedral* and *The Secret*.

43. Steinberg, *Other Criteria*, p. 358.

44. Elsen, *The Partial Figure*, p. 28.

45. Cladel quoted in Laurent and Merle, *Rodin, les mains*, p. 76.

Bibliography

Alhadeff, Albert. "Rodin: A Self-Portrait in *The Gates of Hell.*" *Art Bulletin* 48, nos. 3–4 (September, December 1966), pp. 393–95.

Amaya, Mario. "Rodin's Dancers." *Dance and Dancers* 14, no. 3 (March 1963), pp. 24–26.

Bénédite, Léonce. *Rodin.* Translated by Wilfrid Jackson. London, 1926.

Bowness, Alan. "Rodin: A Conversation with Henry Moore." In *Rodin: Sculpture and Drawings.* Exh. cat. London: Hayward Gallery, 1970, pp. 9–12.

Breck, Joseph. *The Collection of Sculptures by Auguste Rodin.* New York, 1913.

Butler, Ruth (ed.). *Rodin in Perspective.* Englewood Cliffs, N.J., 1980.

de Caso, Jacques. "Balzac and Rodin in Rhode Island." *Rhode Island School of Design Bulletin* 52, no. 4 (May 1966), pp. 1–23.

———. "Rodin and the Cult of Balzac." *Burlington Magazine* 106, no. 735 (June 1964), pp. 278–84.

de Caso, Jacques, and Sanders, Patricia B. *Rodin's Sculpture: A Critical Study of the Spreckels Collection.* San Francisco, 1977.

Cladel, Judith. *Auguste Rodin: L'Oeuvre et l'homme.* Brussels, 1908.

———. *Rodin.* Translated by James Whitehall. New York, 1937.

———. *Rodin: The Man and His Art, with Leaves from His Note-book.* Translated by S. K. Star. New York, 1917.

Descharnes, Robert, and Chabrun, Jean-François. *Auguste Rodin.* New York, 1967.

Donahue, Kenneth (ed.). *Homage to Rodin: Collection of B. Gerald Cantor.* Exh. cat. Los Angeles: Los Angeles County Museum of Art, 1967.

Duncan, Isadora. *My Life.* New York, 1927.

Duthy, Robin. "Rodin Redeemed." *Connoisseur* 215, no. 877 (March 1985), pp. 72–76.

Elsen, Albert E. *The Gates of Hell by Auguste Rodin.* Stanford, 1985.

———. *In Rodin's Studio: A Photographic Record of Sculpture in the Making.* New York, 1980.

———. "A Major Gift of Rodin Sculpture." *Art News* 73, no. 4 (April 1974), pp. 28–34.

———. *The Partial Figure in Modern Sculpture from Rodin to 1969.* Baltimore, 1969.

———. *Rodin.* New York, 1963.

———. *Rodin's Gates of Hell.* Minneapolis, 1960.

———. "Rodin's 'Naked Balzac.'" *Burlington Magazine* 109, no. 776 (November 1967), pp. 606–17.

Elsen, Albert E. (ed.). *Auguste Rodin: Readings on His Life and Work.* Englewood Cliffs, N.J., 1965.

———. *Rodin Rediscovered.* Exh. cat. Washington, D.C.: National Gallery of Art, 1981.

Elsen, Albert E., and Varnedoe, Kirk T. *The Drawings of Rodin.* With additional contributions by Victoria Thorson and Elizabeth Chase Geissbuhler. New York, 1971.

Elsen, Albert E., in collaboration with Henry Moore. "Rodin's 'Walking Man,' as Seen by Henry Moore." *Studio International* 174 (July/August 1967), pp. 26–31.

Elsen, Albert E., with McGough, Stephen C., and Wander, Steven H. *Rodin and Balzac: Bronzes from the Cantor, Fitzgerald Collection.* Beverly Hills, 1973.

Fitchett, Joseph. "France Celebrates a Forgotten Sculptor, a Buried Life." *International Herald Tribune,* 23 March 1984, pp. 7–8.

Frel, Jiří, and West, Harvey. *Rodin: The Maryhill Collection.* Exh. cat. Pullman, Wash.: Washington State University Museum of Art, 1976.

Frisch, Victor, and Shipley, Joseph T. *Auguste Rodin: A Biography.* New York, 1939.

Froissart, Jean. *Chronicles.* Harmondsworth, 1968, pp. 106–109.

Fuller, Loïe. *Fifteen Years of a Dancer's Life.* Boston, 1913.

Fusco, Peter. "The Sculpture of Rodin." *Museum Magazine* 2, no. 3 (July/August 1981), pp. 31–37.

Fusco, Peter, and Janson, H. W. (eds.). *The Romantics to Rodin, French Nineteenth-Century Sculpture from North American Collections.* Exh. cat. Los Angeles: Los Angeles County Museum of Art, 1980.

Geissbuhler, Elizabeth Chase. *Rodin: Later Drawings, with Interpretations by Antoine Bourdelle.* Boston, 1963.

Gernsheim, Helmut and Alison. *The History of Photography 1865–1914.* New York, 1969.

Goldscheider, Cécile. Catalogue notes in *Auguste Rodin 1840–1917: An Exhibition of Sculpture/Drawings.* Exh. cat. New York: Charles E. Slatkin Galleries, 1963, pp. 46–118.

———. Introduction to *Homage to Rodin: Collection of B. Gerald Cantor*, edited by Kenneth Donahue. Exh. cat. Los Angeles: Los Angeles County Museum of Art, 1967.

———. "La Genèse d'une oeuvre: Le Balzac de Rodin." *La Revue des Arts*, no. 1 (March 1952), pp. 37–42.

———. "La Nouvelle Salle des Bourgeois de Calais au Musée Rodin." *La Revue du Louvre et des Musées de France* 21, no. 3 (1971), pp. 165–74.

———. "Rodin et la danse." *Art de France*, no. 3 (1963), pp. 321–35.

Grappe, Georges. *Catalogue du Musée Rodin.* 2d ed., Paris, 1929; 5th ed., Paris, 1944.

Hale, William Harlan. *The World of Rodin 1840–1917.* New York, 1969.

Hare, Marion Jean. "The Portraiture of Auguste Rodin." 2 vols. Ph.D. dissertation, Stanford University, 1984.

Hoffman, Malvina. *Heads and Tails.* New York, 1936.

Janson, H. W. "Rodin and Carrier-Belleuse: The Vase des Titans." *Art Bulletin* 50, no. 3 (September 1968), pp. 278–80.

Janson, H. W., and Rosenblum, Robert. *Nineteenth-Century Art.* New York, 1984.

Jianou, Ionel. *Rodin.* Paris, 1970.

Jianou, Ionel, and Goldscheider, Cécile. *Rodin.* Paris, 1967.

Judrin, Claudie, and Laurent, Monique. *Rodin et l'Extrême-Orient.* Exh. cat. Paris: Musée Rodin, 1979.

Judrin, Claudie; Laurent, Monique; and Viéville, Dominique. *Auguste Rodin: Le Monument des Bourgeois de Calais (1884–1895) dans les collections du Musée Rodin et du Musée des Beaux-Arts, Calais.* Paris, 1977.

Laurent, Monique, and Gaudichon, Bruno. *Camille Claudel (1864–1943).* Exh. cat. Paris: Musée Rodin, 1984.

Laurent, Monique, and Merle, Michel (eds.). *Rodin, les mains, les chirurgiens.* Exh. cat. Paris: Musée Rodin, 1983.

Lawton, Frederick. *The Life and Work of Auguste Rodin.* New York, 1907.

Leslie, Anita. *Rodin: Immortal Peasant.* London, 1939.

Littler, J. William. *The Hand and Upper Extremities.* Vol. 6 of *Reconstructive Plastic Surgery*, edited by John Marquis Converse. Philadelphia, 1977.

Ludovici, Anthony M. *Personal Reminiscences of Auguste Rodin.* Philadelphia, 1926.

McNamara, Mary Jo, and Elsen, Albert E. *Rodin's Burghers of Calais.* Stanford, 1977.

Martin, Marianne. "Modern Art and Dance: An Introduction." In *Art and Dance.* Exh. cat. Boston: Institute of Contemporary Art, 1983, pp. 11–55.

Marx, Roger. *Auguste Rodin: Céramiste.* Paris, 1907.

Mauclair, Camille. *Auguste Rodin: The Man—His Ideas—His Works.* Translated by Clementina Black. London, 1905.

Merryman, John Henry, and Elsen, Albert E. *Law, Ethics, and the Visual Arts.* 2 vols. New York, 1979.

Miller, Joan Vita (ed.). *The Sculpture of Auguste Rodin: Reductions and Enlargements.* New York, 1983.

Miller, Joan Vita, and Marotta, Gary (eds.). *Auguste Rodin: The B. G. Cantor Sculpture Center.* New York, 1981.

Mirolli, Ruth B. [Butler]. "The Early Work of Rodin and Its Background." Ph.D. dissertation, New York University, 1966.

Mirolli, Ruth (ed.). *Nineteenth-Century French Sculpture: Monuments for the Middle Class.* Exh. cat. Louisville: J. B. Speed Art Museum, 1971.

Morhardt, Mathias. "La Bataille du Balzac." *Mercure de France*, 15 December 1934, pp. 463–89.

"News: College Art Association." *Art Journal* 34, no. 1 (Fall 1974), pp. 44–50.

Ramsden, E. H. "The Burghers of Calais: A New Interpretation." *Apollo* (March 1970), p. 235.

Rilke, Rainer Maria. *Rodin.* Translated by Jessie Lemont and Hans Trausil. London, 1946.

———. *Selected Letters of Rainer Maria Rilke 1902–1926.* Translated by R. F. C. Hull. London, 1946.

Rodin, Auguste. *The Cathedrals of France.* Translated by Elizabeth Chase Geissbuhler. Boston, 1965.

———. *On Art and Artists.* Translated from the French ed. of Paul Gsell by Romelly Fedden. New York, 1957.

"Rodin in Paris and Meudon." *Burlington Magazine* 109, no. 776 (November 1967), pp. 605–606.

Rope, H. E. G. *The Pope of Peace*. London, 1941.

Russell, John. "Rodin's 'Gates': Hell Was His Dish." *New York Times*, 20 June 1982, p. 35.

Sickman, Lawrence. *Auguste Rodin from The B. Gerald Cantor Collection and The B. Gerald Cantor Art Foundation*. Exh. cat. Kansas City, Mo.: William Rockhill Nelson Gallery and Mary Atkins Museum of Fine Arts, 1971.

Smiley, Charles Newton. "Rodin in the Metropolitan Museum." *Art and Archaeology* 3 (January–June 1916), pp. 107–14.

Sotheby Parke Bernet. *A Collection of Bronzes by Auguste Rodin*. Sale cat. New York, 22 May 1982, lots 441–45.

Sotheby Parke Bernet. *Modern Paintings and Sculpture*. Sale cat. New York, 19 May 1983, lot 324.

[Spear], Athena Tacha. "The Prodigal Son: Some New Aspects of Rodin's Sculpture." *Allen Memorial Art Museum Bulletin* 22, no. 1 (Fall 1964), pp. 23–39.

Spear, Athena Tacha. *Rodin Sculpture in the Cleveland Museum of Art*. Cleveland, 1967.

———. *A Supplement to Rodin Sculpture in the Cleveland Museum of Art*. Cleveland, 1974.

Steinberg, Leo. *Other Criteria: Confrontations with Twentieth-Century Art*. New York, 1972.

Story, Sommerville. *Rodin*. Catalogue by Georges Grappe. New York, 1939.

Tancock, John. *The Sculpture of Auguste Rodin: The Collection of the Rodin Museum, Philadelphia*. Philadelphia, 1976.

———. "Unfamiliar Aspects of Rodin." *Apollo* (July 1974), pp. 46–51.

Tirel, Marcelle. *The Last Years of Rodin*. Translated by R. Français. New York, 1925.

Tominaga, Soichi. *Catalogue du Musée National d'Art Occidental Tokyo*. Tokyo, 1961.

Varnedoe, Kirk T. "The Ideology of Time: Degas and Photography." *Art in America* 68, no. 2 (Summer 1980), pp. 96–110.

Varnedoe, Kirk T.; Elsen, Albert E.; and Marotta, Gary. "In Defense of Rodin's 'Gates of Hell.'" *New York Times*, 18 July 1982, p. 26.

Vincent, Clare. "Rodin at The Metropolitan Museum of Art: A History of the Collection." *The Metropolitan Museum of Art Bulletin* 38, no. 4 (Spring 1981).

Wasserman, Jeanne L. (ed.). *Metamorphoses in Nineteenth-Century Sculpture*. Exh. cat. Cambridge, Mass.: Harvard University, Fogg Art Museum, 1975.

Checklist of the Exhibition

In the cataloging of the bronze objects on exhibition, the date of the working model is given first, followed by the date of the casting. Where dimensions are cited, height precedes width followed by depth.

Camille Claudel
Bust of Auguste Rodin
1888–92
Bronze, 15¾ x 9¼ x 11 in.
Signed: *Camille Claudel* (rear base)
B. Gerald Cantor Art Foundation

1. **The Three Shades**
1881–86, cast 1969
Bronze, 38¼ x 37 x 20½ in.
Signed: *A. Rodin* (right base)
Marks: © *by Musée Rodin 1969* (rear edge of base); *Georges Rudier / Fondeur Paris* (rear base)
The Metropolitan Museum of Art, Gift of B. Gerald Cantor Art Foundation, 1984, 1984.364.17

2. **Fallen Caryatid with Stone**
Ca. 1881, cast 1981
Bronze, 52½ x 33 x 39 in.
Signed: *A. Rodin / No. 1* (front base)
Marks: © *by Musée Rodin 1981;* Coubertin Foundry seal with a flower flanked by the letters *F* and *C* (rear base)
The Metropolitan Museum of Art, Gift of Iris and B. Gerald Cantor, 1985, 1985.56.2

3. **Fallen Caryatid with Urn**
1883, cast 1981
Bronze, 45¼ x 36¾ x 31⅛ in.
Signed: *A. Rodin / No. 3* (front base)
Marks: © *by Musée Rodin;* Coubertin Foundry seal with a flower flanked by the letters *F* and *C* (rear base)
The Metropolitan Museum of Art, Gift of Iris and B. Gerald Cantor, 1985, 1985.56.1

4. **Drawing of Ugolino and His Son**
Ca. 1875–80
Ink, 5⅜ x 3⅝ in.
Signed: *AR*
Inscribed: *Ugolino* (lower right); *Planche* (upper left, upside down)
B. Gerald Cantor Art Foundation

5. **Ugolino and His Sons**
1882
Plaster, 16½ x 25⅛ x 15 in.
B. Gerald Cantor Art Foundation

6. **Torso of Ugolino's Son**
1882, cast 1980
Bronze, 9½ x 7⅜ x 4½ in.
Signed: *A. Rodin / No. 2* (right thigh)
Marks: *E. Godard / Fond^r* (left thigh); © *by Musée Rodin 1980* (back of right thigh)
The Brooklyn Museum, Gift of B. Gerald Cantor Collections, 84.76

7. **Head of Sorrow**
1882, cast 1963
Bronze, 9 x 9 x 10½ in.
Signed: *A. Rodin* (neck, left side)
Marks: *Georges Rudier / Fondeur Paris* (rear base); © *by Musée Rodin 1963* (neck, right side)
B. Gerald Cantor Collections

8. **Fugitive Love**
1881
Bronze, 20¾ x 33 x 15 in.
Signed: *A. Rodin / No. 2* (right base)
Marks: *Alexis Rudier / Fondeur Paris* (rear base); *Rodin* (impressed underside)
B. Gerald Cantor Art Foundation

9. **The Prodigal Son**
Ca. 1885–87, cast 1969
Bronze, 54⅜ x 34⅜ x 28⅝ in.
Signed: *A. Rodin* (top front base)
Marks: © *by Musée Rodin 1969* (right side base); *Georges Rudier / Fondeur Paris* (rear base)
The Brooklyn Museum, Gift of B. Gerald Cantor Art Foundation, 84.75.4

10. **Paolo and Francesca**
1889, cast 1981
Bronze, 12⅛ x 22¼ x 14¾ in.
Signed: *A. Rodin* (front base)
Marks: *Georges Rudier / Fondeur Paris / * © *by Musée Rodin 1981* (rear base)
The Brooklyn Museum, Gift of B. Gerald Cantor Art Foundation, 86.1

11. **Crouching Woman**
1880–82, cast 1963
Bronze, 37½ x 25 x 22 in.
Signed: *A. Rodin* (top base, below left foot)

Marks: © by *Musée Rodin 1963* (lower right base); *Georges Rudier Fondeur Paris* (rear base)
Los Angeles County Museum of Art, Gift of B. Gerald Cantor Art Foundation

12. I Am Beautiful
Ca. 1881–82, cast 1968
Bronze, 27¾ x 12 x 12½ in.
Signed: *A. Rodin* (base, under right knee)
Marks: *Je suis belle, ô Mortels, Comme un rêve de pierre / Et mon sein, où Chacun s'est meurtri tour à tour / Est fait pour inspirer au poète un Amour / Eternel et muet ainsi que la matière* (lower base, inscribed); © by *Musée Rodin 1968* (left side base); *Georges Rudier / Fondeur Paris* (base edge, rear of male figure)
Jay S. Cantor

13. Danaïd
Ca. 1884–85
Bronze, 8½ x 15⅜ x 10¼ in.
Signed: *A. Rodin* (top base)
Marks: *Gruet Fondeur Paris* (base, below right leg)
B. Gerald Cantor Collections

14. Despair
Ca. 1890, cast 1967
Bronze, 12½ x 12 x 9 in.
Signed: *A. Rodin* (rear base)
Marks: © by *Musée Rodin 1967 / Georges Rudier Fondeur Paris* (rear base)
B. Gerald Cantor Art Foundation

15. Fragment of the Right Pilaster of the Gates of Hell
Ca. 1900, cast 1982
Bronze, 10¾ x 2¼ x 1¼ in.
Signed: *A. Rodin / 4 / 8* (front bottom)
Marks: © by *Musée Rodin 1982* (lower right edge); *E. Godard / Fond.* (lower left edge)
B. Gerald Cantor Collections

16. Embracing Couple
1898, cast 1979
Bronze, 4¼ x 2⅛ x ½ in.
Signed: *A. Rodin* (lower left)
Marks: *No. 9* (front center); © by *Musée Rodin 1979* (right edge); *G. Rudier / Fond. Paris* (bottom edge)

The Metropolitan Museum of Art, Gift of B. Gerald Cantor Art Foundation, 1984, 1984.364.18

17. Protection
1916
Bronze, 3¾ x 1⅝ x ¼ in.
Signed: *Rodin* (front lower center)
Marks: *PROTECTION / COMPOSE PAR / AUGUSTE RODIN / POUR / THE FRENCH ACTORS FUND / AU PROFIT DE L' / AIDE AUX ARTISTES / ET EMPLOYES DE THEATRE / EN COLLABORATION / AVEC / L'ASSOCIATION / DES / DIRECTEURS DE THEATRE / DE PARIS / PARIS. NEW-YORK / MCMXVI* (back)
The Brooklyn Museum, Gift of B. Gerald Cantor Art Foundation, 84.210.1

18. The Creator
Ca. 1900, cast 1983
Bronze, 16 x 14¼ x 2½ in.
Signed: *A. Rodin / No. 3/8* (front lower center)
Marks: © by *Musée Rodin 1983*; Coubertin Foundry seal with a flower flanked by the letters *F* and *C* (front lower edge)
B. Gerald Cantor Collections

19. The First Maquette for the Burghers of Calais
1884
Bronze, 24 x 14⅞ x 13½ in.
Signed: *A. Rodin / No. 1* (front top base)
Marks: *E. Godard / Fond.* / *Paris*; © by *Musée Rodin* (lower base, right side)
The Brooklyn Museum, Gift of B. Gerald Cantor Art Foundation, 84.75.19

20. Eustache de Saint-Pierre, Second Maquette
1885, cast 1971
Bronze, 27½ x 12 x 11½ in.
Signed: *A. Rodin No. 3* (front top base)
Marks: *Susse Fondeur Paris* (rear base); © by *Musée Rodin 1971* (front base)
Stanford University Museum of Art, Gift of B. Gerald Cantor Art Foundation, 74.102

21. Eustache de Saint-Pierre, Nude Study
1885–86, cast 1965
Bronze, 38½ x 13 x 17 in.
Signed: *A. Rodin No. 4* (top base, behind left foot)
Marks: *Georges Rudier / Fondeur Paris*; © by *Musée Rodin 1965* (rear base)
The Fine Arts Museums of San Francisco, Gift of B. Gerald Cantor, 1968.7

22. Eustache de Saint-Pierre, Final Head
By 1889, cast 1983
Bronze, 16 x 9½ x 11½ in.
Signed: *A. Rodin / No. 4* (front base)
Marks: © by *Musée Rodin 1983* (rear base); *E. Godard / Fond* Paris* (right side, lower edge)
B. Gerald Cantor Collections

23. Eustache de Saint-Pierre, Grand Model
1885–86, cast 1983
Bronze, 85 x 30 x 48 in.
Signed: *A. Rodin / No. 3/8* (top base, between feet)
Marks: © by *Musée Rodin 1983*; Coubertin Foundry seal with a flower flanked by the letters *F* and *C* (rear base)
B. Gerald Cantor Collections

24. Jean d'Aire, Second Maquette
1885, cast 1970
Bronze, 27½ x 9½ x 9¾ in.
Signed: *A. Rodin / No. 1* (top base)
Marks: © by *Musée Rodin 1970*; *Susse Fondeur Paris* (rear base)
B. Gerald Cantor Art Foundation

25. Bust of Jean d'Aire
By 1887
Plaster, 19 x 23½ x 16 in.
National Gallery of Art, Washington, D.C., Gift of B. Gerald Cantor Art Foundation, 1984.85.1

26. Pierre de Wiessant, Nude Study
1885, cast before 1952
Bronze, 26⅝ x 14½ x 11¾ in.
Signed: *A. Rodin* (front base)
Marks: *Alexis Rudier / Fondeur Paris* (rear base); *A. Rodin* (impressed underside)
The Metropolitan Museum of Art, Gift of B. Gerald Cantor Art Foundation, 1984, 1984.364.11

27. **Pierre de Wiessant, Second Maquette**
1885, cast 1970
Bronze, 28 x 12⅜ x 12⅜ in.
Signed: *A. Rodin/No. 1* (front top base)
Marks: *© by Musée Rodin 1970* (right side base); *Susse Fondeur Paris* (rear base)
The Brooklyn Museum, Gift of B. Gerald Cantor Art Foundation, 84.75.21

28. **Pierre de Wiessant, Head, Type A**
Ca. 1885–86
Bronze, 11⅜ x 8½ x 10 in.
Signed: *A. Rodin* (neck, left side)
Marks: *Alexis Rudier/Fondeur Paris* (rear base)
The Brooklyn Museum, Gift of Iris and B. Gerald Cantor, 84.77.9

29. **Jean de Fiennes, Second Maquette**
1885, cast 1969
Bronze, 28 x 18¼ x 17⅛ in.
Signed: *A. Rodin* (top base)
Marks: *© by Musée Rodin 1969* (base, near left foot); *Susse Fondeur/ Paris/Cire Perdue* (front interior base, impressed twice, right and left, rectangular seals)
B. Gerald Cantor Art Foundation

30. **Jean de Fiennes, Study**
1885, cast 1979
Bronze, 28⅝ x 10¼ x 14⅛ in.
Signed: *A. Rodin No. 1* (lower front)
Marks: *E. Godard Fond.*; *© by Musée Rodin 1979* (rear base)
B. Gerald Cantor Collections

31. **Jean de Fiennes, Grand Model**
1885–86, cast 1983
Bronze, 82 x 48 x 38 in.
Signed: *A. Rodin/No. 5/8* (top base, between feet)
Marks: *© by Musée Rodin 1983*; Coubertin Foundry seal with a flower flanked by the letters *F* and *C* (rear base)
B. Gerald Cantor Collections

32. **The Burghers of Calais**
1884–95, cast 1985
Bronze, 82½ x 94 x 75 in.
Signed: *A. Rodin No. I/II* (front center base)

Marks: *© by Musée Rodin 1985*; Coubertin Foundry seal with a flower flanked by the letters *F* and *C* (rear base, left side)
B. Gerald Cantor Collections

33. **Study for Claude Lorrain**
1889, cast 1981
Bronze, 20 x 7½ x 8½ in.
Signed: *A. Rodin/No. 2* (front base, below left foot)
Marks: *© by Musée Rodin 1981* (front base, below left foot); *E. Godard/ Fondʳ* (rear base)
The Metropolitan Museum of Art, Gift of B. Gerald Cantor Art Foundation, 1984, 1984.364.16

34. **Balzac in Frock Coat**
1891–92, cast 1980
Bronze, 23½ x 9½ x 11¼ in.
Signed: *A. Rodin No. 10* (left base)
Marks: *© by Musée Rodin 1980* (left base); *E. Godard/Fondʳ* (rear base)
B. Gerald Cantor Collections

35. **Balzac in Dominican Robe**
1891–92, cast 1971
Bronze, 41¾ x 20⅛ x 20 in.
Signed: *A. Rodin No. 1* (right base)
Marks: *Georges Rudier/Fondeur Paris* (rear base); *© by Musée Rodin 1971* (right base)
The Brooklyn Museum, Gift of B. Gerald Cantor Art Foundation, 84.75.22

36. **Naked Balzac with Folded Arms**
1892 or 1893, cast 1972
Bronze, 50¼ x 27¾ x 22¾ in.
Signed: *A. Rodin* (top base)
Marks: *© by Musée Rodin 1972* (base, below left foot); *Georges Rudier/Fondeur Paris* (side of base)
The Brooklyn Museum, Gift of B. Gerald Cantor Art Foundation, 85.198

37. **Naked Balzac**
1896, cast 1979
Bronze, 36¾ x 14⅛ x 14¾ in.
Signed: *A. Rodin/No. 7* (front top base)
Marks: *© by Musée Rodin 1979* (right base); *Georges Rudier/Fondeur Paris* (rear base)
The Brooklyn Museum, Gift of Iris and B. Gerald Cantor, 84.77.10

38. **Balzac Head R**
1892–93, cast 1980
Bronze, 12 x 12¼ x 9¼ in.
Signed: *A. Rodin No. 10* (left shoulder)
Marks: *© by Musée Rodin 1980* (left shoulder); *Georges Rudier/Fondeur Paris* (rear lower neck); *A. Rodin* (impressed underside)
The Metropolitan Museum of Art, Gift of B. Gerald Cantor Collections, 1985, 1985.111

39. **Monumental Head of Balzac**
1897, cast 1978
Bronze, 20¼ x 20⅞ x 16⅜ in.
Signed: *A. Rodin/No. 6* (front neck)
Marks: *© by Musée Rodin 1978/ Georges Rudier/Fondeur Paris* (neck, right side)
The Brooklyn Museum, Gift of B. Gerald Cantor Art Foundation, 84.75.23

40. **Final Study for the Monument to Balzac**
1897, cast 1972
Bronze, 41¾ x 17½ x 16½ in.
Signed: *A. Rodin No. 1* (right front base)
Marks: *© by Musée Rodin 1972* (right edge of base); *Georges Rudier/ Fondeur Paris* (rear base)
The Metropolitan Museum of Art, Gift of B. Gerald Cantor Art Foundation, 1984, 1984.364.15

41. **Jean-Baptiste Rodin**
1860, cast 1980
Bronze, 16⅛ x 11¼ x 9½ in.
Signed: *A. Rodin/No. 1* (front lower right)
Marks: *© by Musée Rodin 1980* (left rear base); *E. Godard/Fondʳ* (right rear base)
The Metropolitan Museum of Art, Gift of B. Gerald Cantor Art Foundation, 1984, 1984.364.14

42. **Young Girl with Flowers in Her Hair**
Ca. 1868
Terra-cotta, 14 x 7¼ x 8 in.
Signed: *A. Rodin* (left shoulder)
B. Gerald Cantor Art Foundation

43. **Mask of Rose Beuret**
1880–82
Plaster, 11 x 6⅜ x 6⅝ in.

The Metropolitan Museum of Art,
Gift of B. Gerald Cantor Art
Foundation, 1984, 1984.364.10

44. Mrs. Russell
1888
Bronze, 13¾ x 10 x 10¼ in.
Signed: *A. Rodin / No. 8* (rear edge,
left shoulder)
Marks: *Georges Rudier / Fondeur Paris*
(rear edge, right shoulder);
A. Rodin (impressed underside);
© *by Musée Rodin 1980* (left rear,
bottom edge)
B. Gerald Cantor Collections

45. Mask of Hanako
Ca. 1908, cast ca. 1950
Bronze, 6 x 3¾ x 4½ in.
Signed: *A. Rodin* (neck, left side)
Marks: *A. Rudier / Fond. Paris* (below
signature)
The Metropolitan Museum of Art,
Gift of B. Gerald Cantor Art
Foundation, 1984, 1984.364.4

46. Pope Benedict XV
1915, cast before 1952 (possibly as
early as 1927)
Bronze, 9⅞ x 7⅜ x 10 in.
Signed: *A. Rodin* (neck, left side)
Marks: *Alexis Rudier / Fondeur Paris*
(rear neck); *A. Rodin* (impressed
underside)
The Metropolitan Museum of Art,
Gift of B. Gerald Cantor Art
Foundation, 1984, 1984.364.3

47. Dance Movement A
Ca. 1910–11, cast before 1952
Bronze, 26 x 6¾ x 12¼ in.
Signed: *A. Rodin* (left arm)
Marks: *Alexis Rudier / Fondeur Paris*
(left foot)
B. Gerald Cantor Collections

48. Dance Movement B
Ca. 1910–11, cast 1956
Bronze, 12½ x 3½ x 4¾ in.
Signed: *A. Rodin / No. 7* (sole of left
foot)
Marks: © *by Musée Rodin 1956* (sole of
right foot)
B. Gerald Cantor Collections

49. Dance Movement D
Ca. 1910–11, cast before 1952
Bronze, 13 x 7¾ x 5 in.
Signed: *A. Rodin* (right leg)

Marks: *Alexis Rudier / Fondeur Paris*
(sole of right foot)
B. Gerald Cantor Collections

50. Dance Movement E
Ca. 1910–11, cast 1956
Bronze, 14 x 4½ x 8 in.
Signed: *A. Rodin / No. 5* (sole of right
foot)
Marks: © *by Musée Rodin 1956* (right
hand)
B. Gerald Cantor Collections

51. Dance Movement F
1911
Bronze, 11 x 10½ x 5½ in.
Signed: *A. Rodin / No. 10* (sole of left
foot)
Marks: © (sole of left foot)
B. Gerald Cantor Collections

52. Dance Movement G
Ca. 1910–13, cast before 1952
Bronze, 13 x 4⅛ x 3⅝ in.
Signed: *A. Rodin* (sole of right foot)
Marks: *Alexis Rudier / Fondeur Paris*
(sole of left foot)
The Metropolitan Museum of Art,
Gift of B. Gerald Cantor Art
Foundation, 1984, 1984.364.2

53. Dance Movement H
Ca. 1910, cast before 1952
Bronze, 11 x 5¼ x 5½ in.
Signed: *A. Rodin* (sole of left foot)
Marks: *Alexis Rudier / Fondeur Paris*
(right foot)
B. Gerald Cantor Collections

54. Pas de Deux B
Ca. 1910–11, cast 1965
Bronze, 13 x 7 x 5 in.
Signed: *A. Rodin* (right hand, front
figure)
Marks: *No. 8* (left foot, front figure);
G. Rudier / Fondeur Paris (sole of
right foot, rear figure); © *by Musée
Rodin 1965* (sole of right foot, front
figure)
B. Gerald Cantor Collections

55. Pas de Deux G
Ca. 1910–13, cast 1967
Bronze, 13½ x 6½ x 6½ in.
Signed: *A. Rodin / No. 6* (sole of left
foot, lower figure)
Marks: *Georges Rudier / Fondeur Paris*
(right foot, lower figure); © *by*

Musée Rodin 1967 (right foot, lower
figure)
B. Gerald Cantor Collections

56. Nijinsky
1912
Plaster, 7½ x 3¾ x 3½ in.
B. Gerald Cantor Collections

57. Head of Nijinsky
1912, cast after 1967
Bronze, 2⅞ x 1¼ x 1½ in.
Signed: *A. Rodin / No. 8* (neck, left
side)
Marks: *G. Rudier / Fond. Paris* (rear
base)
The Metropolitan Museum of Art,
Gift of B. Gerald Cantor Art
Foundation, 1984, 1984.364.8

58. Torso of the Walking Man
Ca. 1877–78, cast 1979
Bronze, 21⅛ x 9¾ x 8½ in.
Signed: *A. Rodin / No. 3* (right leg)
Marks: © *by Musée Rodin 1979*;
Coubertin Foundry seal with a
flower flanked by the letters *F* and
C (right leg)
The Metropolitan Museum of Art,
Gift of B. Gerald Cantor Art
Foundation, 1984, 1984.364.1

59. The Prayer
1909, cast 1980
Bronze, 49½ x 21⅝ x 19⅝ in.
Signed: *A. Rodin / No. 8* (front base)
Marks: *E. Godard Fond* / © *by Musée
Rodin 1980* (rear base)
B. Gerald Cantor Collections

60. Iris, Messenger of the Gods
Ca. 1890–91, cast 1969
Bronze, 38 x 35½ x 17 in.
Signed: *A. Rodin* (sole of right foot)
Marks: © *by Musée Rodin 1969* (right
plinth); *Georges Rudier / Fondeur
Paris* (rear plinth)
B. Gerald Cantor Collections

61. Iris, Messenger of the Gods, with Head
1890 (?), cast before 1981
Bronze, 6⅛ x 3⅝ x 2¾ in.
Signed: *A. Rodin / No. 1* (left leg)
Marks: © *by A. Rodin / E. Godard /
Fond* (left leg)
The Metropolitan Museum of Art,
Gift of B. Gerald Cantor Art
Foundation, 1984, 1984.364.5

62. Flying Figure
Ca. 1890–91, cast 1975
Bronze, 20½ x 29½ x 12 in.
Signed: *A. Rodin* (right top base)
Marks: © *by Musée Rodin 1975* (left
 side base); *Georges Rudier / Fondeur
 Paris* (rear base)
The Metropolitan Museum of Art,
 Gift of B. Gerald Cantor Art
 Foundation, 1984, 1984.364.14

63. Meditation Without Arms
1896–97, cast 1983
Bronze, 57½ x 30 x 20 in.
Signed: *A. Rodin / No. 6/8* (right top
 base)
Marks: © *by Musée Rodin 1983*;
 Coubertin Foundry seal with a
 flower flanked by the letters *F* and
 C (rear base)
B. Gerald Cantor Collections

**64. Spirit of Eternal Repose Without
 Head and Arms**
1899, cast 1980
Bronze, 33¼ x 15½ x 13¼ in.
Signed: *A. Rodin* (left front base)
Marks: *No. 1* (right front edge of
 base); Coubertin Foundry seal
 with a flower flanked by the letters
 F and *C* (rear base); © *by Musée
 Rodin 1980* (back edge of base)
The Metropolitan Museum of Art,
 Gift of B. Gerald Cantor Art
 Foundation, 1984, 1984.364.9

65. Hand of God
1898
Plaster, 28¾ x 25 x 26 in.
Signed: *A. Rodin* (base, under thumb)
Marks: *La Main de Dieu offerte par
 le / Musée Rodin à Monsieur
 B. Gerald Cantor* (base, inscribed)
B. Gerald Cantor Collections

66. Large Clenched Left Hand
Ca. 1885, cast 1974
Bronze, 18¼ x 10⅜ x 7⅝ in.
Signed: *A. Rodin No. 10* (base);
 A. Rodin (impressed underside)
Marks: © *by Musée Rodin 1974*
 (base); *Georges Rudier / Fondeur
 Paris* (base)
The Metropolitan Museum of Art,
 Gift of B. Gerald Cantor Art
 Foundation, 1984, 1984.364.13

67. The Cathedral
1908, cast 1955
Bronze, 25¼ x 12¾ x 13½ in.
Signed: *A. Rodin* (top base)
Marks: *Georges Rudier / Fondeur Paris /*
 © *by Musée Rodin 1955* (side base)
B. Gerald Cantor Art Foundation

68. Study for the Secret
Ca. 1910, cast 1956
Bronze, 4¾ x 2¼ x 2 in.
Signed: *A. Rodin* (base)
Marks: © *by Musée Rodin 1956*;
 G. Rudier Fondeur Paris (base)
The Metropolitan Museum of Art,
 Gift of B. Gerald Cantor Art
 Foundation, 1984, 1984.364.6

69. Hand of Rodin with Torso
1917, cast 1971
Bronze, 8⅞ x 7¹⁄₁₆ x 3¾ in.
Signed: *A. Rodin* (wrist)
Marks: © *by Musée Rodin 1971* (edge
 of wrist); *Georges Rudier / Fondeur
 Paris* (outer wrist)
The Brooklyn Museum, Gift of
 B. Gerald Cantor Art Foundation,
 84.210.7

Chronology

This *Study of Nude Model*, ca. 1857–59, demonstrates the young Rodin's understanding of the human anatomy. Pencil, 23⅞ × 17⅞ in. Musée Rodin, Paris

Rodin with his sister, Maria, ca. 1859–60. (Photo, Musée Rodin)

1840

November 12. Born François-Auguste-René Rodin to Marie Cheffer and Jean-Baptiste Rodin. One sibling, an older sister named Maria, born 1837.

Attends a Catholic school, Ecole des Frères de la Doctrine Chrétienne, until 1849.

1851–54

Attends boarding school at Beauvais.

1854–57

Attends the Ecole Impériale Spéciale de Dessin et de Mathématiques (Petite Ecole). Studies with Horace Lecoq de Boisbaudran; learns to draw from memory. Fellow students include Alphonse Legros and Jean-Charles Cazin.

At the Petite Ecole, copies works by French eighteenth-century artists, such as Boucher, van Loo, Bouchardon, Clodion.

1855. At the age of fifteen, receives a second prize for drawing from memory and is admitted to the sculptor Fort's class.

Studies at the Louvre and the Galerie des Estampes of the Bibliothèque Impériale. Attends drawing course taught by Lucas at the Manufacture des Gobelins in the evenings.

During this period, also attends courses at the Collège de France and reads Hugo, Musset, Lamartine, Homer, Virgil, and Dante.

1856. Receives a second prize for drawing flowers.

1857. Receives first prizes for drawing and for modeling ornaments after the antique.

Applies to Ecole des Beaux-Arts (Grande Ecole) on advice of Etienne-Hippolyte Maindron, a sculptor who had seen Rodin's drawings; fails entrance exam the first time and in subsequent years as well. Drawings later accepted at Ecole des Beaux-Arts, but then fails sculpture exam. Rejection from Ecole des Beaux-Arts proves difficult, as graduation from the school is essential for Salon acceptance and commissions for important public works.

1858–62

Works at odd jobs to support family: commercial decorating, mixing plaster, removing mold marks from sculpture.

Learns modeling in depth through work for the plasterer Constant Simon; gains thorough appreciation of every aspect of the sculptor's craft.

1860. Completes bust of his father, earliest surviving sculpture; portrait is classical in manner and highly refined.

1862. December 8. Rodin's sister, Maria, dies. Deeply shaken, he enters the Order of the Fathers of the Holy Sacrament as Brother Augustine.

1863

Father Pierre-Julien Eymard, founder of the order, recognizes Rodin's artistic ability and encourages him to continue. Rodin sculpts bust of Father Eymard.

End of May. Leaves order and returns to Paris; rents stable for use as studio.

Starts work on *The Man with the Broken Nose*.

Joins Union Centrale des Arts Décoratifs (members: Delacroix, Ingres, Lecoq de Boisbaudran, Dumas *père*, Théophile Gautier); meets Jean-Baptiste Carpeaux.

Supports himself by working for the ornament maker Bies and the jeweler Fanières.

Travels to Strasbourg and works in the Gothic style for a *marchand de bons dieux*.

1864

Studies animal anatomy with Antoine-Louis Barye at the Musée d'Histoire Naturelle, attends anatomy classes at the Ecole de Médecine, and continues work for decorators and commercial sculptors.

Completes *The Man with the Broken Nose* and submits the plaster, under the title *Mask,* to the Paris Salon, which rejects it.

1864–65

Meets Rose Beuret (b. 1844) while working on the Théâtre des Gobelins; she becomes his mistress.

Carves caryatids for the Théâtre des Gobelins; works on a life-size *Bacchante,* using Rose as a model. (Other *décoratifs* include chimney ornamentation for the Théâtre Gaîté-Lyrique, a pediment for the Panorama des Champs-Elysées, and reliefs for the Louvre's Salle de Rubens.)

Meets Albert-Ernest Carrier-Belleuse through the photographer Charles Aubrey; works part time in Carrier-Belleuse's studio, rue de la Tour-D'Auvergne, for the next six years, producing statues that ultimately bear Carrier-Belleuse's name.

Independently works on busts of young women in the manner of Carrier-Belleuse and Carpeaux.

Submits *The Man with the Broken Nose* to the Salon for the second time; it is again rejected.

1866

January 18. Rose bears a son, Auguste-Eugène Beuret (d. April 22, 1934); due to an accident, the boy suffers permanent mental damage. He becomes a disappointment for Rodin; the two are never close.

1870

Enlists in the 158th Regiment of the National Guard, in response to the Franco-Prussian War, and attains the rank of corporal; discharged for myopia.

1871

Work is scarce in wartime Paris; in February 1871 Rodin goes to Brussels to work for Carrier-Belleuse on the Brussels Stock Exchange, and lives in Brussels until fall 1877. During his absence, Rose and son, living in poverty, temporarily stay in Paris; his mother dies.

Executes busts of M. and Mme Garnier.

First exhibition, in Belgium (Brussels or Antwerp).

1872

Rose joins Rodin in Brussels. Rodin works alone at night to save money; hires a stone carver to make a marble version of *The Man with the Broken Nose,* which he sends to the Brussels Salon and which is later accepted at the Paris Salon of 1875 under the title *Portrait of M.B.—.*

Models *Suzon* and *Dosia,* for which the Compagnie des Bronzes purchases reproduction rights and which it subsequently casts in large numbers.

Exhibits plaster *Bust of M.B.—* at the Brussels Salon, and perhaps the *Alsatian Woman* as well (not in catalogue).

1873

Executes a number of oil paintings in the Forest of Soignes; visits the Musée de Moulages and draws from plaster casts; visits the Gothic church of Saint-Gudule.

Friends during this period include Constantine Meunier, Juliaan Dillens, Paul de Vigne, and the engraver Gustave Biot.

About January. First exhibition outside Belgium, at the International Exposition, London; exhibits three decorative busts.

February 12. Enters partnership with Antoine van Rasbourgh, a former employee of Carrier-Belleuse from Belgium; their twenty-year agreement (dissolved 1877) calls for each sculptor to sign the work destined for his respective country, but van Rasbourgh signs all Rodin's work.

Between July and October. Exhibits terra-cottas (?) at the Vienna International Exposition.

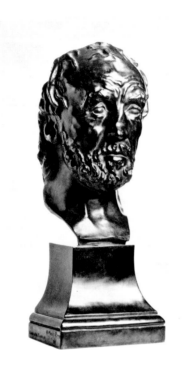

Mask of the Man with the Broken Nose, 1864. (Photo, B. Gerald Cantor Collections)

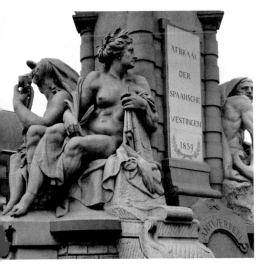

Detail of the *Monument to J. F. Loos* (now destroyed), 1874–76. (Photo, B. Gerald Cantor Collections)

Auguste Rodin, *Study After Michelangelo's Dawn*, ca. 1877. Charcoal on paper, 19 x 24¾ in. Musée Rodin, Paris

1874

Completes several decorative works for buildings in Brussels, including *Caryatids of Saint Gilles* for a home on boulevard Anspach and the *Allegory of the Arts and Sciences* for the Palais des Académies.

Travels to Antwerp with van Rasbourgh to make a commemorative monument to Burgomaster J. F. Loos for Jules Pecher, a wealthy patron and shipowner with aspirations to be a sculptor; with the artists' permission, Pecher signs his own name to the completed work.

Finds work of Michelangelo and Rubens increasingly interesting.

Exhibits at the Ghent Salon.

1875

Returns to Brussels from Antwerp.

Carves a head of Beethoven, two genii, and two caryatids in the main court of the Royal Conservatory of Music, Brussels.

April 1–June 20. Exhibits marble *Portrait of M. B.*— and terra-cotta *Portrait of M. Garnier* at the Paris Salon; first exhibition in France.

June. Begins work on *The Bronze Age*; model is a Belgian soldier/telegrapher, Auguste Neyt.

1876

Winter 1875–March 1876. Departs for Italy to study Michelangelo, leaving Rose in charge of the Brussels studio. Travels through Reims, Turin, Genoa, Pisa, Florence, Naples, and Rome. Studies Michelangelo's tombs in the sacristy of San Lorenzo; sketches in the evenings following Michelangelo's principles absorbed during the day's studies. Donatello's work also impresses him.

About March(?). Returns to Brussels from Italy and resumes work on *The Bronze Age*, which is finished by the end of 1876.

Executes earliest version of *Ugolino and His Sons*, which he ultimately destroys, except for Ugolino's body.

Exhibits *The Renaissance, Loving Thoughts, The Rose, Alsatian Woman,* and other works at the Philadelphia Centennial Exposition in the Belgian section; first exhibition in America.

1877

January. Exhibits *The Bronze Age* for the first time, under its original title, *The Vanquished,* at the Exposition du Cercle Artistique, Brussels. Accused of casting the figure from life.

May 1–June 20. Exhibits *The Bronze Age* (plaster) at the Paris Salon and is again criticized for casting from life.

August 31. Rodin–van Rasbourgh partnership dissolved.

Fall. Tours French cathedrals extensively en route back to Paris with Rose.

Begins *Saint John the Baptist Preaching* with Pignatelli as his model; scales it larger than life to avoid earlier accusations of casting from life.

1878

Continues to earn his livelihood through commercial art, doing furniture decoration and jewelry design. While working in the studio of the sculptor André Laouste, carves decorative masks for the keystones of an arcade in the Palais du Trocadero, for the 1878 Salon exhibition (wins gold medal under Laouste's name in the industrial art division).

May 15–July 5. Exhibits bronze of *The Man with the Broken Nose,* titled *Portrait of M.* —, under his own name at the same Salon, but receives no recognition.

1879

Submits entry, *The Call to Arms,* in the competition sponsored by the city of Paris for a monument to commemorate the city's defense during the Franco-Prussian

War; entry not mentioned by jury.

Unsuccessful in competition for bust of the Republic for Paris's thirteenth arrondissement's new town hall with entry later entitled *Bellona*.

Spring. Goes to Nice to work for the sculptor Cordier on the decoration of the Villa Neptune, promenade des Anglais. Later travels to Marseilles to work under Fourquet on the decoration of the Palais des Beaux-Arts.

May 12–June 30. Exhibits bronzed plaster bust of *Saint John the Baptist Preaching* and terra-cotta *Portrait of Mme. A.C.*— (*Mme Cruchet*) at the Paris Salon.

June–December 1882. Becomes an employee of the Manufacture de Sèvres at the invitation of Carrier-Belleuse, the new director; makes sculptural friezes for vases.

1880

Begins to frequent the salon of Mme Edmond Adam, also attended by Gambetta, Waldeck-Rousseau, Antonin Proust, Castagnary, Sully-Prudhomme, Loti, Carolus-Duran, and Gounod.

Introduced to Edmond Turquet, Antonin Proust's successor as undersecretary of fine arts, by the painter Maurice Haquette.

Auguste Rodin, *Shades Speaking to Dante*, ca. 1880. Sepia, ink, and gouache, over pencil, 7⅝ x 4¹⁄₁₆ in. Fogg Art Museum, Harvard University, Bequest of Grenville L. Winthrop

May 1–June 20. Exhibits *The Bronze Age* (life-size, bronze) and, for the first time, *Saint John the Baptist Preaching* (life-size, plaster) at the Paris Salon. *The Bronze Age* wins a third-class medal, and *The Bronze Age* plaster is bought by the French government for 2,000 francs.

July. Given studios in the state-owned Dépôt des Marbres, 182, rue de l'Université.

July 17. Officially invited to design a monumental portal with sculptural reliefs for the proposed Museum of Decorative Arts; selects Dante's *Divine Comedy* as the subject for what will become *The Gates of Hell*.

August 16. Receives first payment, 8,000 francs, for the *Gates* commission.

November 19. Receives commission for a statue of d'Alembert for the Hôtel de Ville, Paris.

During latter part of year, assembles full-scale architectural framework of *The Gates of Hell*.

Completes *Adam* and related work, *The Shade*; models *The Thinker* and begins *The Helmet-Maker's Wife* and the *Crouching Woman*.

1881

The Gates of Hell and related works, such as *Eve* and *Fallen Caryatid with Stone*, occupy most of Rodin's time, although he also enters a competition for a monument to Lazare Carnot, unsuccessfully, and begins a series of portraits of significant contemporaries that includes Alphonse Legros and Jean-Paul Laurens.

May 2–June 20. Exhibits plaster *Creation of Man* (*Adam*) (grand model) and *Saint John the Baptist Preaching* (life-size, bronze) at the Paris Salon; *Saint John the Baptist Preaching* is purchased by the French government.

Between July 22 and September 1. Makes first of many visits to England, where his friend Alphonse Legros introduces him to the drypoint engraving technique. In England, he meets William Ernest Henley, director of the *Magazine of Art*, Robert Louis Stevenson, John Singer Sargent, Gustave Natorp, and Robert Browning.

1882

Completes busts of Legros and Carrier-Belleuse, as well as the statue of d'Alembert for the Hotel de Ville, Paris.

Begins work on a *Ugolino* group, again using Pignatelli as model.

Meets Mme Lynch de Morla Vicuña, wife of the Chilean diplomat, who introduces him to Parisian society; numerous portrait commissions follow.

Auguste Rodin, *Victor Hugo in Three-Quarters View*, 1884. Drypoint, 8¾ x 5⅞ in. B. Gerald Cantor Art Foundation

April 1–September 30. Exhibits *The Bronze Age* and *Saint John the Baptist Preaching* at the International Exposition, Vienna.

April 24. Exhibits *Saint John the Baptist Preaching* (bust) at the Royal Academy, London, and *The Man with the Broken Nose* and *Alphonse Legros* (both bronzes) at the Grosvenor Gallery, London.

May 1–June 20. Exhibits bronze *Portrait of M. J.-P. Laurens* and terra-cotta *Portrait of M. Carrier-Belleuse* at the Paris Salon.

End of May–June. Returns to England; stays with Gustave Natorp.

September–December. Works at Manufacture de Sèvres under Carrier-Belleuse, then officially resigns.

1882–83. Supervises a sculpture class in the absence of Alfred Boucher.

1883

Meets Camille Claudel, who becomes his mistress and poses for *Aurora* (1885), *Thought* (1886), and *France* (1904), among other works; she also makes many of the small hands and feet used in his sculpture.

Continues series of portrait busts, including Jules Dalou, Maurice Haquette, and Henri Becque; befriends Victor Hugo and sculpts a portrait bust of him.

February. Exhibits a ceramic work for the first time, at the Exposition de "L'Art," avenue de l'Opèra, Paris.

February–March. First known exhibition of his drawings, at the Cercle des Arts Libéraux.

March 1–? Exhibits *The Man with the Broken Nose* (bronze) at the Universal Exposition, Amsterdam; first exhibition in Holland.

May 1–June 20. Exhibits the bronze bust *Danielli* and bronze *Portrait of M. A. Legros* at the Paris Salon.

May–July. Exhibits *Saint John the Baptist Preaching* (large plaster) and busts *Carrier-Belleuse* and *J.-P. Laurens*, among other works, at the Egyptian Hall, London, organized by the Dudley Gallery.

August. Exhibits bronze bust of *Saint John the Baptist Preaching* at the International Exposition, Munich; first exhibition in Germany.

September–November 15. Exhibits *The Bronze Age* and *Saint John the Baptist Preaching* at the Triennial Salon, Paris.

October 26. Rodin's father dies.

1884

Moves to a larger studio at 117, rue de Vaugirard.

Completes busts of Henri Rochefort, Mme Alfred Roll, William E. Henley, Antonin Proust, Mme Lynch de Morla Vicuña, and Camille Claudel.

Submits first maquette for *The Burghers of Calais* monument competition sponsored by the Calais Municipal Council.

Works simultaneously on *The Burghers of Calais* and *The Gates of Hell*, working on the former in the rue de Vaugirard studio and on the latter at the Dépôt des Marbres.

Meets the sculptor Medardo Rosso in Dalou's studio.

Exhibits ceramics at the Union Centrale des Arts Décoratifs, Paris.

May 1–June 20. Exhibits bronze *Portrait of M. Victor Hugo* and plaster *Portrait of M. Dalou* at the Paris Salon.

Before September 24. Exhibits *The Bronze Age* at the Royal Academy, London.

November. *The Bronze Age* is placed in the Luxembourg Gardens. Rodin moves to 71, rue de Bourgogne.

1885

January 28. Signs contract for *The Burghers of Calais* monument.

May 1–June 30. Exhibits bronze *Portrait of M. Antonin Proust* at the Paris Salon.

August. Submits second maquette for *The Burghers of Calais*; design accepted. Works on the figures individually, both nude and draped.

1886

Completion of *The Burghers of Calais* delayed because of financial crisis in Calais.

Project for a monument to Jules Bastien-Lepage is accepted; receives additional commissions for monuments to Benjamin Vicuña-Mackenna and General Patrick Lynch, both to be erected in Chile.

Between 1886 and 1888, completes series of illustrations for Baudelaire's *Les Fleurs du mal* (not published until 1898, in a private edition by Gallimard).

May. Stays with Gustave Natorp in London.

June 15–July 15. Exhibits *Eve* (small marble), *Crouching Woman, I Am Beautiful, Fallen Caryatid with Stone, Andromède,* and portraits of Dalou and Rochefort at the fifth International Exhibition of Painting and Sculpture, Galerie Georges Petit, Paris.

1887

Exhibits *The Kiss* (bronze), a bronze maquette of the *Monument to Bastien-Lepage, Bust of Mme Roll* (marble), and three figures from *The Burghers of Calais*, among other works, at the Galerie Georges Petit, Paris.

December 21. Rodin is notified of his nomination to the jury for the 1889 Exposition Universelle.

December 31. Receives the Cross of the Chevalier of the Legion of Honor.

1888

January 31. Receives state commission for a marble version of *The Kiss*.

May 1–June 30. Exhibits marble *Portrait of Mme M.V.— (Mme Vicuña)* at the Paris Salon.

April 7. Elected to the sculpture jury of the Salon des Artistes Français.

July 20. Bust of Mme Vicuña purchased by the French government for 3,000 francs.

Exhibits two figures from *The Burghers of Calais* at the seventh International Exhibition of Painting and Sculpture, Galerie Georges Petit, Paris (?).

1889

Truman H. Bartlett publishes a series of ten articles on Rodin in the *American Architect and Building News.*

January 23–February 14. First exhibition of prints, at Galerie Durand-Ruel, Paris.

April 7. Elected a member of the sculpture jury of the Salon des Artistes Français, due in part to the intercession of the painter Eugène Carrière.

April 8. Receives commission for the *Monument to Claude Lorrain* to be erected in Nancy.

May 6–November 6. Exhibits one figure from *The Burghers of Calais, Portrait of M. Antonin Proust, Portrait of M. Dalou, The Bronze Age, Saint John the Baptist Preaching,* and *Portrait of Victor Hugo* at the Exposition Universelle, Paris.

June 21–August. Exhibits jointly with Claude Monet at the Galerie Georges Petit, Paris; Rodin shows thirty-six works, among them the complete ensemble of *The Burghers of Calais*, on view for the first time, as are twenty-one of the other works. The exhibition confirms his reputation; supporters now include the period's outstanding critics, Camille Mauclair, Gustave Geffroy, Octave Mirbeau, and Roger Marx.

July–August. Travels to Toulouse by way of the Loire Valley châteaux and immerses himself in a study of architecture; then travels to Clermont-Ferrand, Albi, Rodez, and Bayonne.

September 16. Receives commission from the French government for the *Monument to Victor Hugo*, to be erected in the Panthéon; as a first project he

creates a seated figure surrounded by muses rather than the standing figure requested.

September 29. The *Monument to Bastien-Lepage* unveiled in the cemetery at Damvillers.

About October. Exhibits *The Helmet-Maker's Wife* in Angiers.

1890

Moves from Paris to Bellevue; occupies house at 8, chemin Scribe.

Becomes a founding member of the Société Nationale des Beaux-Arts with Dalou, Meissonier, Carrière, and Puvis de Chavannes.

Begins bust of Puvis de Chavannes.

April, then September–October. Travels in Touraine and Anjou; visits Rodez and Saumur as well and studies architecture there.

May 15–June 30. Exhibits silver-plated bronze *Bust of Mme R.—* (Mrs. Russell), bronze *Torso*, bronze *Helmet-Maker's Wife*, bronze *Sketches*, and marble *Danaïd* at the Salon de la Société Nationale des Beaux-Arts, Paris.

June 11. *Monument to Castagnary* unveiled at Montmartre Cemetery.

July 19. Second project for the Victor Hugo monument is also rejected for installation at the Panthéon.

Fall or winter. Rodin begins work on the third project for the Victor Hugo monument to be erected in the Panthéon, the "Apotheosis"; important related works are *Flying Figure* and *Iris, Messenger of the Gods*.

December 18–January 15. Exhibits *Andromède* (marble) and *The Helmet-Maker's Wife* at Galerie Durand-Ruel, Paris.

1891

Continues work on Victor Hugo; the monument for the Panthéon is never delivered. The second project is considered for installation in the Luxembourg Gardens.

Receives commission for a funerary medallion of the composer César Franck (d. November 8, 1890); completed May 1891.

May 15–July 10. Exhibits plaster bust M. P. *Puvis de Chavannes* at the Salon de la Société Nationale, Paris.

June 19. Receives official commission for a Victor Hugo monument for the Luxembourg Gardens.

July. Receives commission from the Société des Gens de Lettres for a monument to Balzac, thanks largely to its president, Emile Zola.

August–October. Visits Tours and the Indre Valley, making sketches of Balzac's home province.

1891–92. Reads widely and makes studies of Balzac's head, using models from Balzac's native Touraine and portraits by other artists.

1892

Begins a commission for the *Monument to Baudelaire*, later aborted for lack of funds.

By February. Completes a standing draped figure of the *Balzac*; also works on a standing nude figure with arms crossed, in the stance of a wrestler.

May 7–June 30. Exhibits marble bust M. P. *Puvis de Chavannes* at the Salon de la Société Nationale, Paris.

May 31–June 7. Travels to Nancy.

June 6. The Claude Lorrain monument is unveiled in Nancy, to strong criticism, and Rodin—against his better judgment—modifies the pedestal with Apollo and his chariot.

July 19. Appointed Officer of the Legion of Honor.

August 5–10. Travels to Nancy.

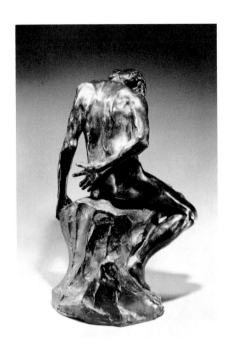

The Helmet-Maker's Wife (rear view), 1884. Bronze, 19½ x 9¼ x 10½ in. B. Gerald Cantor Art Foundation

1893

Health declines, and work on the *Balzac* slows.

Elected president of the sculpture division and vice-president of the Société Nationale des Beaux-Arts, Paris.

Bronze medallion for César Franck placed on his tomb at Montparnasse Cemetery.

Fame spreads in Germany because of Count Kessler's writings.

Exhibits three sculptures in the Chicago Columbian Exposition; second exhibition in America.

May 10–July 10. Exhibits plaster medallion *Bastien-Lepage* at the Salon de la Société Nationale, Paris.

August 13–ca. 24. Travels to Guernsey with Gustave Geffroy and Eugène Carrière.

September. Subscription for *The Burghers of Calais*, dormant since 1886, is renewed.

1894

Accounts of bitter quarrels between the sponsors of the *Balzac* reach the press, and newspapers begin to fill with gossip and criticism of Rodin.

Throughout the mid-1890s, bouts of influenza and depression plague Rodin, his poor health worsened by difficulties over the *Balzac*.

Begins the *Monument to Labor*, a tower inspired by a staircase at the Château de Blois, and creates *The Benedictions* to crown the monument.

January. *Monument to César Franck* completed at Montparnasse Cemetery.

May. Goes to Calais to study locations for the *Burghers*.

August–October. Travels to Nièvre and Aveyron.

October 12. Receives threat from the Société des Gens de Lettres that legal action will be taken if the statue of Balzac is not delivered in twenty-four hours.

November 12. Arrives at new agreement concerning the *Balzac*, with the time clause removed; agrees to make no demands for remuneration until delivery.

November 28. Visits Claude Monet at Giverny, along with Clemenceau, Mirbeau, Geffroy, and Cézanne.

November 30. Receives commission for the *Monument to President Domingo Faustino Sarmiento*, the Argentine political hero.

December. Deposits his 10,000-franc advance for the *Balzac* with the lawyer for the Société des Gens de Lettres as collateral.

1895

Leaves Bellevue for his new residence, the Villa des Brillants, Meudon.

With Monet, Degas, Renoir, Besnard, Satie, Gide, Redon, Mallarmé, Colette, and Willy, frequents the salon of composer Ernest Chausson.

January 16. Hosts banquet in honor of Puvis de Chavannes.

April 25–June 30. Exhibits marble *Head (Thought)*, *Bust of Octave Mirbeau*, and *Eustache de Saint-Pierre* at the Salon de la Société Nationale, Paris.

June 3. *The Burghers of Calais* is unveiled, installed in the Place de Richelieu, Calais, on a pedestal and surrounded by a Gothic-style fence, all contrary to Rodin's specifications; in 1924, the *Burghers* is moved to the square in front of the town hall and placed at ground level, as Rodin had originally wished.

December 19. Buys his house in Meudon, which remains his principal residence.

1896

Elected a member of the sculpture grand jury for the Salon des Artistes Français until 1910.

February 2–13. Exhibits at the Musée Rath, Geneva; first presentation of photographs of his works. Donates three bronze sculptures to the museum: *The*

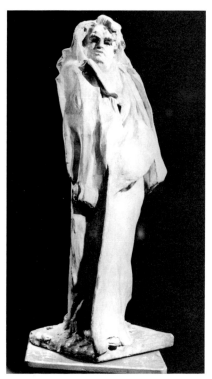

Robed Balzac, 1897. Plaster study, height 41¾ in. (Photo, Musée Rodin)

Man with the Broken Nose, *The Thinker*, and *Crouching Woman* (which is judged indecent and put in storage).

April 25–June 30. Exhibits *Illusion, Daughter of Icarus*, and several other works at the Salon de la Société Nationale, Paris.

1897

Les Dessins d'Auguste Rodin, the first significant analysis of Rodin's drawings, prefaced by Mirbeau, is published by the Maison Goupil.

The maquette for the Balzac monument is finished and enlarged.

February 2. Hosts a dinner with François Vielé-Griffin and Claude Debussy in honor of Mallarmé's publication of *Divagations*.

April 22–October 31. Exhibits five plasters, including *Danaïd, Ugolino*, and *Despair*, at the second International Exhibition of Art, Venice (later known as the Biennale).

April 24–June 30. Exhibits plaster group of *Victor Hugo* (final project for Luxembourg Gardens), *The Thought of Life* (marble column), marble group of *Love and Psyche (Eternal Springtime)*, small marble group of *The Thought, Fallen Caryatid with Stone*, and Camille Claudel's bust of Rodin at the Salon de la Société Nationale, Paris.

May 15–October 1. Exhibits bronze bust *Dalou*, plaster *Inner Voice*, and marble *Resurrection of Adonis* in Stockholm.

1898

Relationship with Camille Claudel ends.

March. *Monument to Balzac* completed.

March 26–June 15. Exhibits at the first Vienna Secession.

May. Société des Gens de Lettres refuses the *Balzac* on grounds that it does not pass as a completed work of art. Exhibits at the first exhibition of the International Society of Painters, Sculptors, and Engravers, London, presided over by J. A. M. Whistler.

May 1–June 30. Exhibits plaster *Balzac* for the first time and *The Kiss* (marble) at the Salon de la Société Nationale, Paris.

Violent press campaign emerges against Rodin, who receives offers for the *Balzac* from a committee in Belgium, from a group of subscribers, and from the collector Auguste Pellerin; Rodin decides to keep the sculpture and removes it to his home in Meudon. (The *Balzac* is not cast in bronze during Rodin's lifetime.)

1899

March 27. Receives commission for a monument to Puvis de Chavannes; monument never completed.

May 1–June 30. Exhibits bronzes *Eve* and *Bust of Falquiere*, a plaster of *Rochefort*, and a marble *Group* at the Salon de la Société Nationale, Paris.

Spring. Travels to Belgium and Holland with Judith Cladel to administer the first significant touring exhibition of his work, organized by Cladel. Exhibition seen at Maison d'Art, Brussels, May 8–June 5; in Rotterdam, June 19–July 30; at Arti et Amicitiae, Amsterdam, August 15–September; and at Haagsche Kunstkring, The Hague, October 9–ca. November. While in Antwerp, Rodin is impressed by the work of Rubens, van Dyck, Teniers, Snyders, and Jordaens; in Holland, Rembrandt's work most interests him.

July 12. Receives authorization to install a pavilion on the Place de l'Alma for a one-man exhibition, to be known as the Exposition Rodin.

August 10–19. Travels to Amsterdam.

End of August–September. Travels to Rotterdam.

End of 1899. Works on the creation of a school of sculpture and drawing.

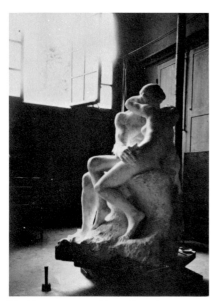

The Kiss, 1898, marble. (Photo by Eugène Druet, Musée Rodin)

1900

May 2–November 12. Exhibits eight works at the Exposition Centennale de l'Art Français; exhibits *The Kiss* at the Exposition Décennale. Both exhibitions celebrate the inauguration of the Grand and the Petit Palais.

May 25. *Monument to President Domingo Sarmiento* unveiled in Buenos Aires to a hostile public and press.

June 1–end of November. Major retrospective exhibition, the Exposition Rodin, held near the Exposition Universelle, Paris, and housed in a temporary, Louis XVI-style pavilion on the Place de l'Alma. Exhibition is financed by Rodin and three bankers: Louis Dorizon, Albert Kahn, and Joanny Peytel. Of the 150 sculptures, works totaling more than 240,000 francs are sold; requests for busts increase after the exhibition, and Rodin's international renown grows among collectors in Germany, the United States, England, and Denmark.

June 11. Banquet is held in Rodin's honor, organized by the magazine *La Plume*, which also devotes a special issue to his art.

July 12. Nominated a member of the Royal Academy of the Plastic Arts, Dresden.

1901

Begins no new monumental works this year; concentrates on portrait busts, many of Englishmen and Americans, and on small, informal pieces, including dancers.

Numerous exhibitions follow the celebrated Exposition Rodin, in Barcelona, Berlin, Budapest, Dresden, Prague, Venice, and Vienna, as well as Glasgow, The Hague, and Helsinki.

Saint John the Baptist Preaching purchased through public subscription in England.

Increases the number of studio assistants trained to reproduce his sculptures in marble to fill the many commissions received.

Photographer Edward Steichen visits Rodin at Meudon and begins a photographic study of the artist and his sculpture.

May 22–June 30. Exhibits the full-figure marble *Victor Hugo* intended for the Luxembourg Gardens at the Salon de la Société Nationale, Paris.

October 25–ca. November 12. Travels to Italy: Turin, Florence, Livorno, and Ardenza, among other locations.

1902

Judith Cladel begins her biographical study of Rodin.

Completes the bust of Mrs. John W. Simpson.

April 20–June 30. Exhibits *The Three Shades* (plaster, grand model) and *Heroic Bust of Victor Hugo* (plaster), as well as other works, at the Salon de la Société Nationale, Paris.

May 10–August 10. Major retrospective exhibition in Prague, sponsored by the Manes Society, includes about ninety sculptures and seventy-five drawings. Accompanied by Mařatka, Mucha, and Vacha, Rodin travels through Europe, arriving in Prague by way of Cologne and Dresden on May 28.

May 14–20. Travels to England in honor of the donation of *Saint John the Baptist Preaching* to the government by the National Arts Collection Fund.

June. Exhibits at the fifth Berlin Secession.

September. Meets and begins correspondence with Rainer Maria Rilke; they correspond until Rodin hires him in 1905. Rodin employs the firm of Alexis Rudier as his principal founder and René Chéruy as his secretary.

1903

Two important books on Rodin are published: Rainer Maria Rilke, *Auguste Rodin*, and Judith Cladel, *Auguste Rodin: Pris sur la vie*.

Executes the busts of the Honorable George Wyndham, secretary of state for Ireland, Eugène Guillaume, and Mrs. Potter Palmer.

A view of one room of the 1902 Prague exhibition. (Photo, Musée Rodin)

Rodin with the Duchesse de Choiseul—
"the Muse," as Rodin's friends called her.
(Photo, Musée Rodin)

April–June. Exhibits at the seventh Berlin Secession.

April 22–October 31. Exhibits at the fifth Venice Biennale.

May 7–17. Exhibits at the National Arts Club, New York.

May 20. Becomes Commander of the Legion of Honor.

End of May. Returns to London at the request of students to attend a dinner in his honor, given on May 25.

June 30. Banquet in his honor at the Bois de Vélizy organized by friends, with Emile-Antoine Bourdelle presiding.

November. Elected president of the International Society of Painters, Sculptors, and Engravers following Whistler's death on July 17, 1903.

1904

Returns funds advanced for *The Gates of Hell* to the government.

January. Travels to London to accept the presidency of the International Society of Painters, Sculptors, and Engravers. Meets Claire Coudert, Duchesse de Choiseul, who dominates his life for the next several years and who is viewed by Rodin's friends as exploitative.

January 9–March. Exhibits large plaster and small bronze of *The Thinker* plus six more works in the International Society of Painters, Sculptors, and Engravers exhibition, London.

April 17–June 30. Exhibits *The Thinker* (large bronze) and *Bust of Mme S.* (*Mrs. John W. Simpson*) (marble) at the Salon de la Société Nationale, Paris.

Throughout the year, has several important exhibitions in Germany, including Düsseldorf, Dresden, Weimar, and Leipzig. Exhibitions are also held in Berlin, Edinburgh, Krefeld, and Saint Louis.

1905

Acquires the ruins of the eighteenth-century Château d'Issy and plans to rebuild it to house his collection of antique sculpture. Only the façade is renovated; it is placed near the 1900 Exposition Rodin pavilion at Meudon, where it now overlooks Rodin's tomb.

Finishes the busts of Gustave Geffroy, Eve Fairfax, and Georges Hecq.

January 9–June. Under Rodin's direction, the International Society of Painters, Sculptors, and Engravers' exhibition travels from London to Manchester to Burnley, in accordance with Whistler's wishes.

February 3–end of March. Exhibits prints and decorative bas-reliefs for the Villa La Sapinière, Evian, at the Musée du Luxembourg.

March. Exhibits at the Copley Society, Boston.

April 15–June 30. Exhibits the plaster grand models of *Ariane* and *Cybèle* plus the bronze *Bust of M. Guillaume* at the Salon de la Société Nationale, Paris.

May 9. Nominated for an honorary degree by the University of Jena; reciprocates by donating the bust *Minerva* (bronze) to the university.

June. Travels to Spain—Madrid, Toledo, Córdoba, Seville, and Pamplona—with Rilke and the painter Ignacio Zuloaga.

September. Rainer Maria Rilke begins work as Rodin's secretary. Rodin receives commission for a Whistler memorial.

October 18–November 25. Exhibits for the first time at the third Salon d'Automne, Paris; at least six works are presented.

1906

Completes series of portraits of George Bernard Shaw as well as portraits of Mrs. and Miss Hunter, Lord Howard de Walden, Marcelin Berthelot, Comtesse Mathieu de Noailles, Georges Leygues, and Mme de Goloubeff.

Works on an enlargement of *Ugolino*, with Pignatelli again as model.

Exhibits at the Society of Finnish Art, Helsinki.

January. Nominated for an honorary degree by the University of Glasgow; he offers them the bronze relief *La France*.

February 22–? Exhibits in London.

March 11–? Exhibits at the Galerie Georges Petit, Paris.

March 14–April 22. Exhibits at the Kunsthalle, Basel.

April 15–June 30. Exhibits *Sculpture* (*Marcelin Berthelot*) and a bronze medallion of Stendhal at the Salon de la Société Nationale, Paris.

April 21. *The Thinker* is erected in front of the Panthéon, where it remains until relocation to the Court of Honor of the Musée Rodin in 1922.

May. Dismisses Rilke following a complaint that he was mishandling correspondence; hires the Englishman Anthony Ludovici to replace him. Nominated honorary member of the Berlin Academy of Fine Arts.

July 15–20. Travels to Marseilles with Georges Bois to visit the Exposition Coloniale.

Inspired by the dance as a new subject, Rodin produces a series of drawings of the dancers in King Sisowath's Royal Ballet of Cambodia; he also draws the dancers at Isadora Duncan's school in Paris.

December 1. First exhibition of the acquisitions and commissions of the French government, at the Ecole des Beaux-Arts, Paris.

December 26. Receives second commission for the Victor Hugo monument for the Luxembourg Gardens, modifying that of June 19, 1891.

December 31. The French government purchases the marble *Monument to Victor Hugo*.

1907

Nominated a corresponding member of the Associazione degli Artisti Italiani.

Completes busts of Mme Elisseieff and Joseph Pulitzer.

January 7–March 30. Exhibits at the International Society of Painters, Sculptors, and Engravers, London.

January 27–March 9. Exhibits with other members of the Academy in Berlin.

March 2–April 7. Exhibits at the Société des Amis des Arts, Strasbourg.

April 14–June 30. Exhibits large plaster of *The Walking Man* and busts of Mrs. Goloubeff (marble), Mrs. Hunter (marble), and Miss Fairfax at the Salon de la Société Nationale, Paris.

April 23–July 15, then September–November. Exhibits in Barcelona.

May 31–? Participates in the Exposition de la Porcelaine at the Musée Galliera, Paris; this first presentation of an important group of ceramic works brings Rodin great success.

May. Nominated for an honorary degree by Oxford University, along with Mark Twain, William Booth, and Camille Saint-Saëns. On June 26, Rodin goes to Oxford to accept the degree and then travels to London to supervise the installation of the bust of William E. Henley in the crypt of Saint Paul's, unveiled July 11.

October 1–22. Exhibits bronze busts of Georges Leygues and Comtesse Mathieu de Noailles at the fifth Salon d'Automne, Paris.

About October 10–30. First significant exhibition of Rodin's drawings held at the Galerie Bernheim Jeune, Paris (includes 303 drawings that could not be displayed at the Salon d'Automne because of a shipping delay).

December. Second exhibition of the acquisitions and commissions of the French government, at the Ecole des Beaux-Arts, Paris.

Exhibitions are also held in Budapest, New York, and Venice.

1908

Portraits executed this year include those of the Japanese dancer Hanako, the

Duchesse de Choiseul, J. Winchester de Kay, and Lady Warwick.

January 7–February. Exhibits at the International Society of Painters, Sculptors, and Engravers, London.

March 6. Visit by King Edward VII of England to Meudon; Rodin leaves only selected marbles and plasters in the studio for the occasion.

April 15–June 30. Exhibits *Orpheus* (plaster), *Triton and Nereid* (plaster), and *Muse* at the Salon de la Société Nationale, Paris.

May 1–November 1. Exhibits at the Exposition Franco-Britannique, London.

June 1. *Monument to Henri Becque* unveiled at the Place Prosper Goubeaux, Paris.

September. Edward Steichen returns to Meudon and photographs the *Balzac* by moonlight.

September 27–November 1. Exhibits in Frankfurt am Main.

October 15. Begins living in the Hôtel Biron, rue de Varenne, which had been bought by the state in 1904 and rented as apartments; tenants before Rodin included Rilke, Isadora Duncan, Jean Cocteau, and Henri Matisse.

October 19–November 5. Exhibits at the Galerie Devambez, Paris.

November 28–December 20. Third exhibition of the acquisitions and commissions of the French government, at the Ecole des Beaux-Arts, Paris.

Exhibits drawings at Alfred Stieglitz's 291 Gallery, New York, as a result of his friendship with Edward Steichen.

Exhibitions are also held in Berlin, Brussels, Buenos Aires, Edinburgh, Florence, Liverpool, Lyons, Moscow, Munich, Saragossa, Stockholm, and Vienna.

1909

Portraits executed this year include those of Renée Vivien, Jules Barbey d'Aurevilly, Edward Harriman, Gustav Mahler, Thomas Fortune Ryan, the Duc de Rohan, and Napoleon.

January 27–March 7. Exhibits at the Academy of Fine Arts, Berlin.

About February–March. Exhibits at the International Society of Painters, Sculptors, and Engravers, London.

April 15–June 30. Exhibits marble bust of Mme Elisseieff at the Salon de la Société Nationale, Paris.

August 20–September 9. Travels to the Château de Josselin, home of the Duc de Rohan, to execute his portrait.

September 30. Victor Hugo monument destined for the Luxembourg Gardens is installed in the gardens of the Palais Royal.

October 1–16. Exhibits at the Galerie Devambez, Paris.

November 28. *Monument to Barbey d'Aurevilly* is unveiled at Saint-Sauveur-le-Vicomte.

Exhibitions are also held in Bordeaux, Hanover, Liège, Montreal, and Paris (Ecole des Beaux-Arts).

1910

Thomas Fortune Ryan donates three Rodin works to The Metropolitan Museum of Art—*Cupid and Psyche*, *Orpheus and Eurydice*, and *Pygmalion and Galatea*; this gift is supplemented by funds for the future purchase of other Rodin pieces (nine marbles and bronzes and one terra-cotta are acquired with Ryan funds).

March. Rodin's article *Venus de Milo* published in *L'Art et Les Artistes*.

March 9–? Exhibits at the Galerie Georges Petit, Paris.

March 31–April 18. Exhibits at Gallery 291, New York.

April 15–June 30. Exhibits plaster *Torso of a Woman*, *La Prière*, bronze *Mme R.—* (*Mme Rodin*), and bronze *M.R.—* at the Salon de la Société Nationale, Paris.

May 14–November 15. Exhibits at the International Exposition, Palais du Cinquantenaire, Brussels.

May 16. Made Grand Officer of the Legion of Honor.

About May 25. Travels to Brussels for the International Exposition.

May 26–? Exhibits at the International Society of Painters, Sculptors, and Engravers, London, and at the Grafton Galleries, London.

June 16. Banquet in Rodin's honor given by the Legion of Honor.

June 28. Reception in Rodin's honor given at the Ritz by Jane Catulle-Mendès.

August 14. Rodin's works escape damage in the fire at the Palais du Cinquantenaire, Brussels.

October 16–November. Exhibits in the Exposition d'Art Français, Leipzig.

Exhibitions are also held in Brussels (Libre Esthétique), Buenos Aires, Interlaken, Lyons, Paris (Ecole des Beaux-Arts), and Zurich.

1910–11

Produces a number of studies of dancing figures based on a model named Moreno.

1911

Executes portraits of Professor Gabritchewski and Georges Clemenceau.

Conversations with Rodin published in *L'Art, Entretiens réunis par Paul Gsell.*

January 20–March. Exhibits at the Academy of Fine Arts, Berlin.

February 26. Receives commission from the Ministry of Fine Arts for a marble bust of Puvis de Chavannes, to be placed in the Panthéon.

Beginning of March–end of May. Exhibits at the Royal Scottish Academy, Edinburgh.

March 31–November 30. Exhibits at the International Exposition, Rome; one of the sculptures displayed, a large bronze figure of *The Walking Man,* is purchased by a group of admirers and is presented to the French government for its embassy in the Palazzo Farnese, Rome.

April 16–June 30. Exhibits marbles *Portrait of the Duc de Rohan* and *Gustav Mahler,* among other works, at the Salon de la Société Nationale, Paris.

July. The Hôtel Biron is purchased by the French government, which decides to evict the tenants. Judith Cladel, Gustave Coquiot, and others propose the creation of a Rodin museum, amidst great opposition.

November. The British government purchases a cast of *The Burghers of Calais* through the National Arts Collection Fund.

Exhibitions are also held in Berlin (Secession), Glasgow, London, Paris (Galerie Georges Petit), Prague, and Turin; a traveling exhibition organized by the Société de Peintres et de Sculpteurs (formerly the Société Nouvelle de Paris) tours to Boston, Buffalo, Chicago, and Saint Louis.

1912

Executes drawings and sculpture of the dancer Nijinsky in the nude, after seeing him perform *L'Après-midi d'un faune,* and publicly defends the dancer against accusations of indecency.

Works on a project for a monument to Eugène Carrière; never completed.

Gives eighteen plaster casts and an original terra-cotta to The Metropolitan Museum of Art.

French ambassador disapproves of *The Walking Man* in the courtyard of the Palazzo Farnese, Rome; the sculpture is moved to Lyons in 1923.

During this period of his life, Rodin's mental abilities decline markedly; supposed friends take advantage of his condition and attempt to gain control of his work and estate; forgeries and thefts abound. Only through the diligence of loyal friends such as Judith Cladel is Rodin's life work salvaged from opportunists.

Beginning of February. Exhibits in the Centennale de l'Art Français, Saint Petersburg.

February. Exhibits in Tokyo.

April 23–November 22. Exhibits in the tenth Venice Biennale.

May 1–? Exhibits at the first Salon de Mai, Marseilles.

May 2. The Metropolitan Museum of Art's Rodin collection opens.

May 3. The Champlain monument, based on the head of Camille Claudel and called *La France* (bronze relief), is unveiled at Crown Point, New York, in honor of the three-hundredth anniversary of the discovery of Lake Champlain.

August. Relationship with the Duchesse de Choiseul ends; however, she continues her campaign to be named in his will.

Exhibitions are also held in Amsterdam, Dresden, Frankfurt am Main, London, Manchester, Paris (Galerie Georges Petit and the Triennale), Strasbourg, and Vienna.

1913

Executes a portrait of Lady Sackville.

Conversations with Henri-Charles-Etienne Dujardin-Beaumetz, undersecretary of fine arts, are published.

February 17–March 17. Exhibits *A Lion Roaring* (bronze) and *The Centauress* (marble) at the first Salon de la Société des Artistes Animaliers, Paris.

March 17–26. Exhibits at the Exposition de l'Education Physique et des Sports, Faculté de Médecine, Paris.

March 22–June. Exhibits in the first Rome Secession.

After March 29. Exhibits in Tokyo.

April–May. Supervises the installation of *The Burghers of Calais* next to the Houses of Parliament in London; unveiled in October.

April 14–June 30. Exhibits a plaster work, *L'Homme qui court*, and a marble bust of Puvis de Chavannes at the Salon de la Société Nationale, Paris.

May 5–October. Exhibits in the International Exposition, Ghent.

May 10–? Exhibits at the Royal Scottish Academy, Edinburgh.

June 1–October 31. Exhibits at the eleventh International Exposition of Fine Arts, Munich.

September 7–ca. October 7. Exhibits at the Exposition d'Art Francais, São Paulo.

1914

Rodin's health and mental faculties decline precipitously; he travels to the Midi to rest.

Publishes *Les Cathédrales de France* with an introduction by Charles Morice and illustrated by his own drawings.

May–July. Divides his time between Paris, Meudon, and Châtelet-en-Brie, the home of Dr. Vivier.

June 29–July 3. Goes to London to assist with the opening of the Exposition d'Art Français.

July 1–ca. 21. Presents twenty sculptures (seventeen bronzes, one terra-cotta, two marbles) to the Exposition d'Art Français at Grosvenor House, London.

July 19–24. Again visits London.

Between July 21 and August 22. Rodin's works are installed in the South Kensington Museum (now the Victoria and Albert Museum).

Before September 9. Goes to London with Rose Beuret and Judith Cladel, and probably stays at Cheltenham until November 11; presents eighteen sculptures to the British government as a gesture of gratitude for Britain's support of Belgium.

End of November–beginning of December. Leaves for Rome, where he stays at the home of John and Mary Marshall until February 1915.

1915

April 8–May. Visits Florence briefly, following his abbreviated sittings with Pope

Henriette and Jeanne Bardey with Rodin and Rose. (Photo, B. Gerald Cantor Art Foundation)

Rodin's funeral, November 24, 1917. As Rodin had requested, *The Thinker* stands at his tomb in Meudon. (Photo, Musée Rodin)

Benedict XV in Rome.

June 4–? Exhibits *The Thinker* (large bronze), among other works, at the Panama-Pacific International Exposition, San Francisco.

July 21. *The Burghers of Calais* is purchased by the British government for installation in the Victoria Tower Gardens.

1916

Completes his final work, the *Portrait of Etienne Clémentel*, minister of commerce.

March. Suffers a fall, which worsens his already extremely poor condition.

March 11–April 9. Exhibits at the Albright Art Gallery, Buffalo, as part of the Exposition d'Art Français et Belge (a selection from the Panama-Pacific International Exposition held in San Francisco, 1915); four bronzes then travel to Toledo for exhibition around November.

April 1. Formally offers his entire oeuvre, in the form of three donations, to the French government for the establishment of a Rodin museum in the Hôtel Biron and outlines the first donation. The second and third donations follow in September and October, respectively.

July. Judith Cladel and Etienne Clémentel protect Rodin's estate from the attempts of Loïe Fuller and Mme Bardey to seize considerable portions for themselves.

July 10. Suffers another fall.

July 12. He makes a will in favor of Mme Bardey.

September 14. The Chamber of Deputies votes 379 to 56 to accept the donations.

November 9. The French Senate votes by a majority of 209 to 26 to accept the three donations of Rodin's work.

December 15. The National Assembly votes to establish a Musée Rodin in the Hôtel Biron.

December 26. Receives a commission for a monument to the defense of Verdun.

1917

January 29. Marries Rose Beuret at Meudon to protect her legal rights in case of his sudden death.

February 14. Rose dies.

March 3–? Exhibits at the Galerie Georges Petit, Paris.

April 23–? Exhibits at the Exposition des Sociétés d'Art Français, Barcelona.

April 25. Makes a final will, to which he adds a codicil on November 15.

October 25. Paul Cruet makes a cast of Rodin's hand, into which he places a female torso.

November 6–? Exhibits at the Galerie Haussman, Paris.

November 17. Rodin dies.

November 24. He is buried at Meudon next to Rose; his grave lies before the reconstructed façade of the Château d'Issy with *The Thinker* as its headstone. (Eulogies are delivered by M. Lafferre, minister of public instruction and fine arts; M. Clémentel, minister of commerce; M. Bartholomé, on behalf of the Société Nationale; Frantz Jourdain, on behalf of the Salon d'Automne; Albert Besnard, director of the French Academy in Rome; and the writer Séverine.) Simultaneously, a memorial service is held in Saint Margaret's, Westminster, with Queen Alexandra attending.

1918

The Musée Rodin receives official recognition, and its financial autonomy is confirmed by law.